© 2007 Assouline Publishing
601 West 26th Street, 18th floor
New York, NY 10001, USA
Tel.: 212 989-6810 Fax: 212 647-0005
www.assouline.com

Color separation by Luc Alexis Chasleries
Printed in China

ISBN: 978 2 75940 164 2

Inspired Styles

Artists inspire us. This much we know. But what inspires artists? What strange and wonderful experiences shape and shade their unique visions of the world?

This book provides a glimpse into the inner worlds of seventeen gifted artists. They are artists of interior design. We all know what it means to feel inspired, but it takes a special kind of talent to express design inspirations so that others can appreciate them. The seventeen interior designers featured in this book have demonstrated this talent again and again. Their work rarely appears in museums. Instead, they create artful environments where we can live and breathe every day.

This book is a testament to the art of interior design. Its distinguished contributors have spoken in their own words, selected images that inspire them, and shared a few choice examples of their own interior designs.

My association with these designers has been one of the many rewards of a fulfilling career in the interior design industry. Working alongside them has deepened my appreciation of what it means to provide fabrics, furniture, trimmings, and other decorative products to the interior design trade. As Kravet is a fourth-generation company, it seems fitting to honor the art of interior design as we near the end of our first century in the industry. When we started licensing fabrics and furnishings, our goal was to showcase the artistic tastes of some of the world's most inspiring interior designers. Though this book focuses on a few selected designers, it is meant as a tribute to all those who have made our industry what it is today.

Whenever artists move me, I am always struck with the same questions: How do they do it? How does the world look and feel to them, and how do they express their unique perspectives with such courage, candor, and elegance? This book provides some answers. It has inspired me. I hope you find yourself similarly inspired.

CARY KRAVET
PRESIDENT, KRAVET INC.

CONTENTS

Foreword by Dominique Browning 8

Barbara Barry 10

Michael Berman 22

Barclay Butera 36

Eric Cohler 48

Diamond & Baratta 60

David Easton 74

Alexa Hampton 88

Allegra & Ashley Hicks 102

Thomas O'Brien 116

Candice Olson 130

Suzanne Rheinstein 142

Windsor Smith 154

Kelly Wearstler 168

Michael Weiss 180

Vicente Wolf 194

Credits 206

FOREWORD

The act of designing anything at all is quite mysterious, even when you have the chance to quiz the artist about what she or he has created. As far as I can tell, two important things are involved—besides, of course, the innate talent and drive necessary to begin with—and those are Dreams and Research. One of the most fascinating things about creative people is the way they inhabit the space from which originality springs. And though you can't go there with them, you can glimpse the beginnings of the process, the springboards, if you will. For scattered about most designers' desks, or pinned to their walls, are the pictures and objects that inspire them.

You'll see, if you visit a designer—and that's just what you can do in the pages of *Inspired Styles* where the eminent creators for Kravet and Lee Jofa are profiled—all sorts of inspiration. Some of the people in this book look to the world of plants; some to the grit of urban life. Some find ideas in the color of a beloved dog's fur; some in the color of a flashing stiletto. Buttons, boxes, bowls, and beads; lipsticks, shoes, shells, and books: All these humble, everyday things—things most of us look right past—have stirred a designer's soul, igniting the spark from which creation begins.

Inspiration comes at odd moments, and not necessarily (and maybe hardly ever) when you are actually sitting down to do the hard work of designing. That is why creative people make those wonderful boards covered with photographs and postcards and bits of color and pages torn from magazines; they get a feeling when they see something, that it will someday be meaningful to them. They just can't predict how or when. They gather their inspirations, husbanding their resources—hoping to one day make the connection between a thing that moved them, and something that will move others.

I have had the opportunity to work with many wonderful designers—most recently with an architect in rebuilding a house in Rhode Island that had to be torn down due to structural problems and plain old rot. I handed him a seashell from the beach near my house; it wasn't even a whole shell, just the inside spiral, bleached and smoothed by the sun and waves. I asked him if he could design my staircase to look like that bit of shell. And he did.

But it takes knowledge—education, reporting, and a certain worldliness—to go from seeing the color on a robin's breast to developing a fabric that perfectly captures it. You would want to know, for instance, how velvet is made, and how it takes the light, and how it ages and wears; you would want to have enough experience to decide that perhaps linen would carry that hue more successfully.

Only with knowledge can you translate inspiration into reality—and only then do you see magic being made.

DOMINIQUE BROWNING
HOUSE & GARDEN

BARBARA BARRY

Over the years I have come to appreciate what it means to have been raised by an artist. I grew up seeing the world in a painterly way, and I find the creative act as natural as breathing. As a young girl, I set out to create beauty wherever I could. The light, colors, and smells of my native California have influenced me profoundly. They are all stored in my sense memory. They are the source of my sensibility—and of my unique palette. I see the world in terms of color, form, and light, so everything I look at becomes a composition. Because I see so actively, inspiration is everywhere: the color of the water in the bath, the morning light that pours through my window, the way that light casts itself—turning my bedroom into a "still life." Even the arrangement of objects on my desk, or the color of the grains of sand on the beach, or the water leading to the horizon serves as inspiration. I operate on a visceral and intuitive level. I dream a lot. I draw a lot. I write a lot. It all seems part of the creative process, a process that is fluid, and generally begins with a sketch or a watercolor. Ideas seem to come to mind "fully formed." I reach to capture them quickly, before they fade. I am in constant motion, almost always with pencil in hand: drawing, erasing, drawing again, building, rebuilding, and wrestling an idea into submission—and into design. There isn't a color, a chair, or a trim that hasn't had my complete attention and passion.

I have always been interested in unencumbered design, design apart from fashion or trends, design that emerges from a philosophy rather than a style. For me, that philosophy is based on principles of balance, proportion, and symmetry. I like to know how things are constructed, so I travel the world visiting the places where my products are made. I like to meet the people who produce them, and I want to learn the nature of the materials they handle. When I began working in crystal, experienced artisans taught me that crystal can do things that glass can't, and vice versa. And artisans well versed in the art of the table taught me that because bone china wiggles in the mold, it will not form as crisp an edge as porcelain—but that is also why it feels so sensuous. Limitations and opportunities come with each material. That is what design is about.

I design for the universal everyday acts of living, and I strive to uplift those acts with things that delight the eye and invite the body. The simplest things can also be the most elegant: a polished apple sitting in a glass bowl, crisply ironed sheets on a mahogany bed, a single flower in a graceful vase. Life is meant to be lived fully and enjoyed deeply, and our homes are the great backdrops upon which our lives unfold. They are where we begin and end each day. Any room in which we spend time should feed us, nurture us, and improve the quality of our lives. People are what bring rooms to life. Good design—quiet luxury, subtle pattern, easy elegance—supports this.

In design, as in life, nothing stands alone, not a chair, not a lamp, not a spoon. Each is part of a larger whole, and the interconnections must be taken into account at the earliest stages of the design process. When they are, and when the balance, proportion, and symmetry are right, the vast network of connections gives way to a feeling of effortless simplicity. It's a feeling I strive for in my work. Attaining it leads to designs that express harmony, tranquility, and calm—the things we need to support us and sustain us in our hectic lives.

From the beginning of my career, I have wanted to make rooms where the power of beauty holds us. For me, beauty heals. That is its transformative power. I pursue it daily. I live unabashedly for beauty, both inner and outer—in my world, they are intimately connected.

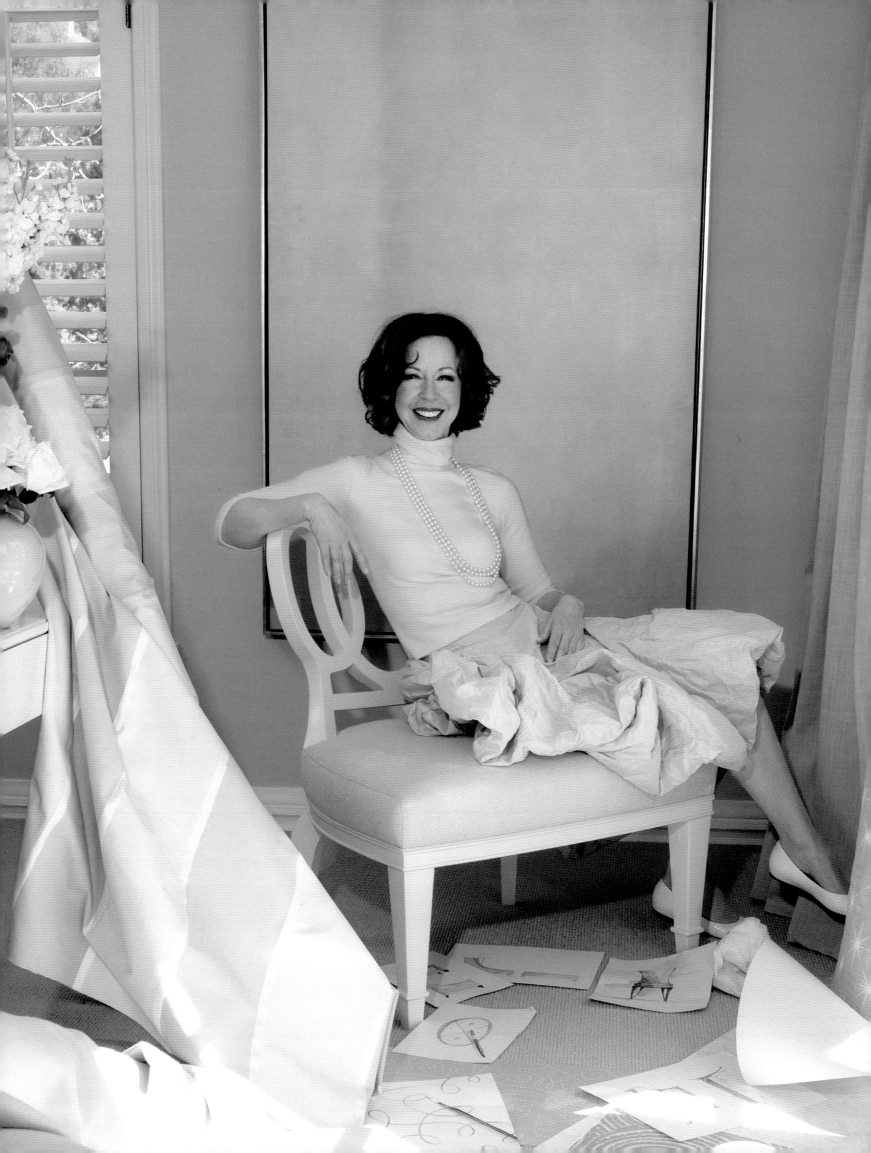

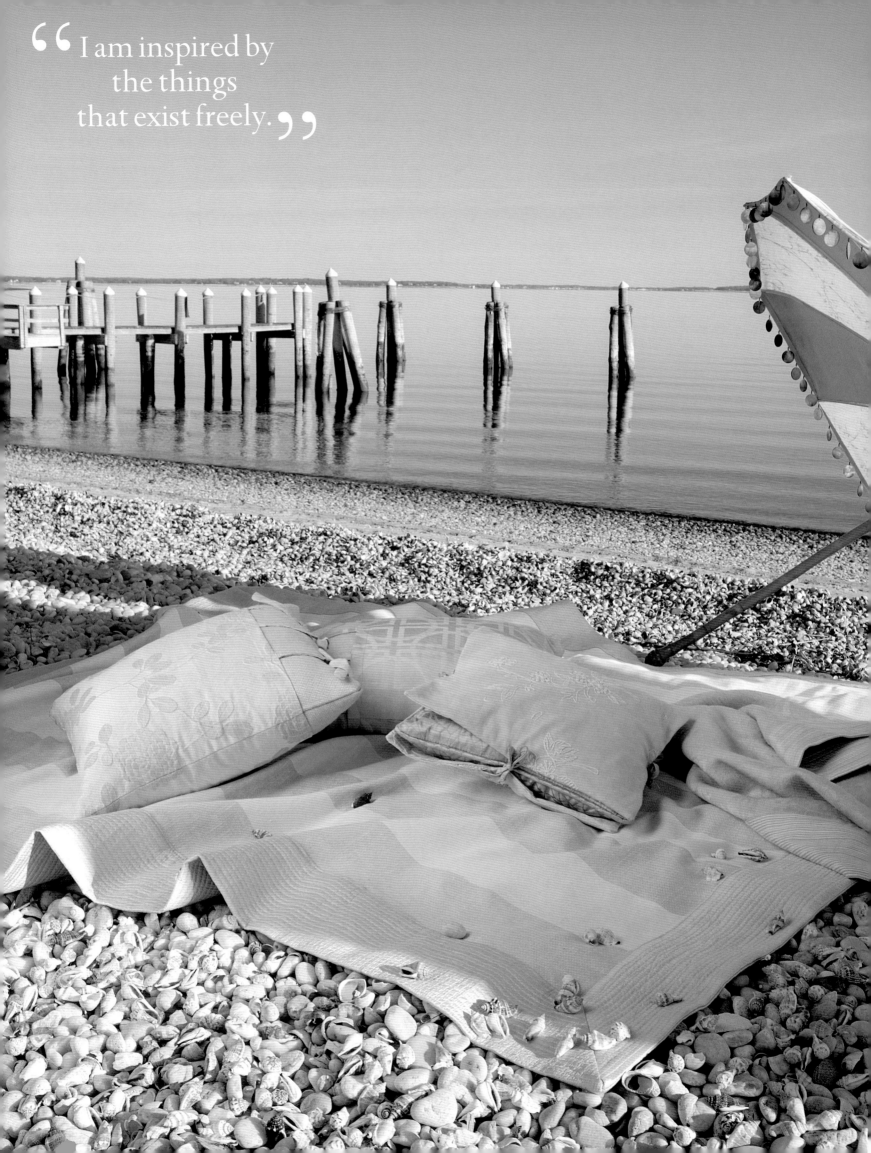

"I am inspired by the things that exist freely."

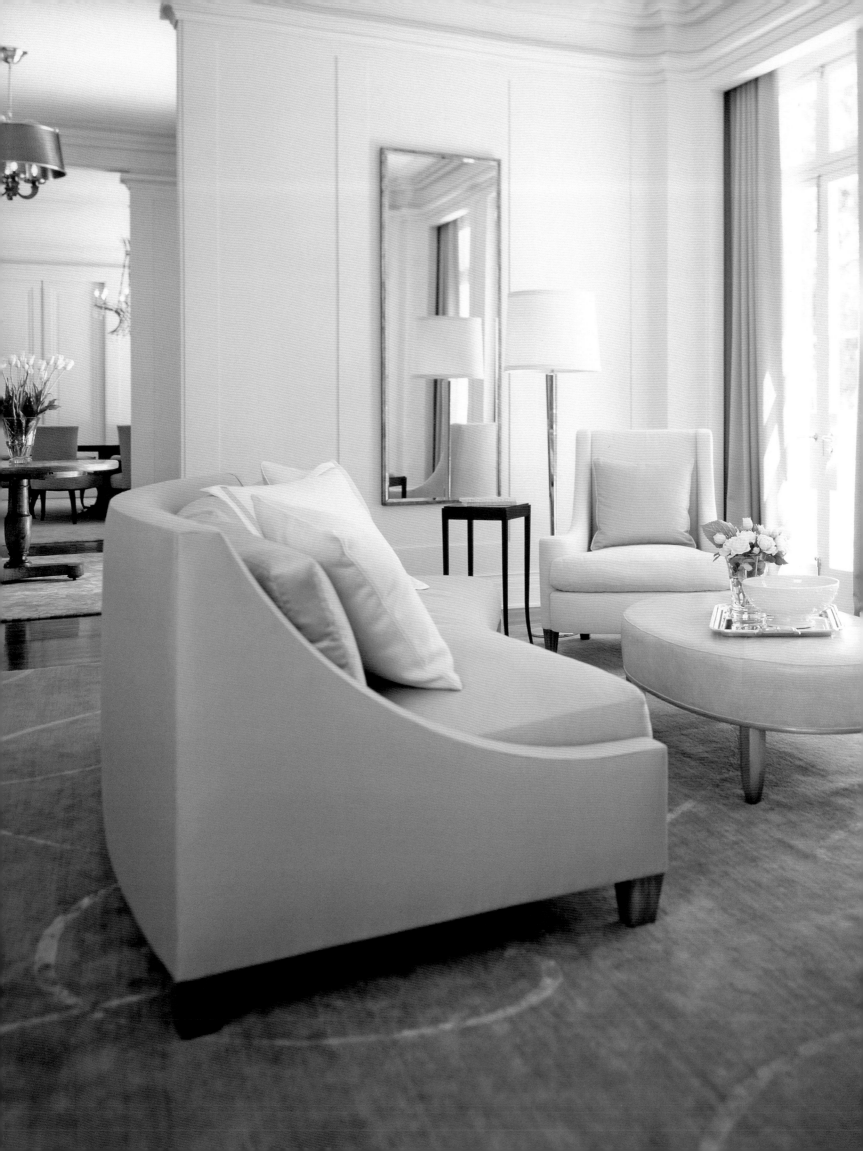

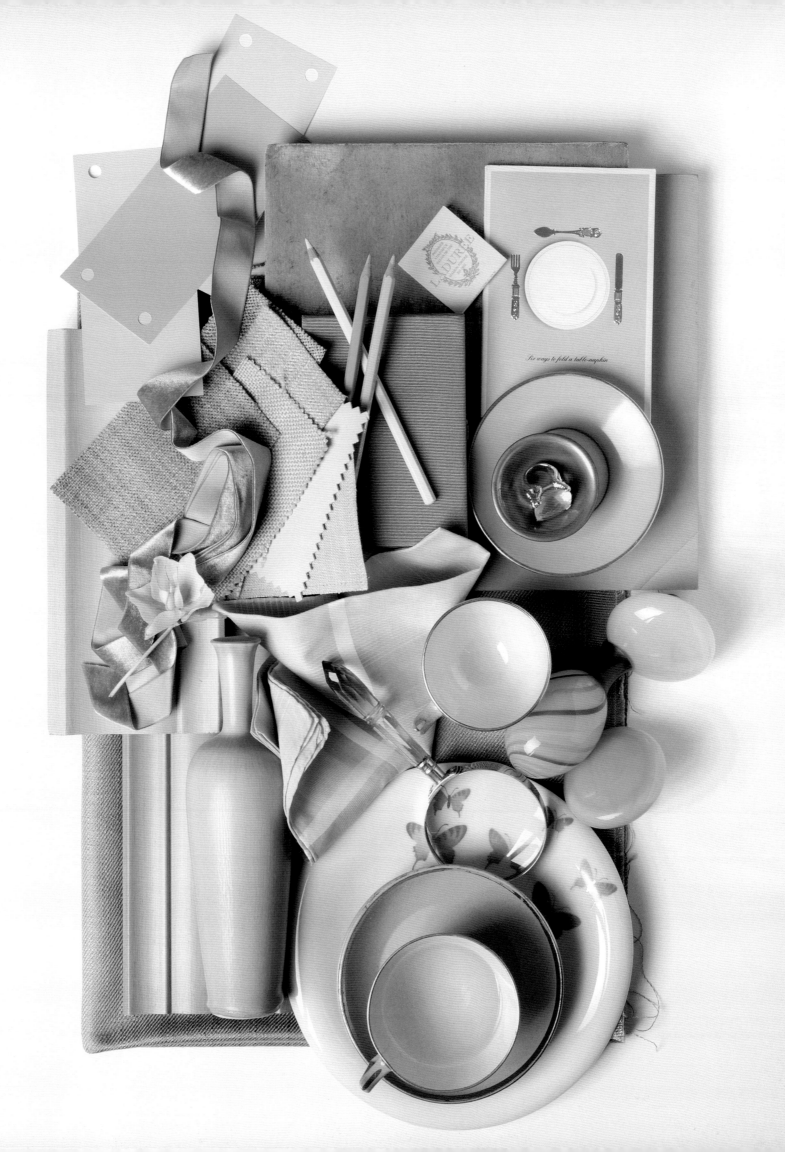

Six ways to fold a table-napkin

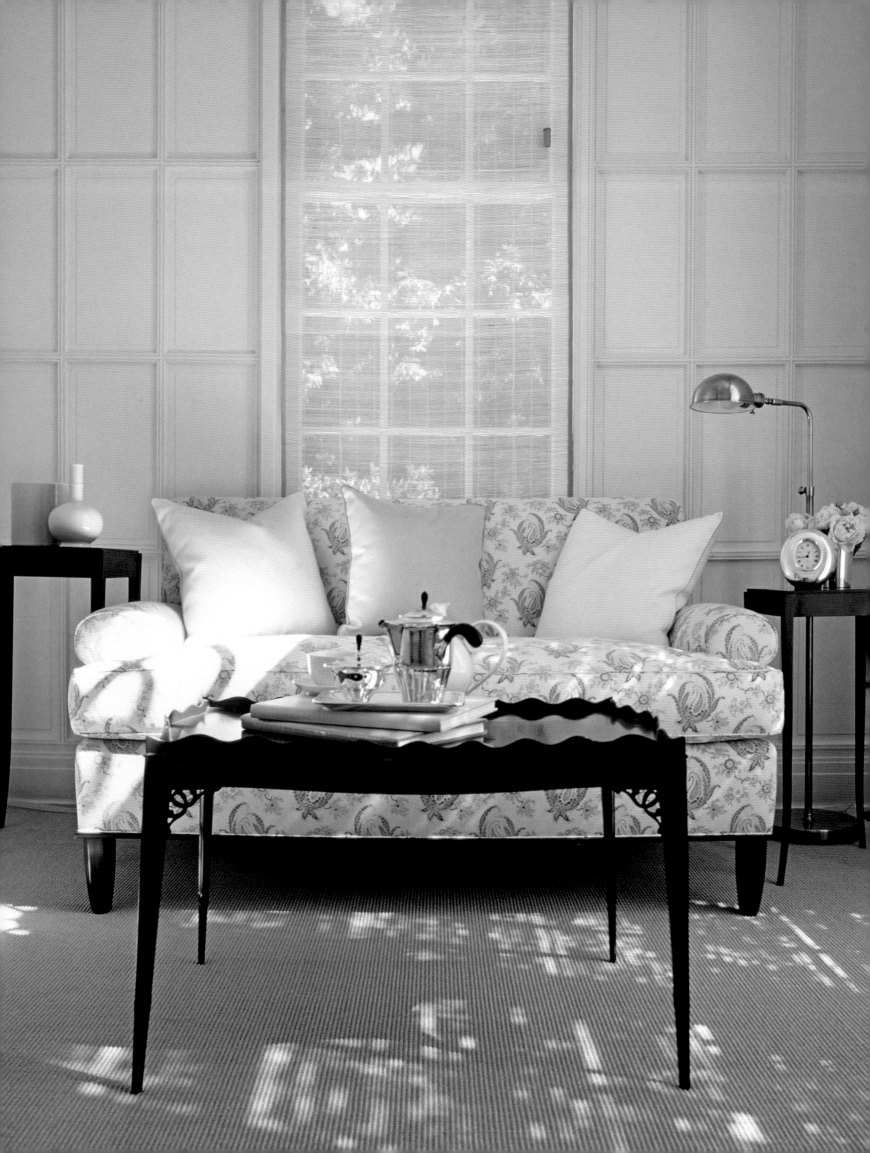

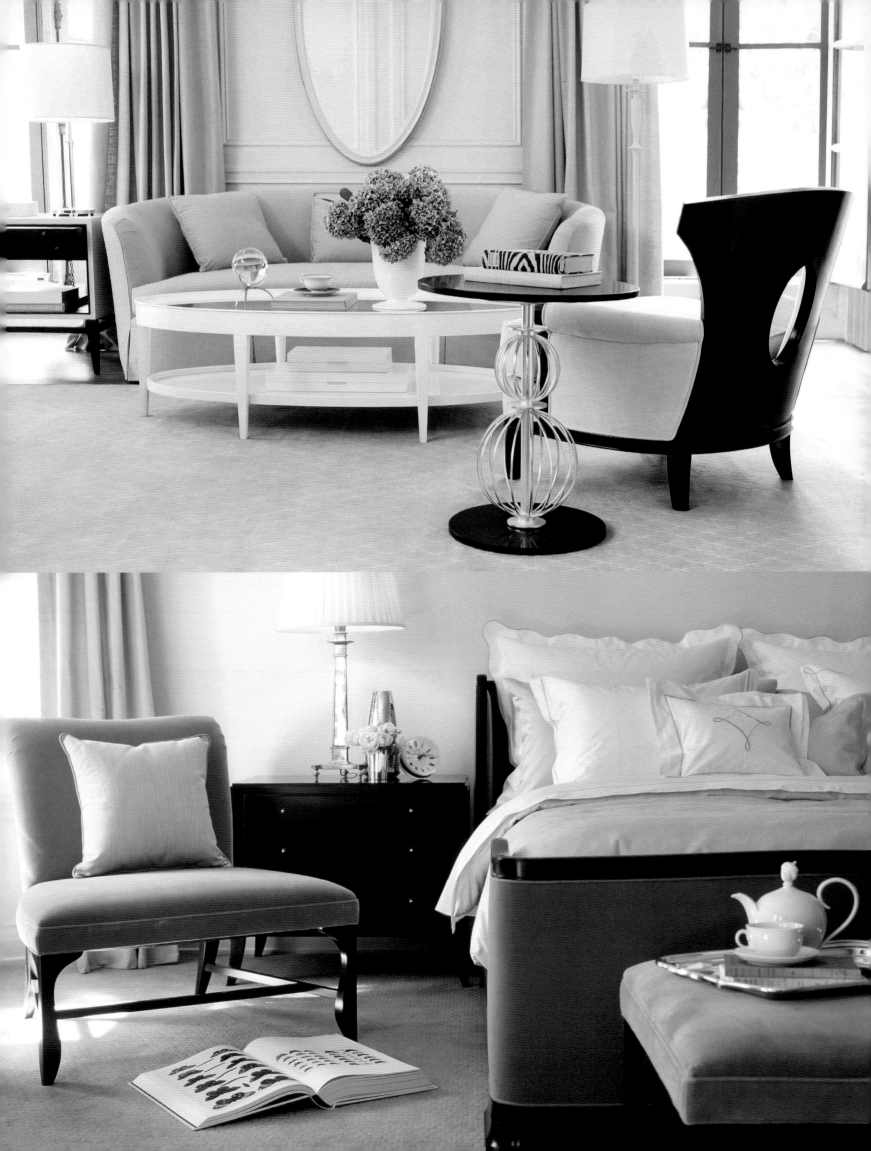

MY INSPIRATIONS AND PASSIONS

What's your favorite . . .

Accessory *My Valextra handbag*

Artist *Brancusi, Sargent, Sorolla, Egon Schiele*

Bar *The Long Bar, designed by John Pawson, Hong Kong International Airport*

Book *A General Theory of Love*

Car *1958 Mercedes 220 S Coupe in ivory*

Chair *My Bracelet chair in ivory from Barbara Barry, Realized by Henredon.*

Chef *Hiro of Nishimura, Los Angeles*

Chocolate *Puccini Bomboni chocolate, Amsterdam*

City *Amsterdam*

Color *The color of the water in the bathtub*

Country *Italy*

Dessert *My lover's Tarte Tatin*

Drink *Belvedere Vodka with fresh chopped ginger*

Fashion designer *Balenciaga*

Flower *Ranunculus & anemones*

Gadget *Bose Acoustic Noise Cancelling Headphones*

Garden *Jacques Wirtz's own, Belgium*

Guilty pleasure *More than one bath in a day & the NYT crossword puzzle*

Hotel *Eichardt's, Queenstown, New Zealand*

Lamp *The Mariano Fortuny Umbrella floor lamp, 1907*

Perfume/cologne *L'Heure Bleue by Guerlain*

Restaurant *Noma, Copenhagen*

Season *Spring*

Shoes *Roger Vivier*

Singer *Mirella Freni*

Sport *Tennis*

Amsterdam

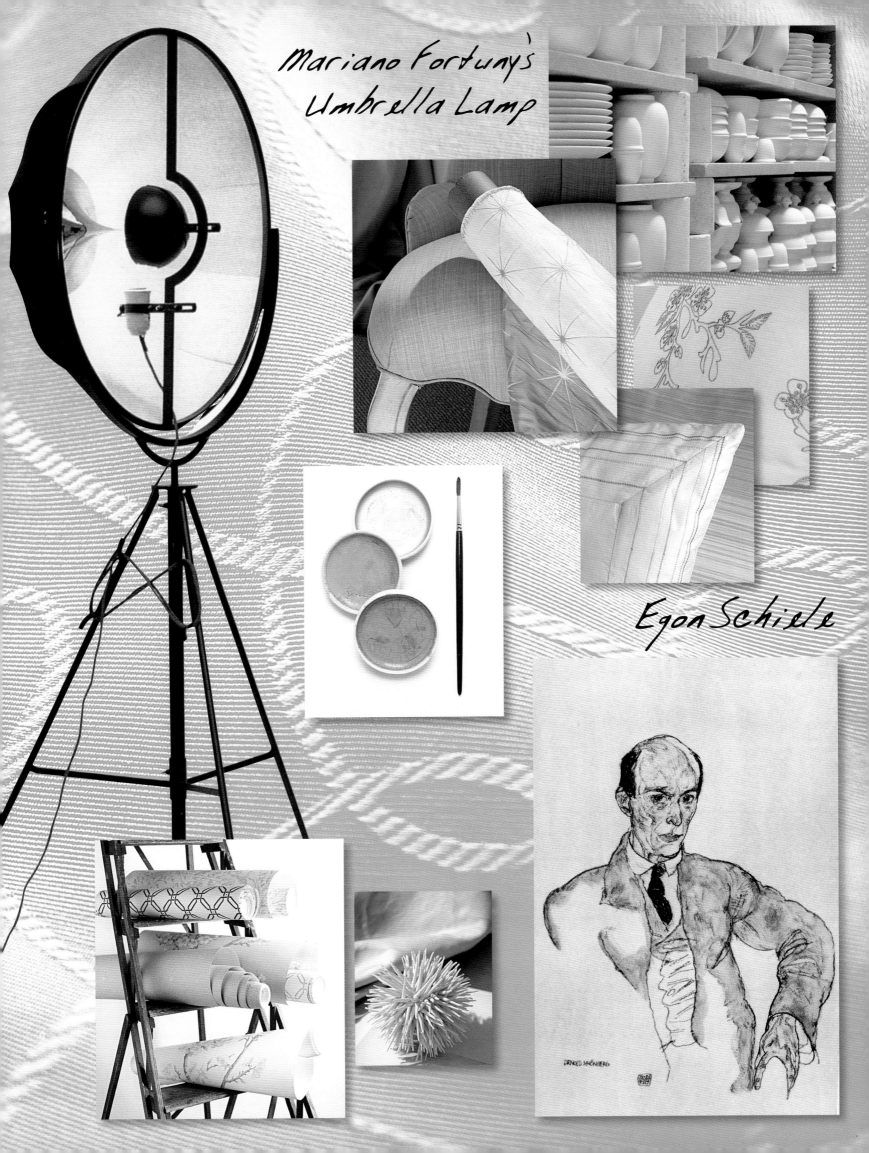

Mariano Fortuny's
Umbrella Lamp

Egon Schiele

MICHAEL BERMAN

As a student of art and architecture, as well as an admirer of Hollywood glamour, the links between film, photography, and design have inspired my career. For me, interior design is the ultimate form of set design, where the clients are the characters who inhabit the sets in which they live. I have a particular fondness for the sort of eclecticism brought about by the art directors of the '40s, '50s, and '60s, where, inevitably, European style crept into set design in its most extreme form. I often draw inspiration from the exaggerated elements found in the sets of television shows like *I Love Lucy* and old feature films like *The Fountainhead*.

When taking on a new project I envision the ideal setting based on the client's personal style as if it were a photograph to which I add my signature touch. Photography resonates with me, and I love the simplistic nature of black-and-white photography, in which the composition becomes purely a matter of positive and negative space. The photos derive structure, form, and substance from the contrasts and from the range of shades in-between. Irving Penn, Sheila Metzner, and Cecil Beaton are all masters of constructing powerful imagery from simple elements. When designing, I consider how my projects will look on film—zeroing in on details and composing the tablescape as a still life. Designing interiors involves calculating how light reflects off one object and how that may affect the perception of another object. Architecture is paramount.

Through photography I have documented many iconic architectural buildings, and I have been inspired by America's twentieth-century architectural roots for the new Kravet textile collection. Where there is good architecture and fine details, you can do anything; however, you must know where to draw the line and pay homage to the original blueprint. I have had the opportunity to work on the restorations of many architecturally significant projects in Los Angeles—houses by Paul Williams, Wallace Neff, and Rafael Soriano, to name a few.

Recently, I worked on a modern home with thirteen-foot-high ceilings and vast windows. The landscape was so dynamic that it impelled me to create an interior that was less dominant, and to use the landscape and fine details of the property as the primary artwork. I enjoy neutral backgrounds and only add colors for contrast. I tend to use a lot of earth tones: oranges, browns, umber, gold, ocher, eggplant, leaf greens, and olives. These colors have always formed my palette of choice; however, I enjoy the challenge of using vibrant colors, such as turquoise, coral red, and signature Hermès orange for contrast.

I find great joy in creating something new, whether it is an original piece of furniture or an individual style. When designing furniture, there is usually something in particular that has inspired me— a past or present direction that I want to pursue. I'm sort of a scavenger by nature and am constantly purchasing vintage objects and furniture because of their lines and form. When I see a particularly irresistible detail, I will use that as an idea, a starting point. For example, the hardware that I design has an auto-industry aesthetic. I want it to feel like the hardware in an old Lincoln Continental— finely tooled, tactile, and precisely machined. I tend to think of upholstery in terms of really fine American coach work: the bucket seats of a Cadillac, say, with double-stitched quilted and tufted brocade upholstery. I have a special place in my heart for the luxury automobiles from the '60s and '70s, probably because I am a product of Detroit, the Motor City. Beauty and functionality are my constants, conveying a balance of formal and casual in life and in design.

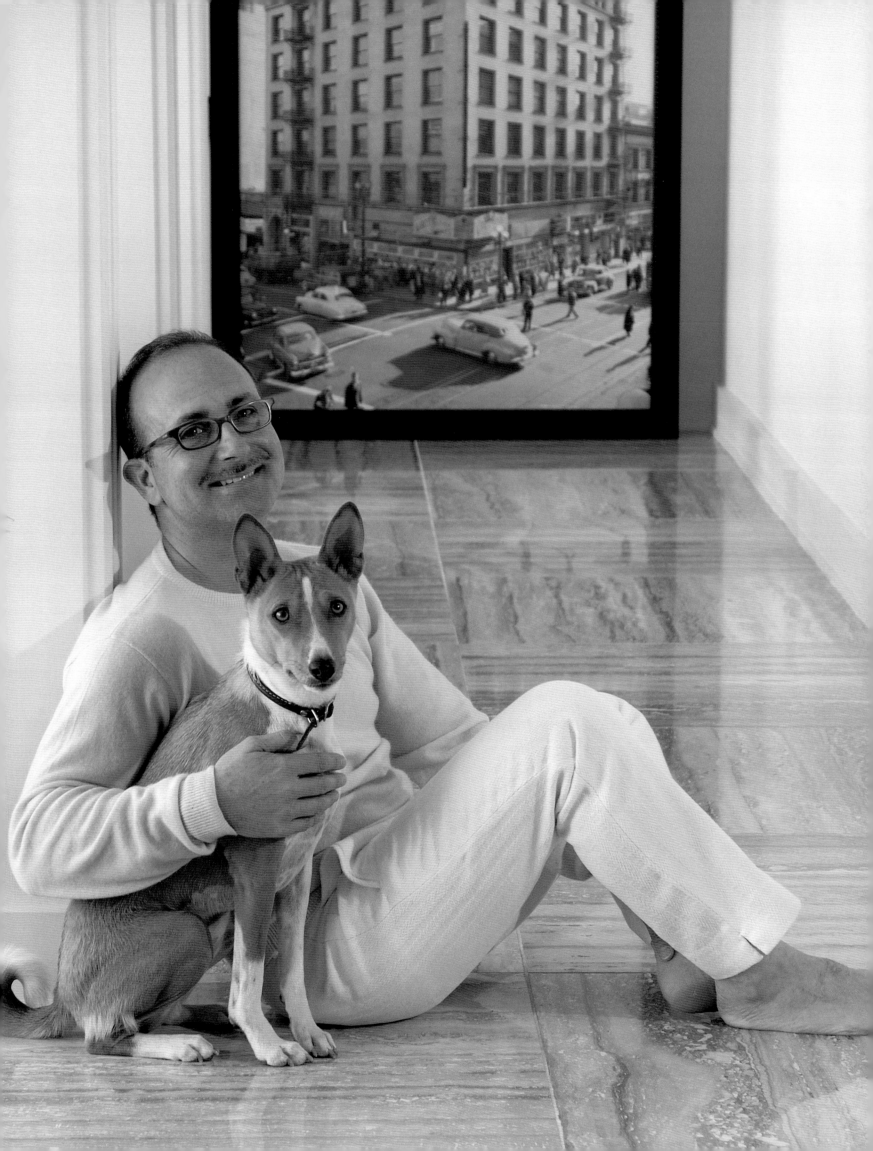

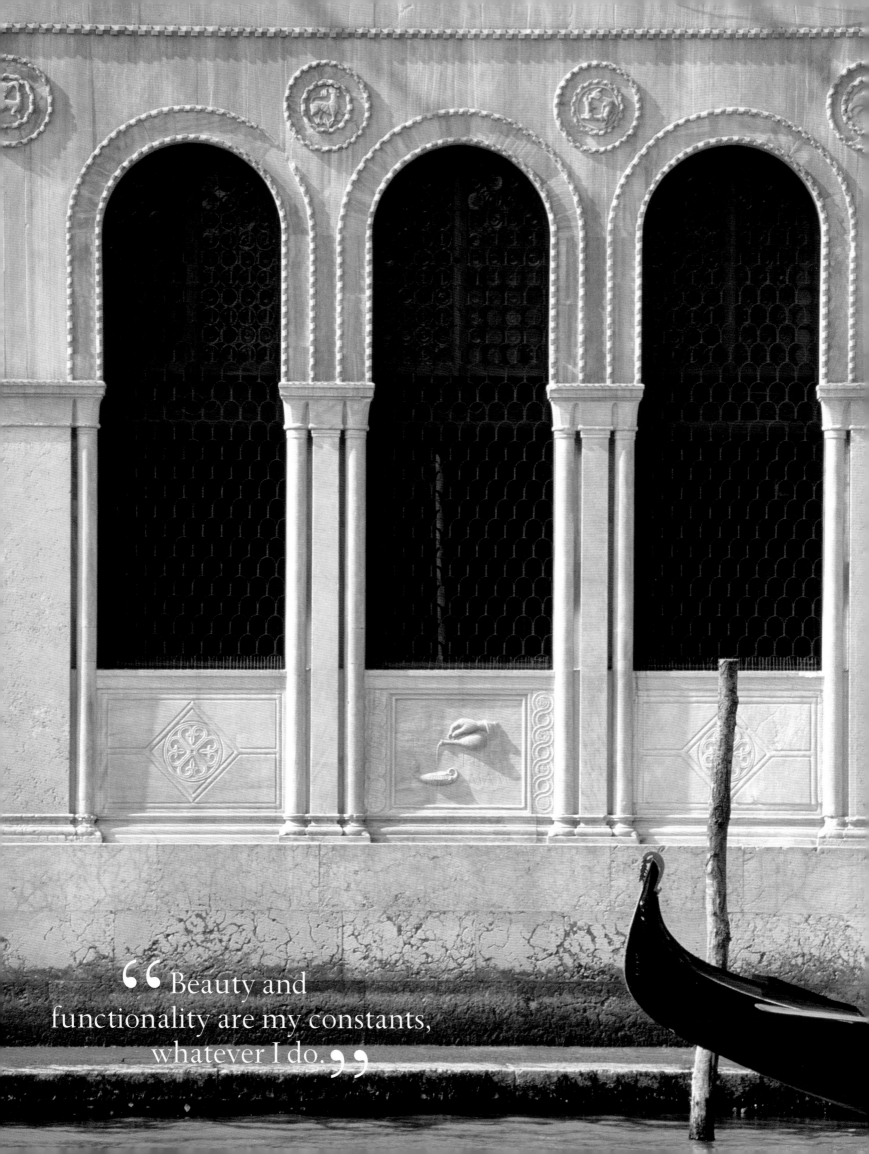

“ Beauty and
functionality are my constants,
whatever I do. ”

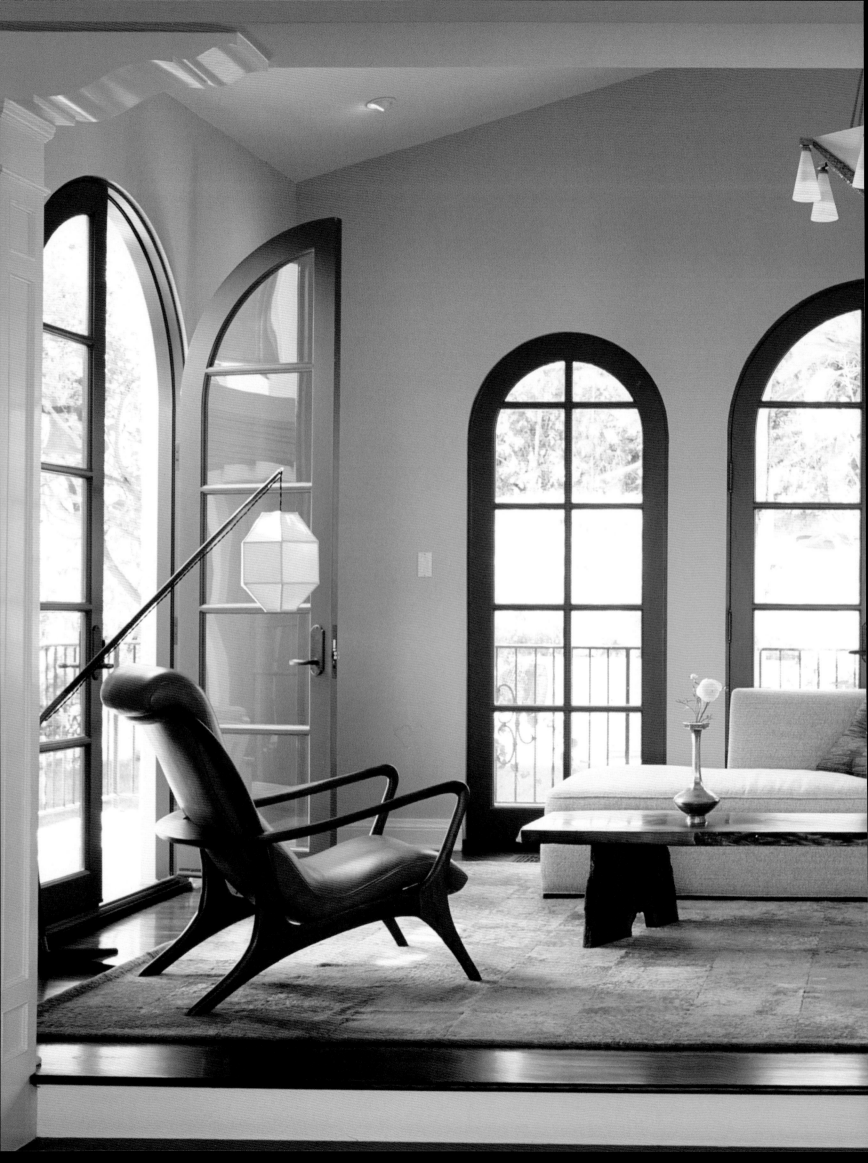

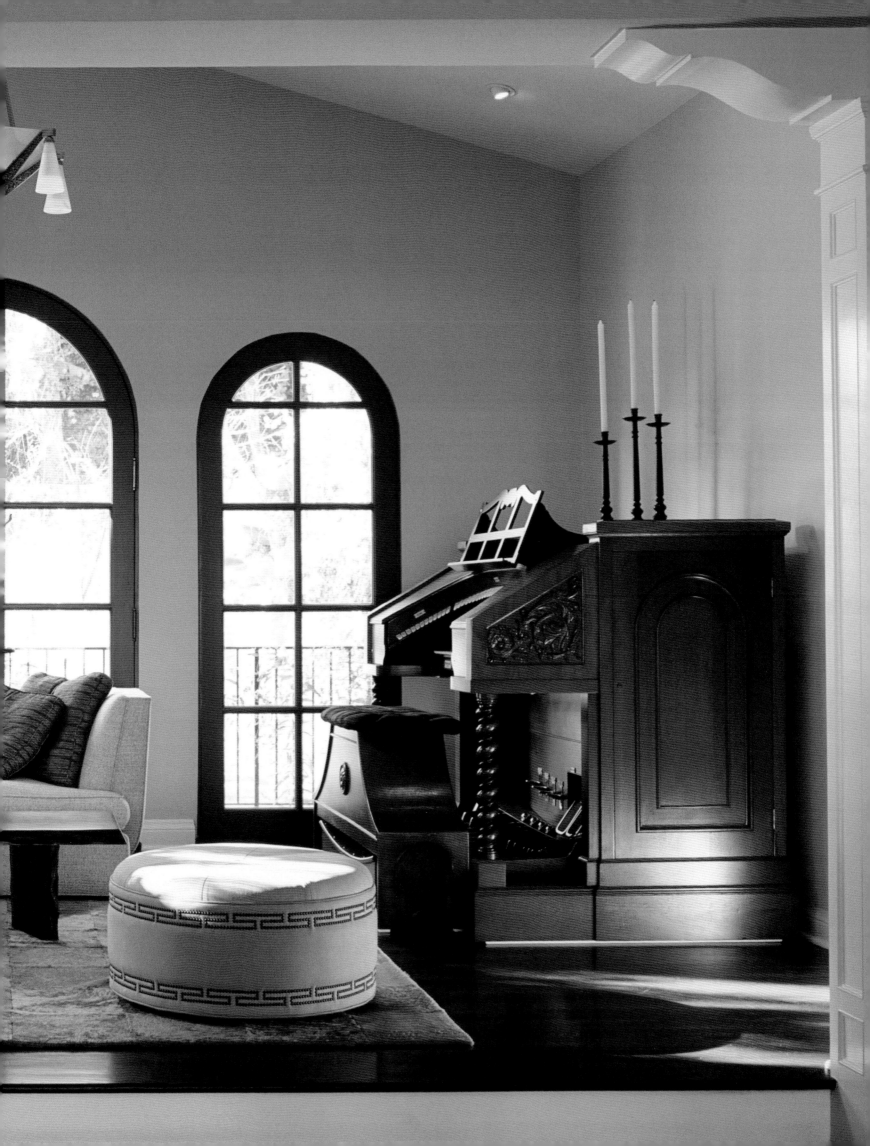

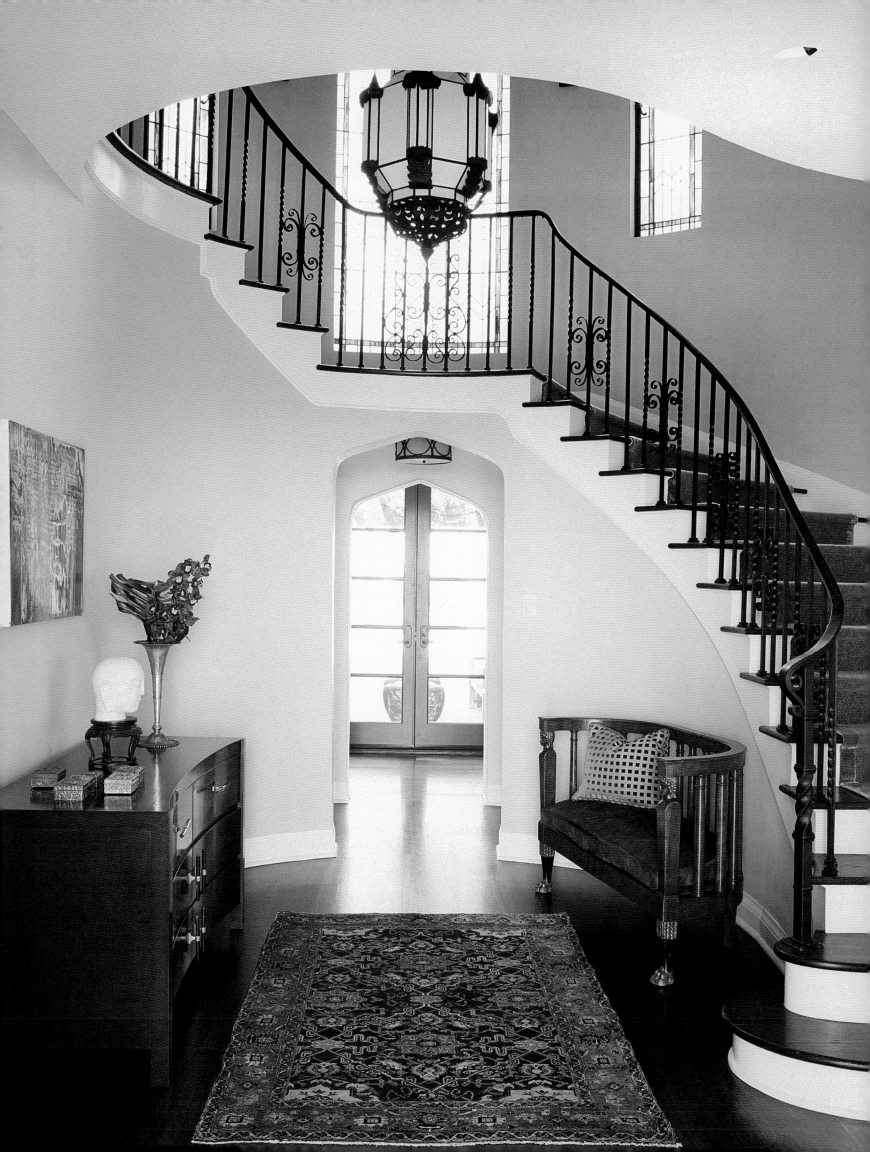

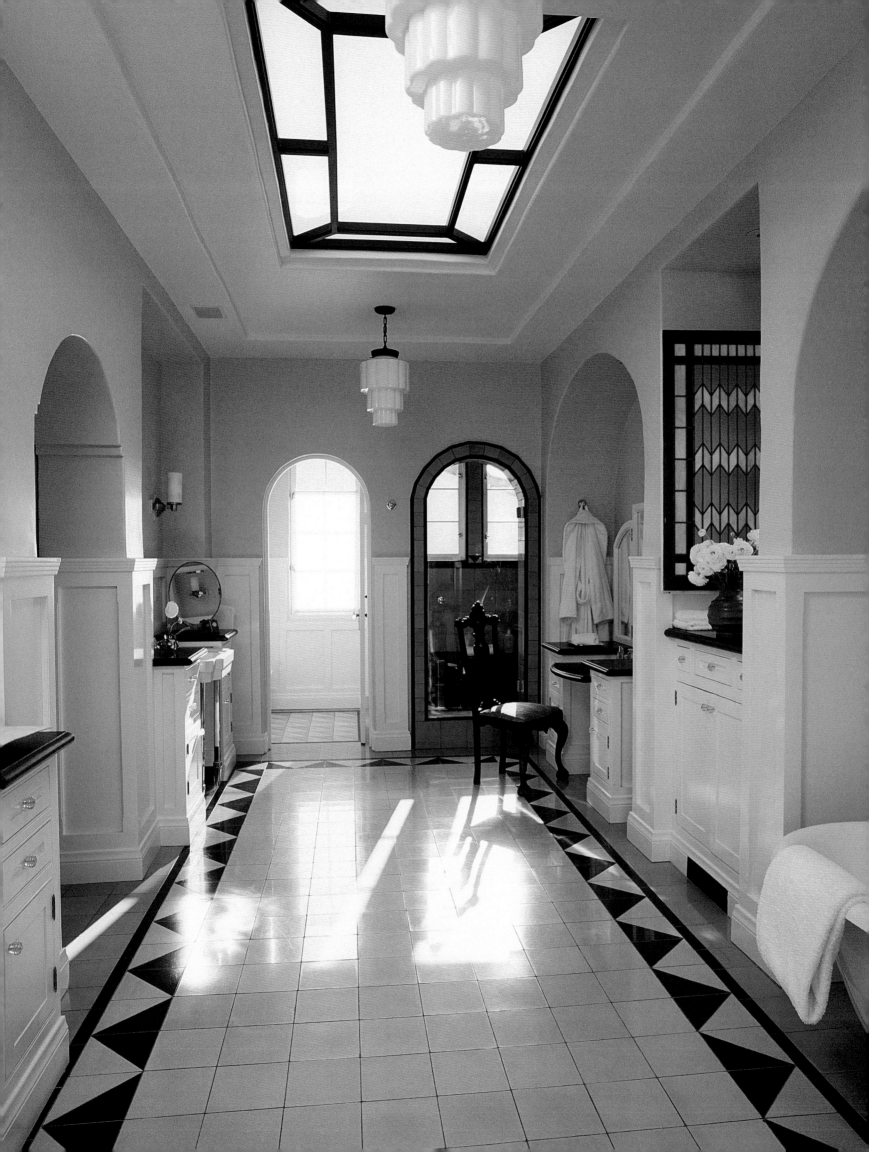

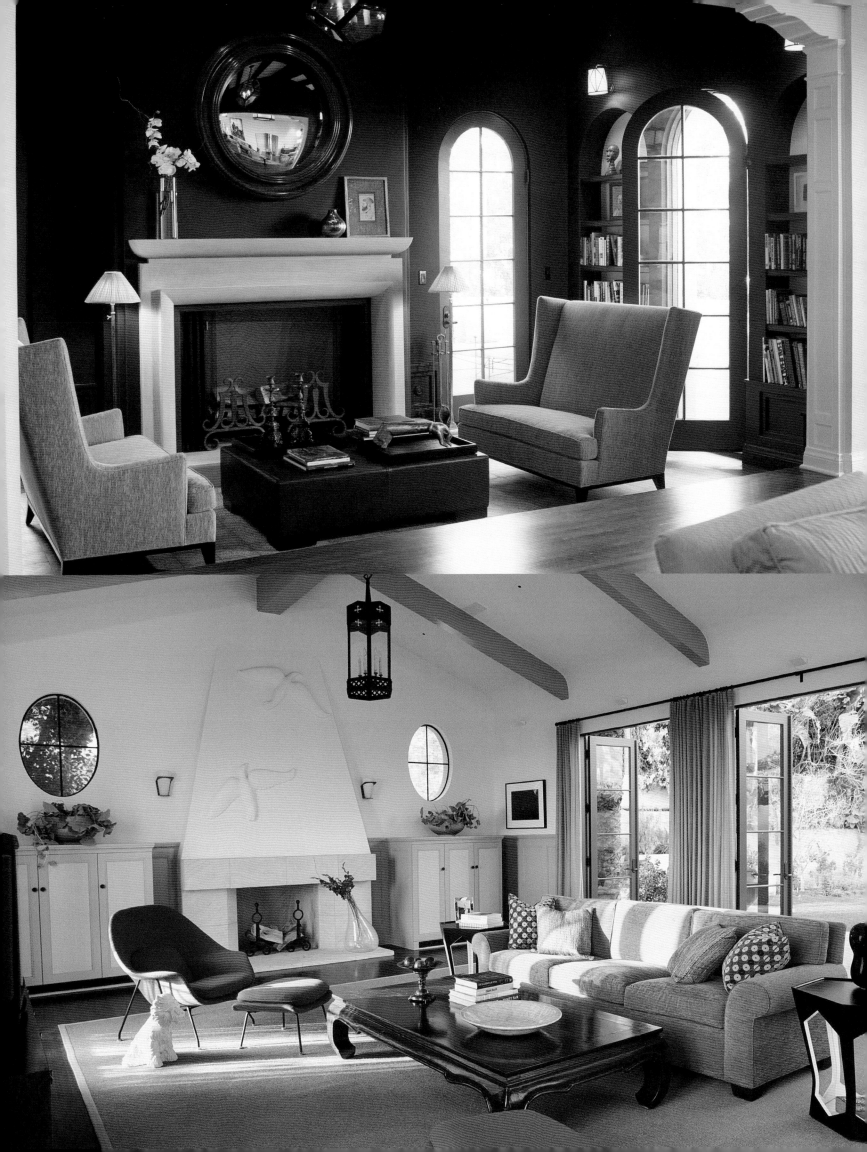

MY INSPIRATIONS AND PASSIONS

What's your favorite . . .

Accessory *Large, gorgeous, overscaled men's cuff links from the '70s*

Activity *Swimming at home in Palm Springs*

Actor *Steve McQueen*

Airport *Eero Saarinen TWA Terminal at JFK*

Bar *Red Pearl Kitchen in L.A. for the Jade Mistress martinis*

Broadway show *Sweeney Todd*

Car *My 1964 Oldsmobile Starfire and all GM cars of the '60s and '70s*

Chair *Warren Platner wire chair, circa 1967*

City *New York*

Color *Chartreuse green*

Country *Greece*

Fashion designer *Prada. All the clothes are cut slim and designed for a tailored, fitted look.*

Flower *Chinese magnolia and chocolate cosmos*

Food *Indian—chicken tikka masala and raita*

Garden *Lotusland in Santa Barbara, California*

Hobby *Antiques store and flea market shopping*

Hotel *Cipriani in Venice, Italy*

Jewelry *Georg Jensen silver bracelet*

Lamp *Black lacquered classic Maison Charles, circa 1977*

Luggage *My Bottega Veneta oxblood leather hard suitcases*

Magazine *Maison Française*

Memory *Meeting my life partner, Lee, in 1981*

Movie *Cinema Paradiso*

Museum *Musée D'Orsay, Paris*

Perfume/cologne *Roger & Gallet " Cologne"*

Singer *Dionne Warwick singing Bacharach*

Toiletry *Agraria Balsam body lotion*

Chartreuse Green

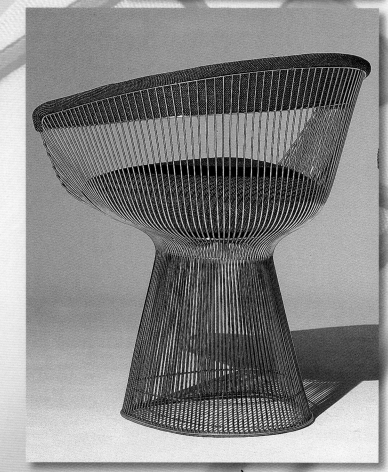

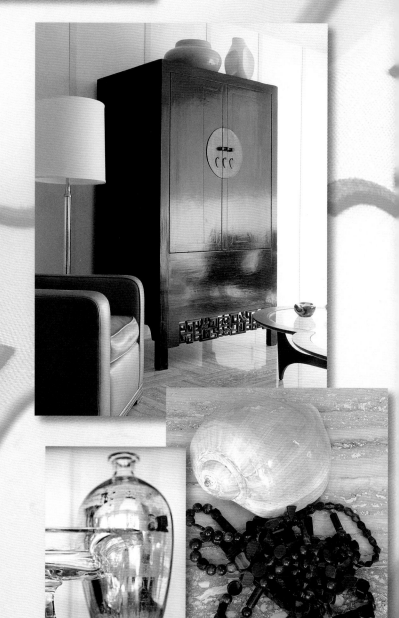

Warren Platner's Wire Chair

Venice

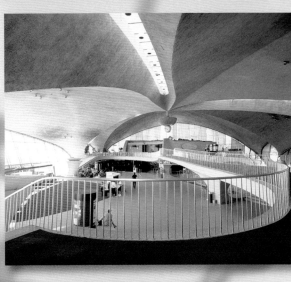

New York

BARCLAY BUTERA

I have a passion for fine living, and I am inspired by wherever life takes me. Furnishings don't make a home; life does. Lifestyle design is a way of carefully placing selected elements together so a room or a home feels warm, comfortable, and inviting.

When creating lifestyle design, my decisions depend on the personality of my clients—their dreams and their aspirations. I manifest the lifestyle by incorporating my elements of design with those of the client to create a unique environment down to the fine details of upholstery and accessories. I love it when a house feels finished and lived in, with many layers of color and texture. Every choice I make as a designer translates design essentials, including wall furnishings, flooring, textiles, case goods, and furnishings, into elements of living, to evoke an emotional environment.

Throughout my life, my homes have each been completely different and right for the context of their location and purpose. My mid-century home in the Hollywood Hills, previously owned by Desi Arnaz, Jr., is designed for indoor-outdoor living. It's comfortable, not too large, and feels destined to host parties and small gatherings—a favorite pursuit of mine. Because the house had not been occupied in 30 years, it was in great disarray. However, there was depth to the architecture and details in true 1950s style. I restored it to its Hollywood Regency era, making the interior feel nostalgic. The walls are covered in subtle patterns with gold overlay and early Hollywood photography. The upholstery is done in chocolate velvets, raffia, and raw silks, and finished with high-gloss white trim. My Newport Beach home is an eclectic mixture of lifestyles. Everything about it appeals to the senses, from the large outdoor terrace and true formal English gardens to the British Colonial interior. The palette is blue and white with Asian influences, toile and ticking stripe wallpaper, blue velvet upholstery, seashell-encrusted chandeliers, antiques, and a special collection of English silver.

Heading inland, I've always been attracted to Palm Springs and the old Hollywood history it evokes. Inspired by the Rat Pack era, I owned for a time the Frank Sinatra Twin Palms, which was designed by E. Stewart Williams. It's a mid-century home with a piano-shaped pool and incredible views. While keeping with the integrity of the architecture, I added white shag carpeting, period wallpaper, and my tufted upholstery with luxurious fabrics.

My current desert house is just outside Zion National Park. It is done in clean raw woods, leather-slung dining chairs, suede sofas, faux coyote pillows, and platform beds. The focus here is the view and serenity, so I've done my utmost to respect the landscape and capitalize on the views, making the place suited to a casual, tranquil lifestyle.

I never limit myself to one particular category or style. Design is always dependent upon location, tradition, and personal preferences. From antique clocks to clean modern hurricanes, I use collections to help give an interior the flavor of a particular period and style.

It has been fifteen years since I opened my first showroom; it has since grown to more than 100 employees with a manufacturing facility and four national locations. One thing I have learned is that good design isn't something that comes from a store; it is the presentation of your lifestyle. That is when the right furnishings make all the difference.

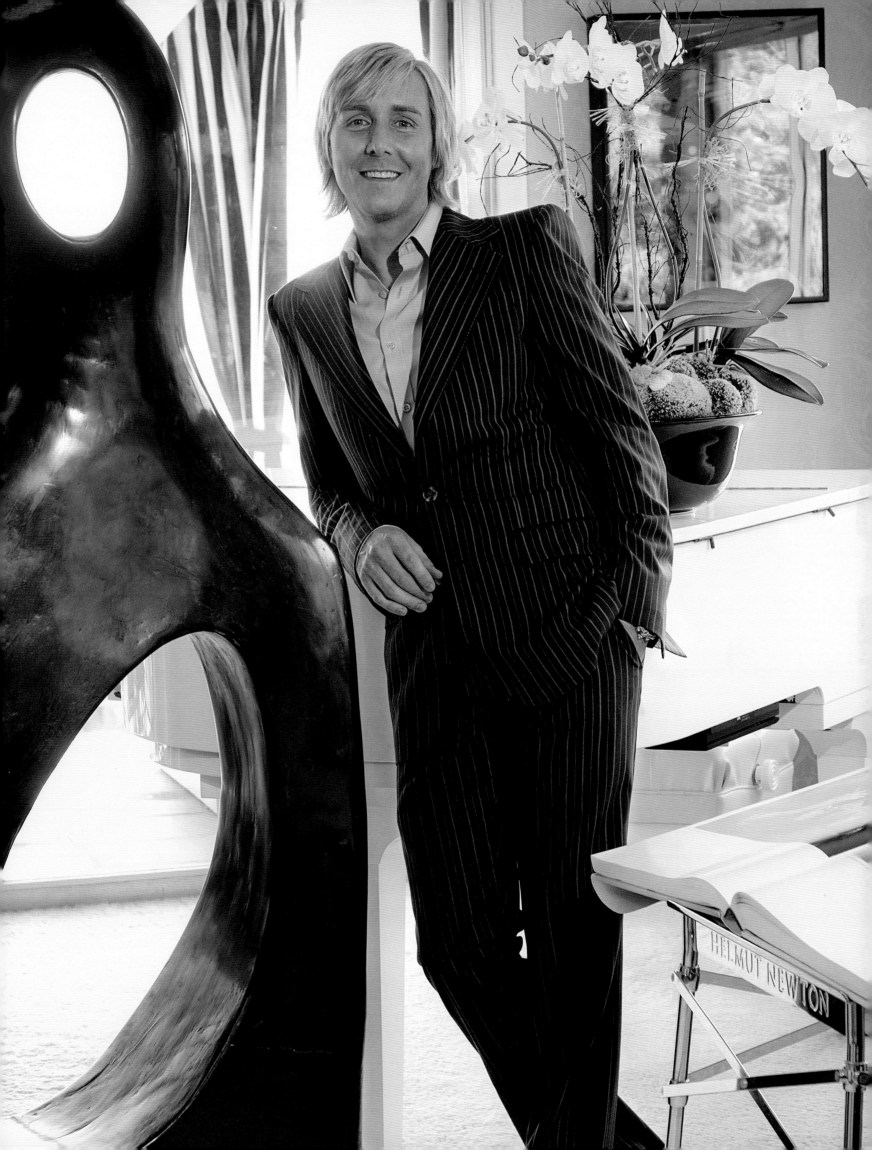

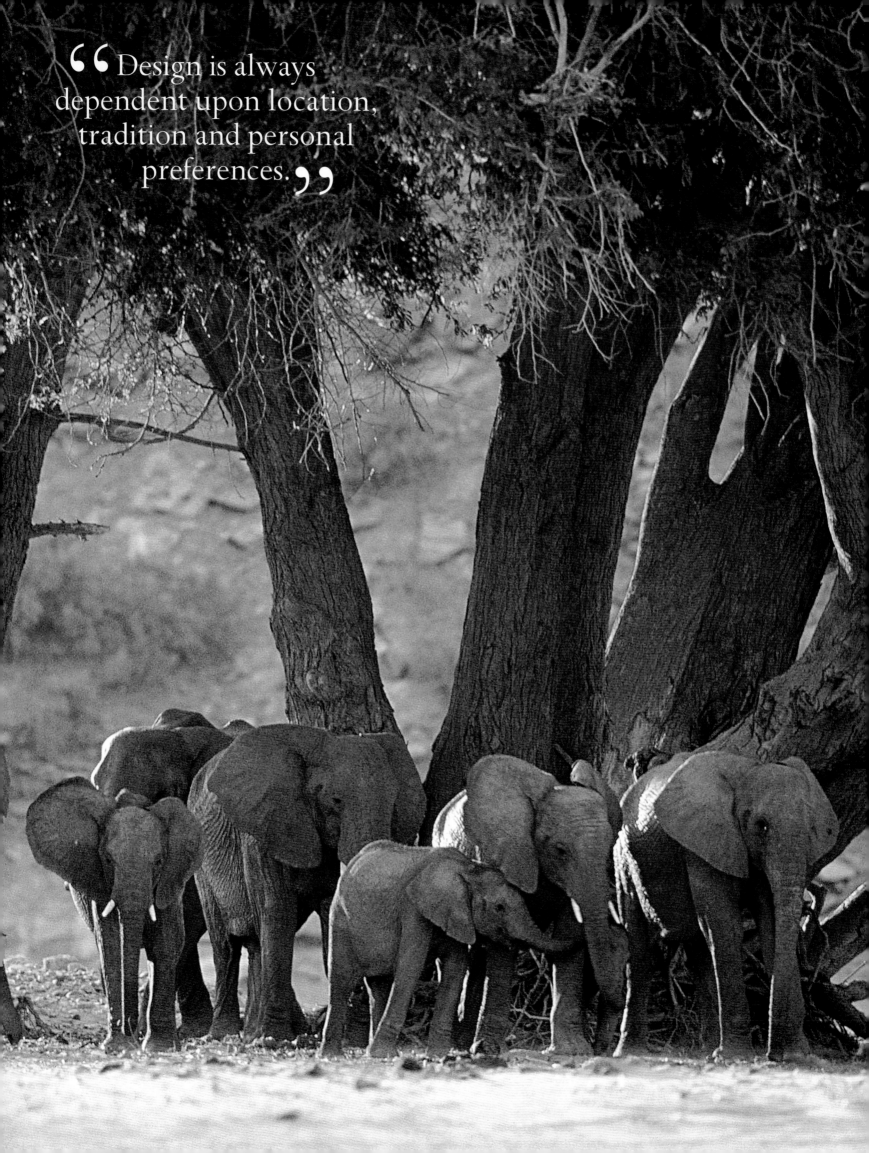

"Design is always dependent upon location, tradition and personal preferences."

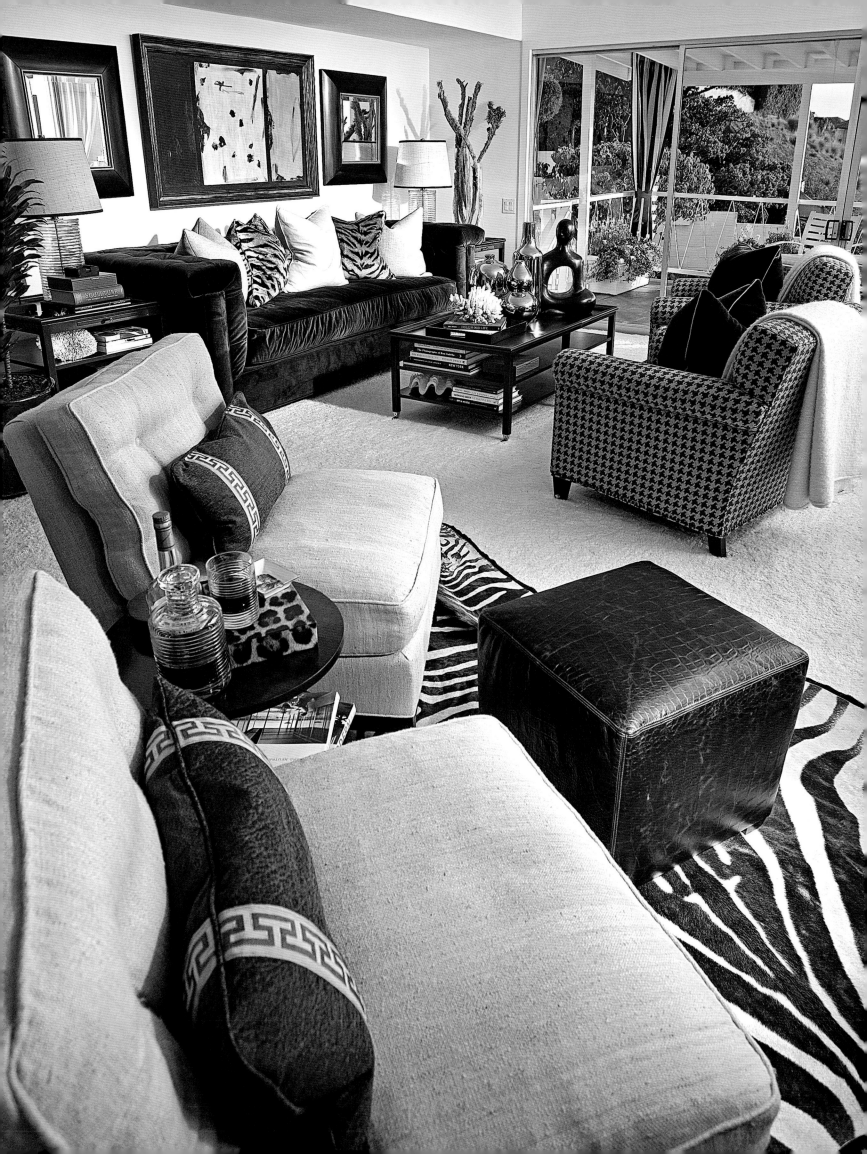

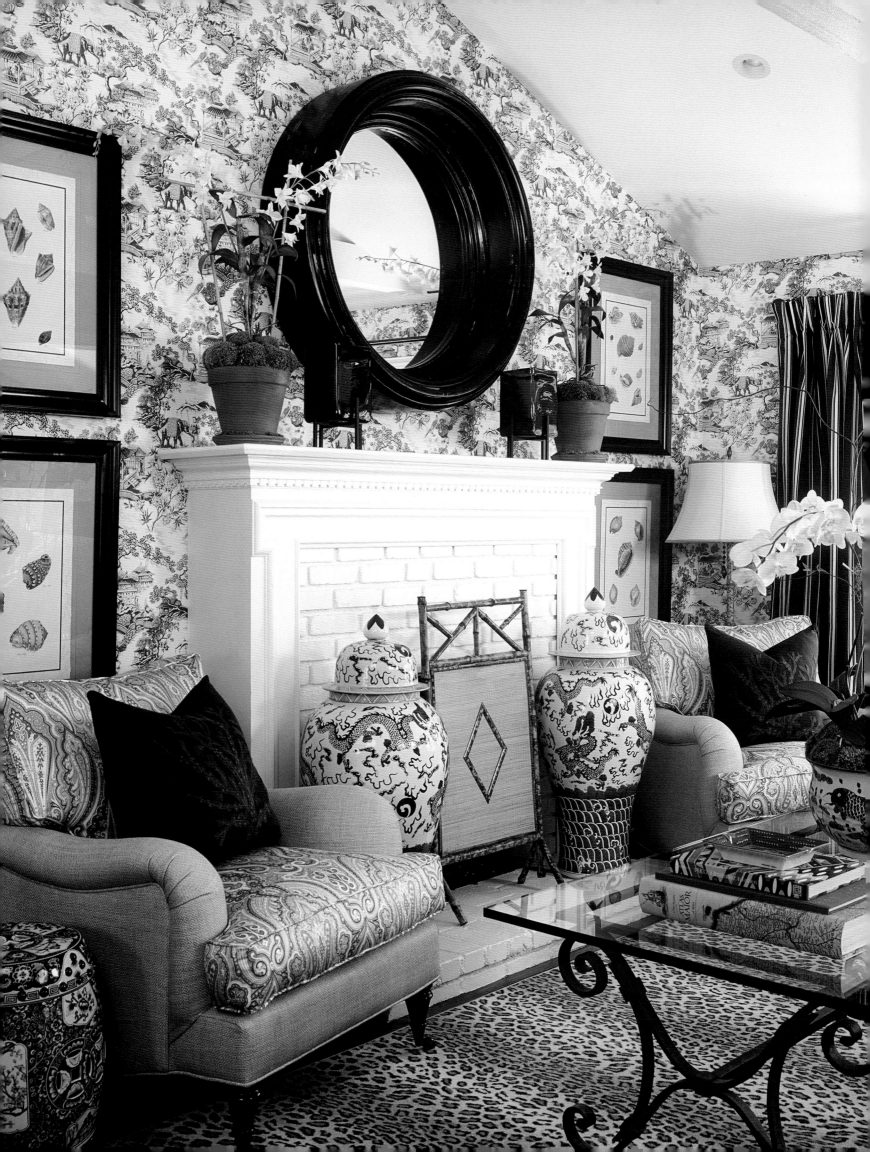

HAPPY TIMES / LEE RADZIWILL ASSOULINE

GERMAINE GREER THE BEAUTIFUL BOY

OPEN HOUSE Unbound Space and the Modern Dwelling

MY INSPIRATIONS AND PASSIONS

What's your favorite . . .

Accessory *A classic watch—Cartier Roadster*

Actor *Al Pacino*

Airport *Zurich*

Artist *Slim Aarons*

Book *Hollywood Homes*

Broadway show *Fosse*

Chair *An early 1900s zebra-upholstered Empire chair*

Chef *Danny Meyer (Eleven Madison Park, New York)*

Color *Mediterranean blue*

Drink *Greyhound/vodka grapefruit*

Fashion designer *Tom Ford/Bill Blass*

Flower *White hydrangea*

Gadget *Bang & Olufsen wall-mount six-disk player*

Garden *Tuileries, Paris*

Hobby *Antiquing*

Lamp *Ralph Lauren Dobson table lamp*

Luggage *Bric's luggage*

Magazine *Destinations*

Movie *Giant*

Perfume/cologne *Vintage Tom Ford Gucci Envy Cologne*

Pet *Miniature dachshund, smooth and longhaired*

Restaurant *Hotel Costes, Paris (great people watching!)*

Shoes *Gianni Barbato Italian boots*

Singer *Chris Martin (of Coldplay)*

Spa *Las Ventanas al Paraíso, Cabo San Lucas*

Sport *Tennis*

Wine *Krug Brut Rosé Champagne*

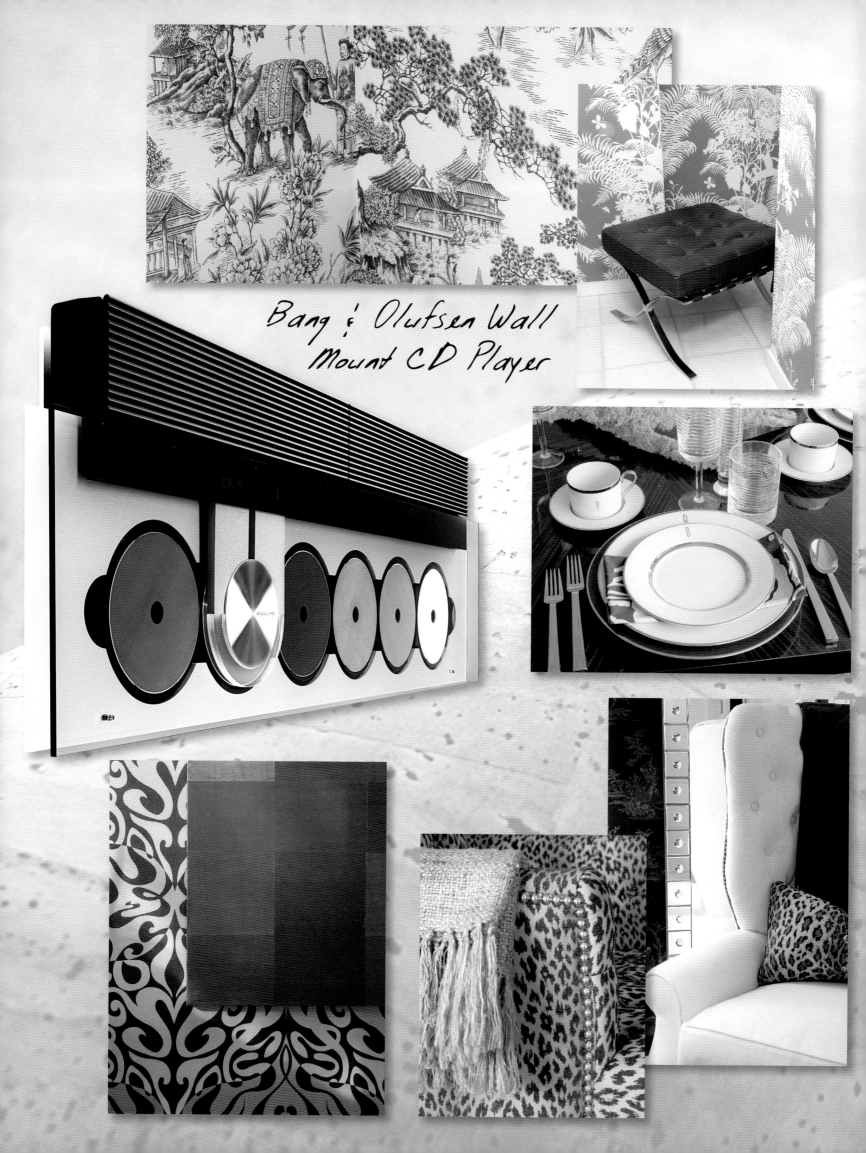

Bang & Olufsen Wall
Mount CD Player

Paris

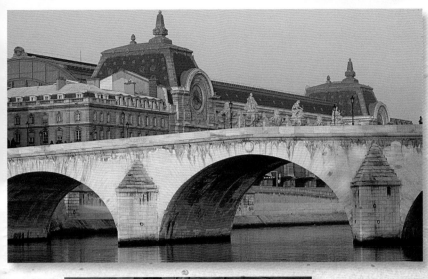

Hollywood Homes

HAMPTONS THE OUTDOOR LIVING ROOM ASSOULINE

malibu A Century of Living by the Sea

ELLEN GRAHAM THE BAD & THE BEAUTIFUL

ULTIMATE STYLE ASSOULINE

ERIC COHLER

Joan Miró, the great Spanish artist, said, "*Je travaille comme un jardinier.*" Miró cut, pruned, and distilled each piece of his art until he got it right. My process, though related, is slightly different: it combines the skills and disciplines and philosophies of the archaeologist, the artist, and the gardener. I cut and prune my designs, yes, but I also curate. I probe at them, carefully and gently, until I get to their essence.

For me, the past is prologue; for me design is all about pentimento: You have to discover the substrates, and you can think in terms of veneer. There's always layer upon layer upon layer of history, and of life, in every room, in every building. You have to scrape the surface to see what's there, but you must respect what you find, otherwise you can't go forward. I want interiors to last, and I believe in making the best of things, not in throwing them out. I'm architecturally trained, so for me, the plan comes first, then the nuances, the shapes, and the forms before the tangible: Working with clients once the floor plans and budget are set, I start to fill in the holes. Then we shop.

I think about design as an art, like architecture. It is visceral, ephemeral, personal, subjective. It's a process that evolves all the time, and that's what brings it such a fresh quality and keeps it interesting. Yet whatever you do as a designer, whatever your personal aesthetic, you have to be trained in the classics. For me, and for most architects, that means Vitruvius, and Andrea Palladio and his work, *The Four Books on Architecture*. If you know them well, then you can corrupt them—but you can only do that as long as you know the basics. I don't do it for shock value. I do it because I love the canon.

I'm a traditionalist wrapped in a cloak of modernity: My look is tailored and traditional with a twist. Much of what I do is based on the genius of Sir John Soane, on the extraordinary work of the brothers Adam, and on the purity of Mies and Philip Johnson. It's important to remember that whenever anything was originally conceived, it was contemporary for its own time. Much as I like to think outside the box, I want my work to emerge from grounded reality.

My family history is in the textile business and in men's clothing. That menswear sensibility inspires me: the colors from the 1920s, the turn-of-the-century palette, the unusual and interesting linings in cloaks and coats—there was so much freedom then. These things translate into my own designs, especially my textile designs, and specifically prints and geometrics. Regardless of what it is you're working on, it is crucial to do the research first. You have to look at everything—and look all the time. You have to be an explorer and take a world view. You need to search out the best of the best of whatever it is, from Tunisian tiles to ikats from Istanbul. You have to continue to learn, and to educate yourself, to look for the ineffable beyond beauty — to look for the sublime.

To make something beautiful, you need to be a seer and an alchemist, so I seek out the unusual, the rare, and the prosaic: a shell, a tree branch, the delicious golden-violet light at the end of the day. Design is history, and that history is object related. Wherever you go, the things that you find represent, in some way, the essence of a life. When I'm working on a residence, for example, I walk through the client's home to see what I can use. I have to harvest a little bit of their personal past to help the future grow, and in that sense I really do work like a gardener.

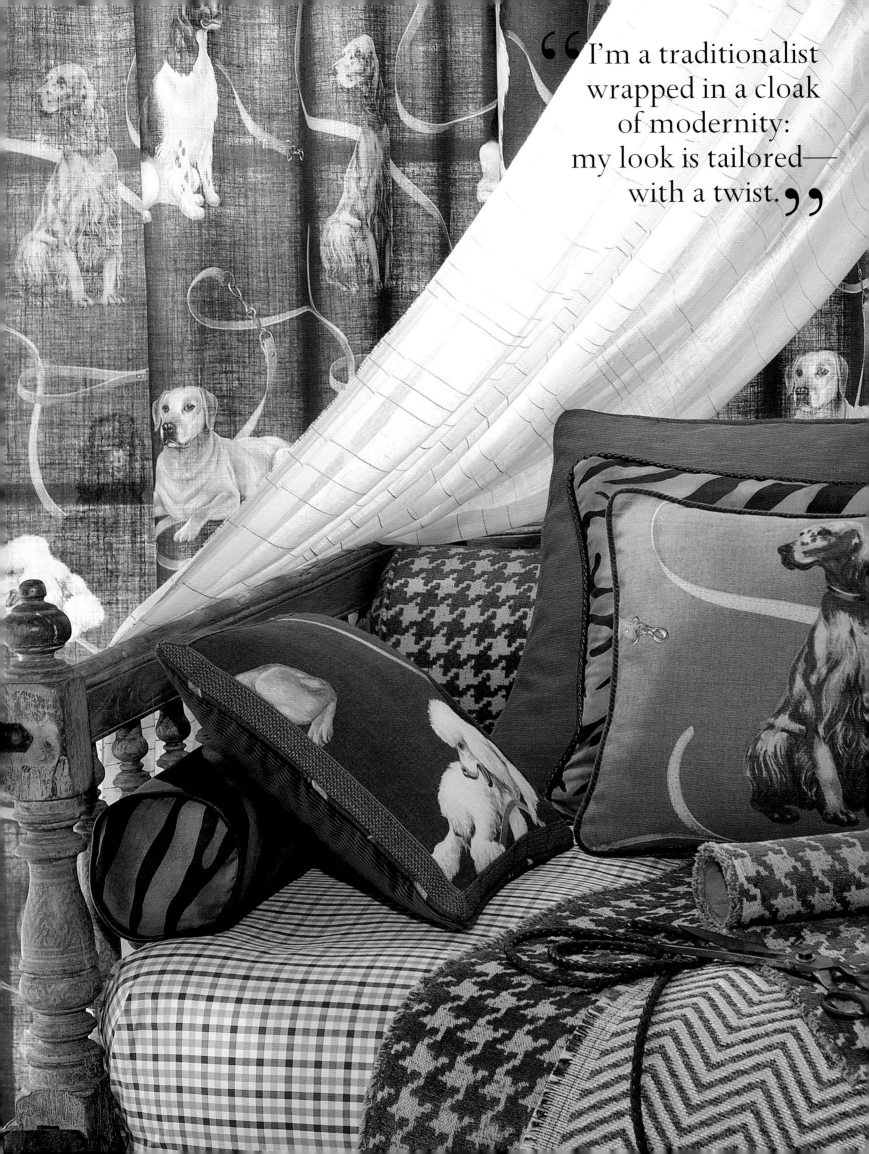

"I'm a traditionalist wrapped in a cloak of modernity: my look is tailored— with a twist."

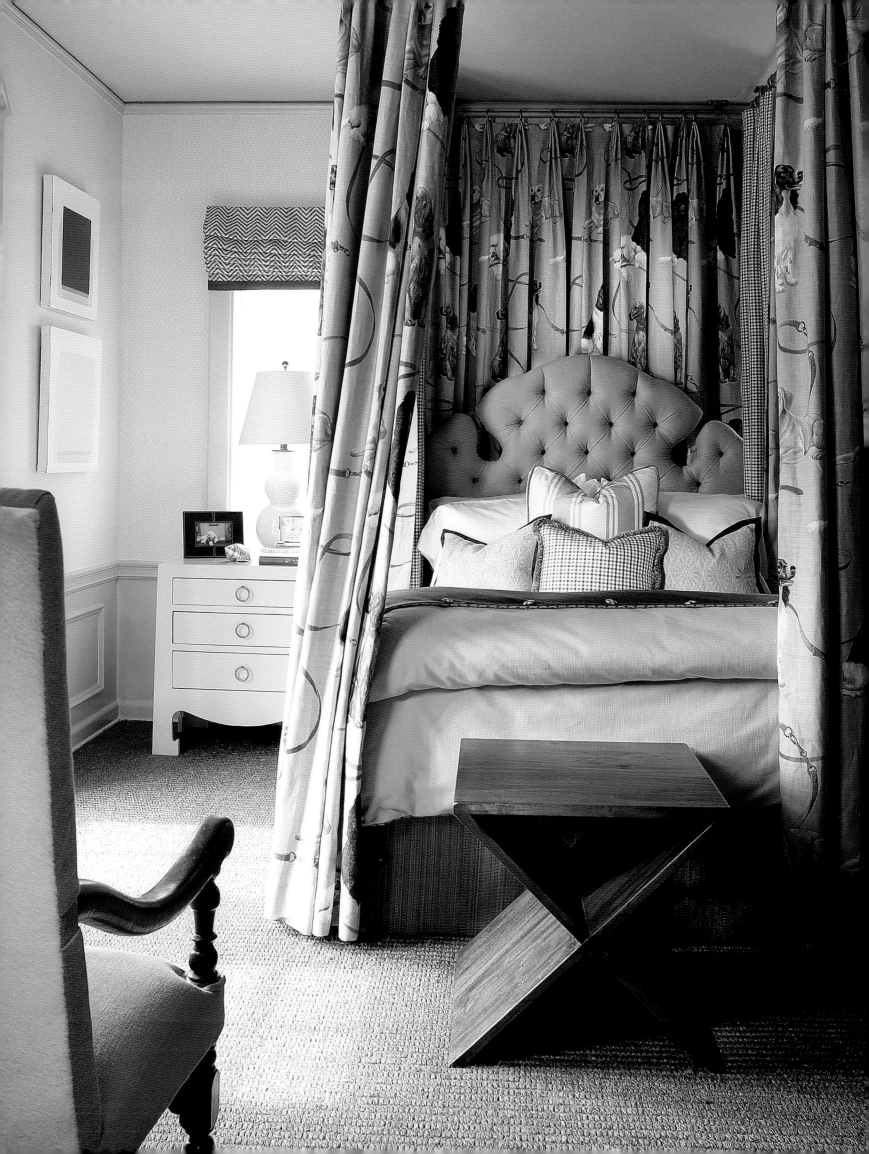

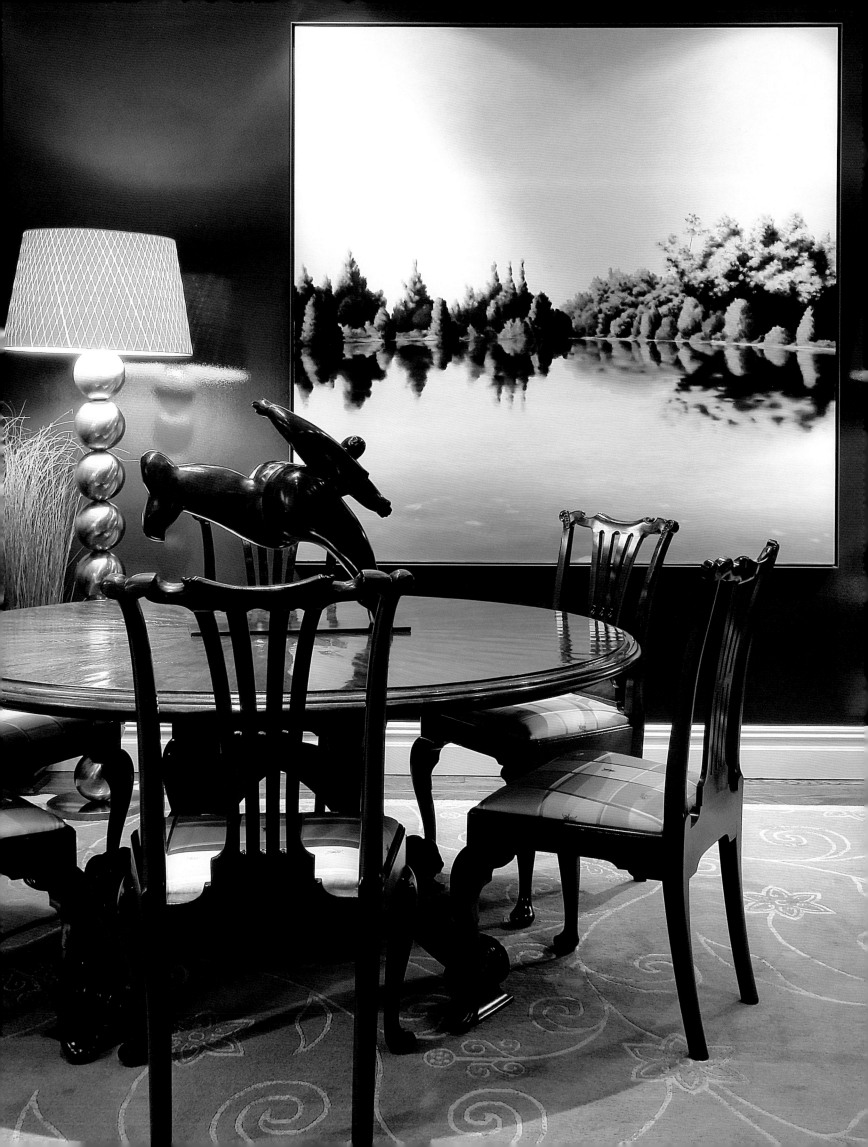

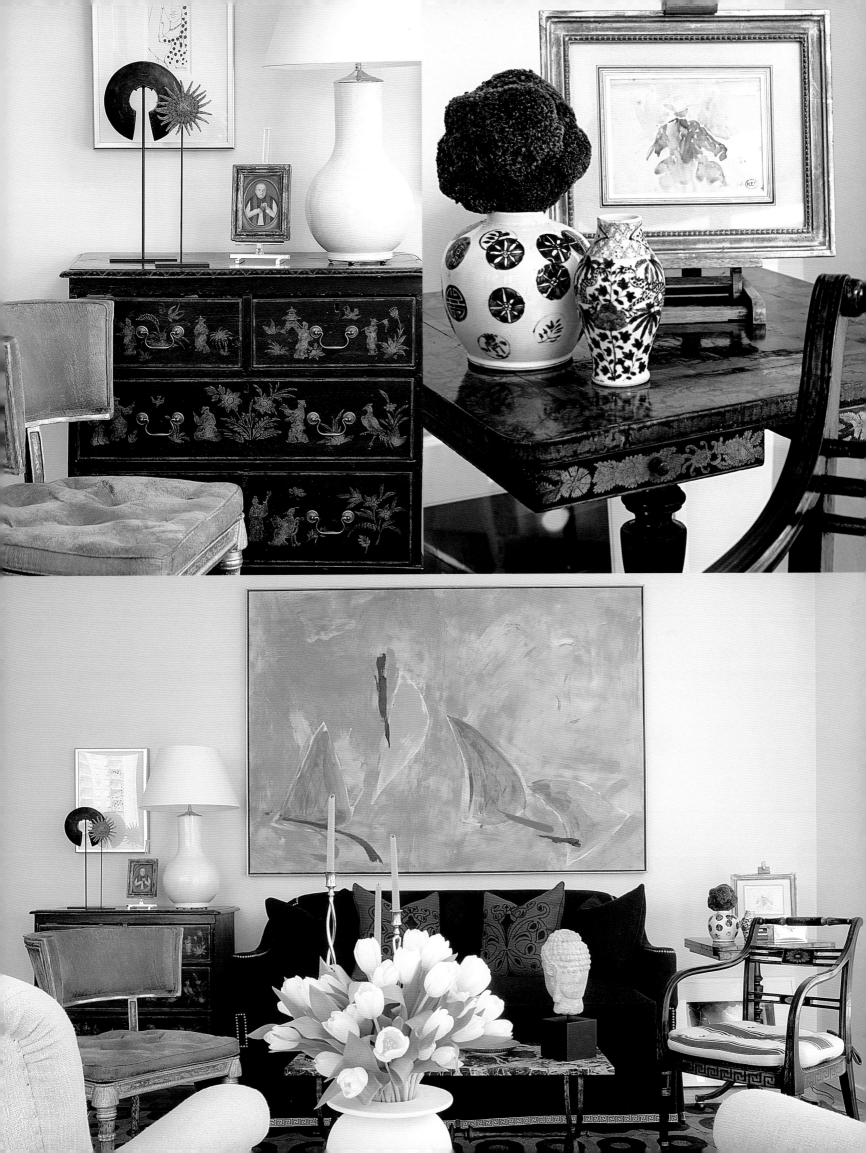

MY INSPIRATIONS AND PASSIONS

What's your favorite . . .

Artist *Mark Rothko*
Bar *Bemelmans at The Carlyle, New York*
Bed sheets *Frette*
Book *The Fountainhead, by Ayn Rand*
Car *A silver Mercedes Gullwing with red interior, circa 1962*
Chair *Klismos chair*
Chef *Myself*
City *Stockholm*
Coffee *Tea*
Fashion designer *Balenciaga*
Gadget *A legal pad*
Garden *Parc de Sceaux in Paris*
Guilty pleasure *Collecting art*
Hobby *Reading*
Hotel *The Park Hyatt in Buenos Aires*
Jewelry *Antique Rolex watch*
Lamp *The Giacometti Lady lamp*
Magazine *The World of Interiors*
Memory *My dog Tyler*
Movie *-North by Northwest*
Museum *The Menil Collection in Houston*
Newspaper *The New York Sun*
Perfume/cologne *Hermès Eau d'Orange Verte*
Restaurant *Swifty's, New York*
Room in the house *Library*
Shoes *John Lobb*
Singer *Ella Fitzgerald*
Time of day *The violet hour (just before dusk)*

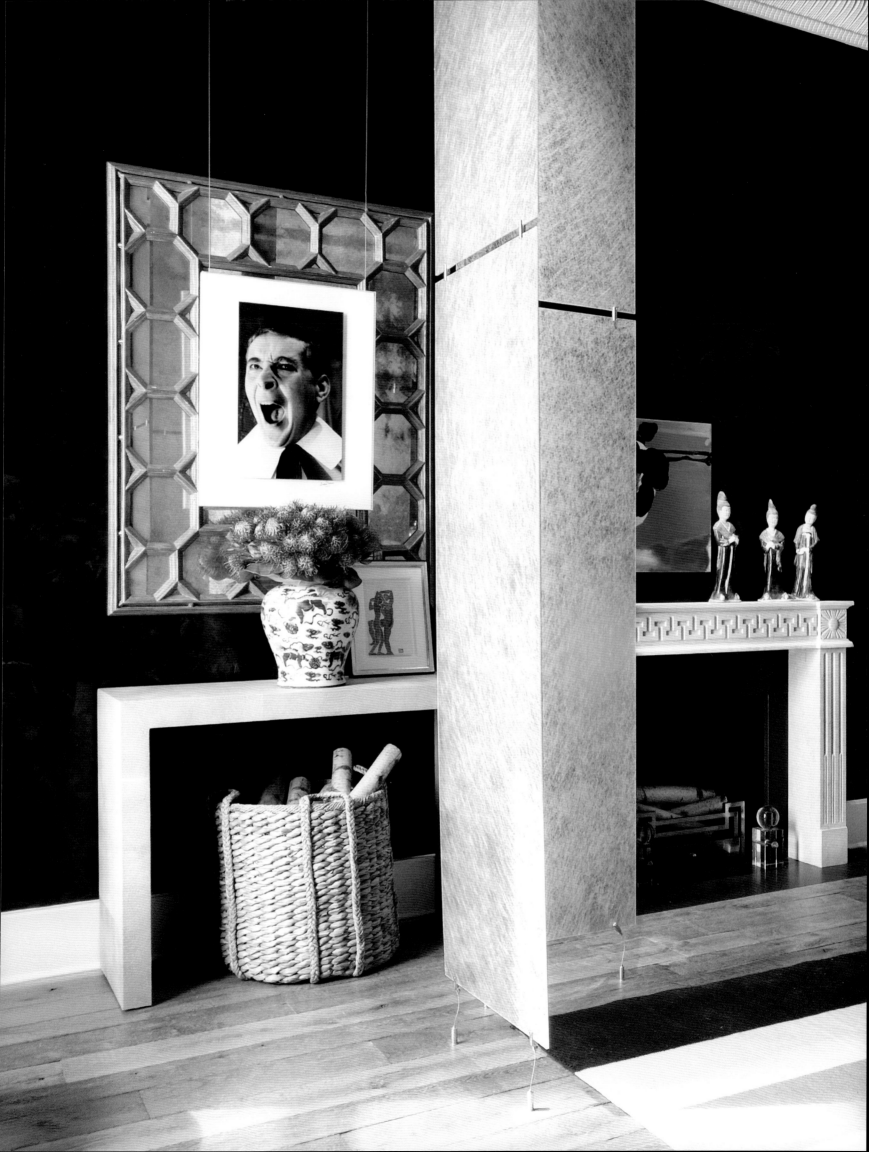

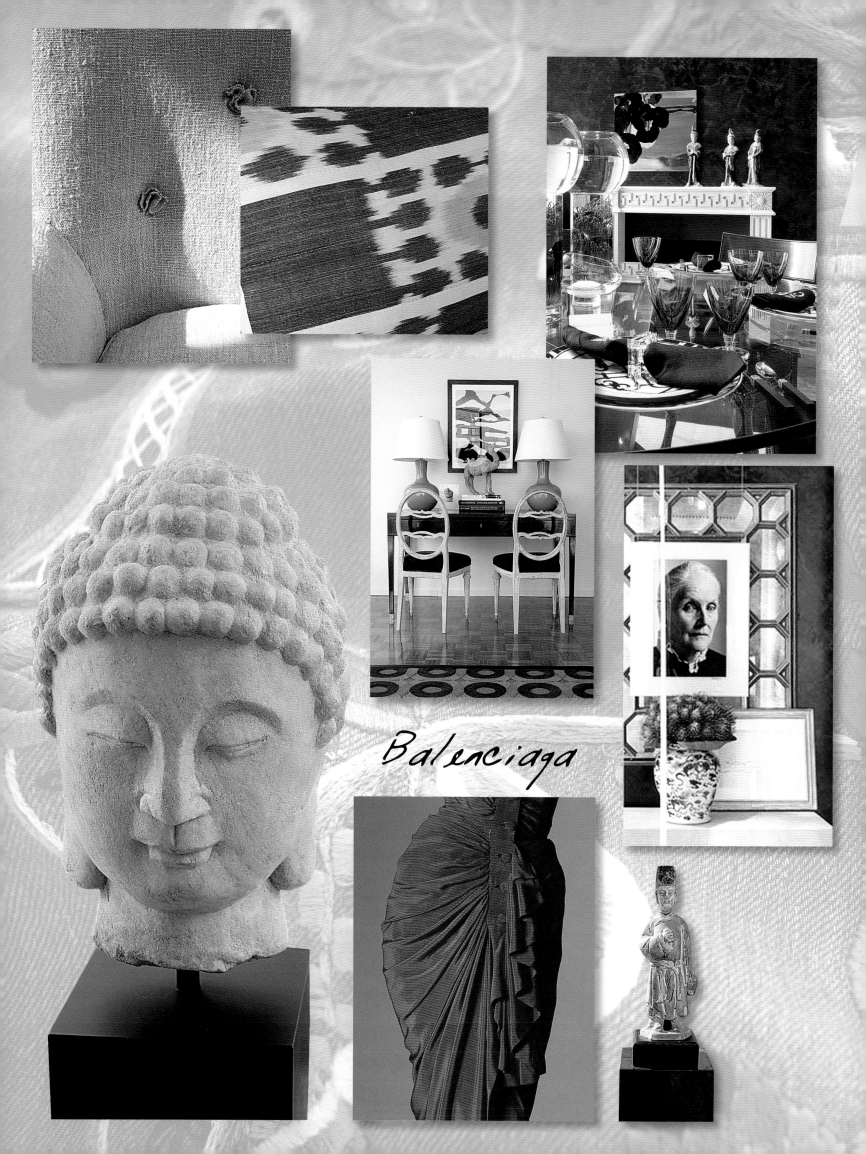

Balenciaga

Stockholm

Diego Giacometti's Lady Lamp

Mark Rothko

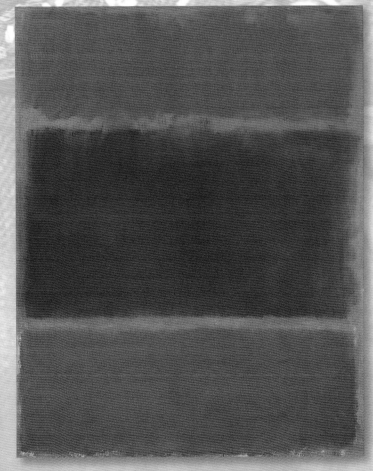

DIAMOND & BARATTA

We have always loved all styles and periods—French, English, Asian. These are the underpinnings of our work, and the roots of American style as we know it. We understand the American sensibility, and are trained in the classics. When I first started twenty-six years ago, Bill taught me everything. He pored over the work of the greatest decorators with me, from Billy Baldwin, Sister Parish, and Madeleine Castaing to Michael Taylor and Renzo Mongiardino and many others, explaining what was beautiful and why. Now I have that reference in my head of what is great.

Bill had that same kind of mentor in Pauline Feldman, his partner for thirty years. She was twenty-five years his senior—a true professional, and brilliant at mixing patterns and colors. She would say to prospective clients, "I can only take on your project if I can work on the architecture," so Bill started his career doing architecture and decorating, and it's been that way ever since. The same is true for me. When I started as an assistant, my first job was a big architecture and decorating project. What we do today has come out of that.

One of the things Pauline instilled in Bill is that all design is a celebration of life: Interiors should be happy, and they should rejoice in a happy home life. Decorating is about people's lives and their homes, and interiors should take a positive outlook on life. Pauline also taught that the design had to be as good as you could get, so if achieving that meant rethinking it 1,000 times, that's what it took—no compromises. The vast majority of what we do is entirely by our own design. We're used to coming up with concepts and bringing them to fruition. Simply shopping the market is not an option for us. When the product or the color doesn't exist, we create it. We've been lucky to find artisans to work for us, a whole stable of exceptional craftspeople— quilters, weavers, upholsterers, and so on. Most of them work for us full-time, like an atelier, so we can just pick up the phone, send sketches and colors, and a memo sample comes quickly via return mail. And as our work changes, they adapt and we adapt.

Bill and I know how to design rugs, furniture, color—and what to do with them. That's thanks to knowing the classics. You have to study historic houses to learn every detail. The same goes for modern work. You have to study the best: Le Corbusier, Mies, Joe D'Urso—the work of the '20s, '30s, '40s. Scale can be learned. When you know what's great, you have it in your body, in your consciousness. We have worked with all colors, they are beautiful, and it's hard to make mistakes. As for patterns, we break all the rules. If you decorate long enough, you find yourself breaking every rule you've ever made. We need new pattern in our world, and we are excited again by design from the 1970s. As a result, our work is becoming more modern, more geometric—with clean-lined furniture and fabrics, and modern art. Twentieth-century art, and much from the late nineteenth century, inspires us enormously. We love Frank Stella, early Mondrian, Joseph Albers, Victor Vasarely, and Bridget Riley. And we're passionate about the textiles of Lucien Day and Alexander Girard. We've been exploring Gio Ponti and his patterns. We're looking at Memphis, simplifying those patterns and mixing them with others. We're exploring Art Deco ornamentation—filtering those period patterns through our eyes. We've also been working with menswear patterns like glen plaid, blowing them up so they look like computer chips. And we're reinventing florals. But who knows what we'll be doing a year from now. The world is about reinvention. If you can keep reinventing, you can stay ahead.

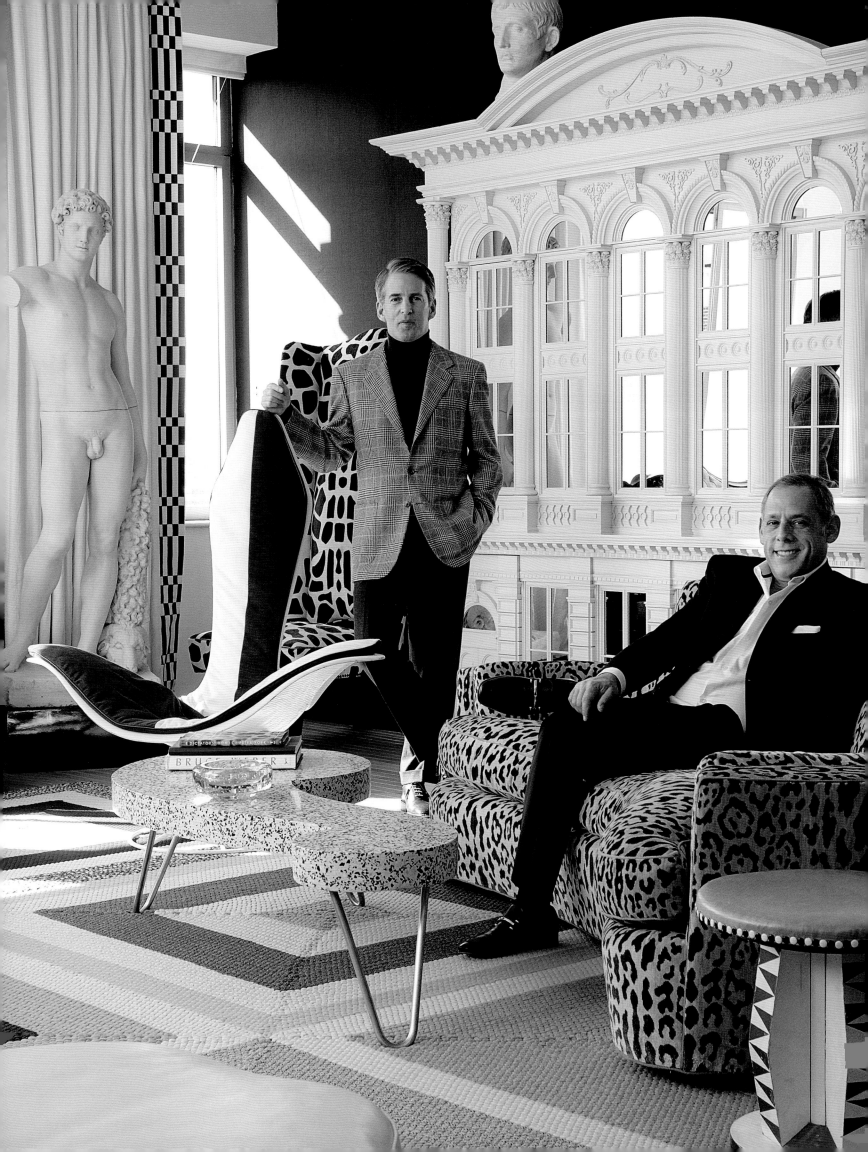

"Interiors should be happy, and they should rejoice in a happy home life."

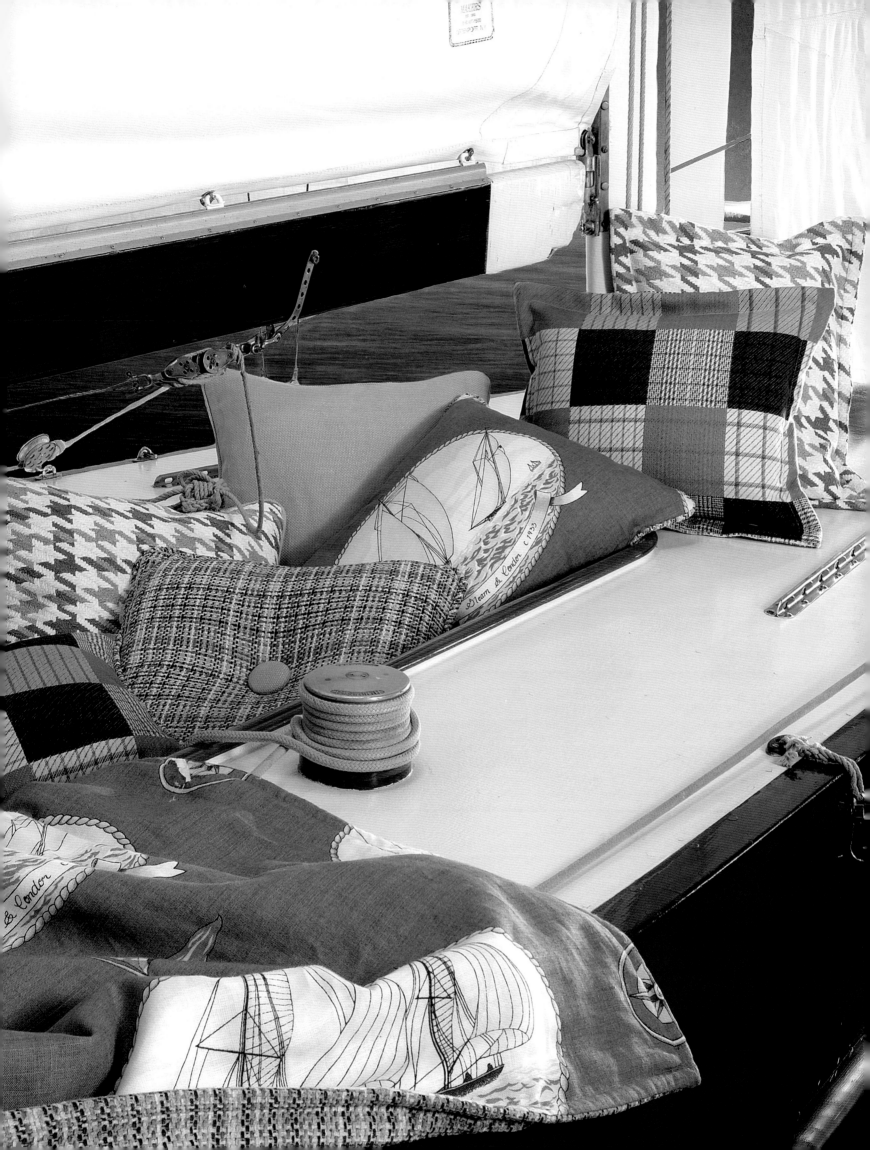

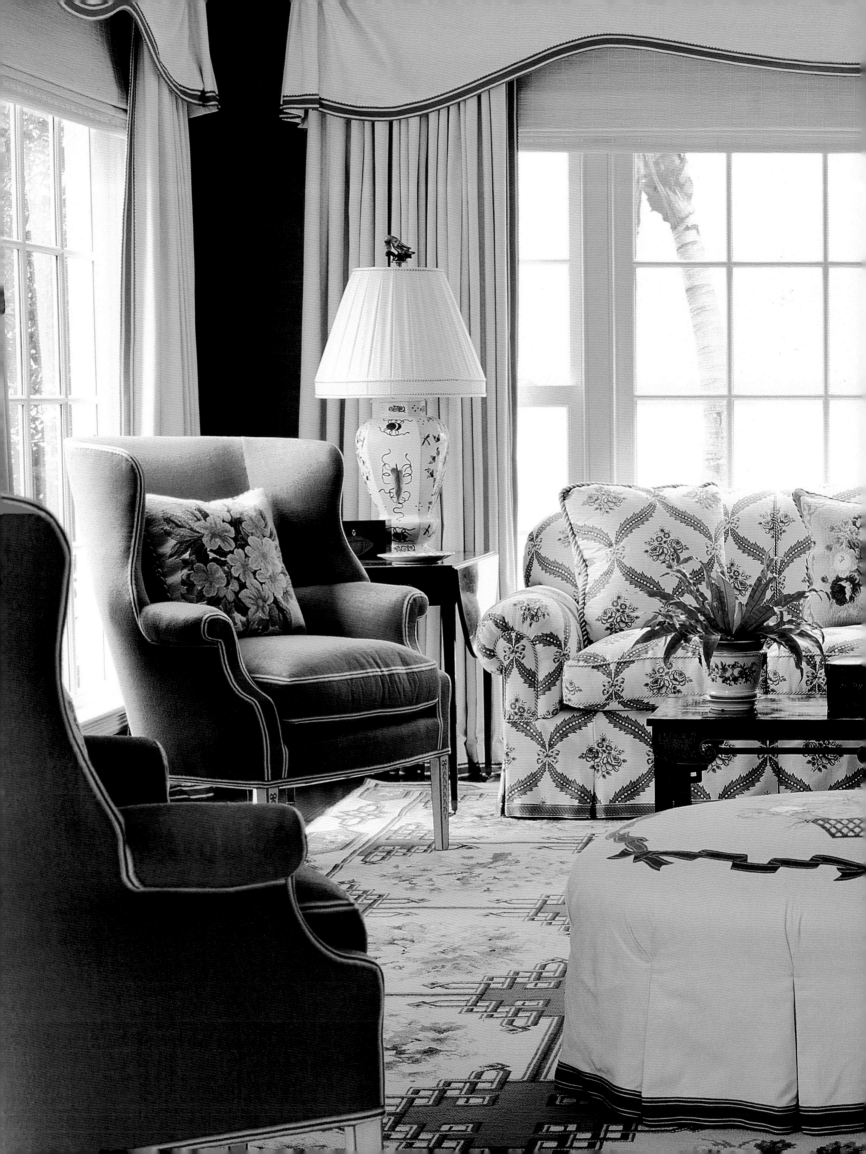

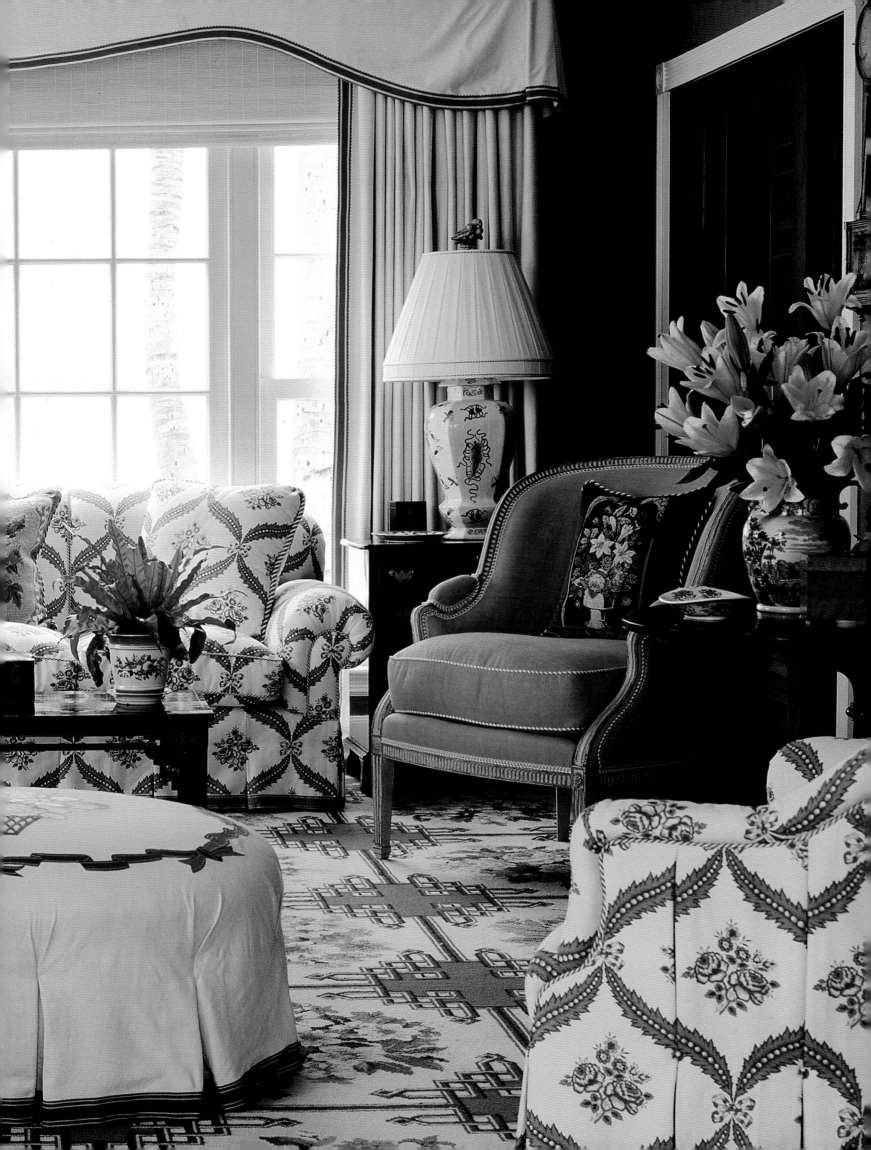

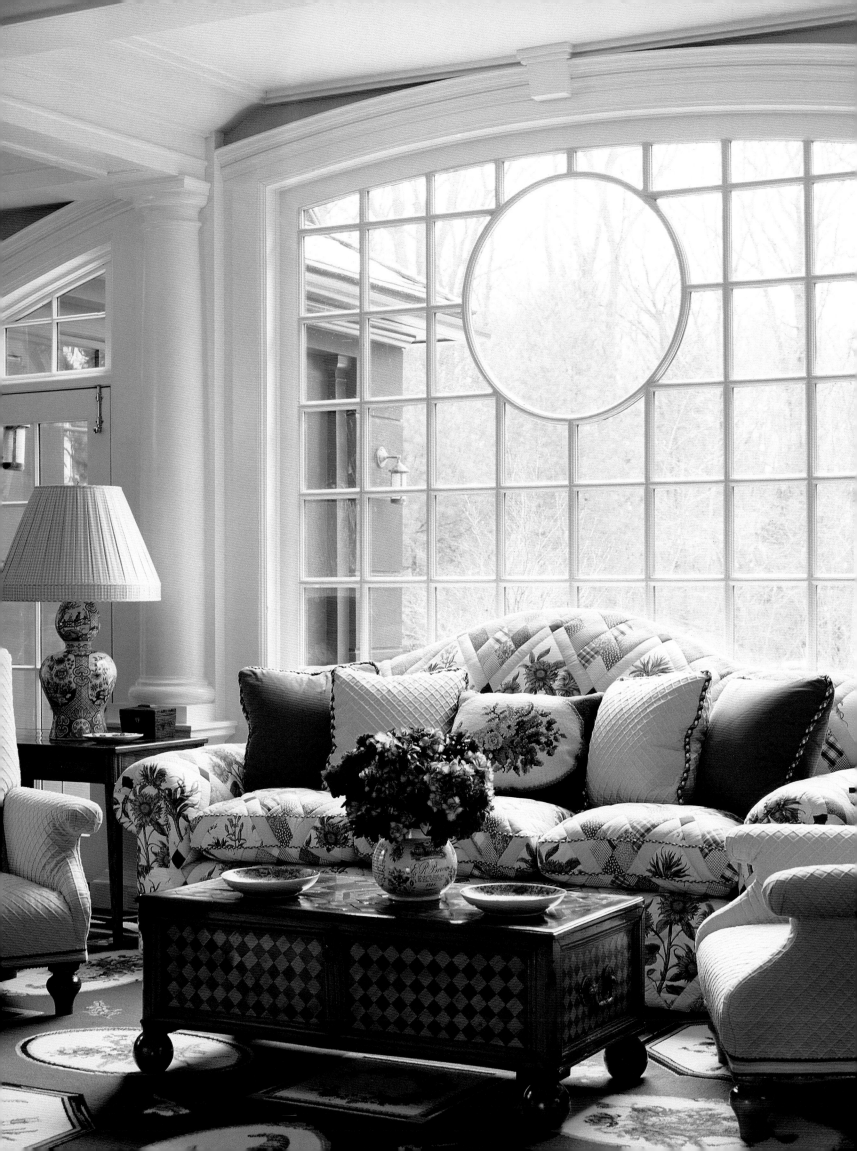

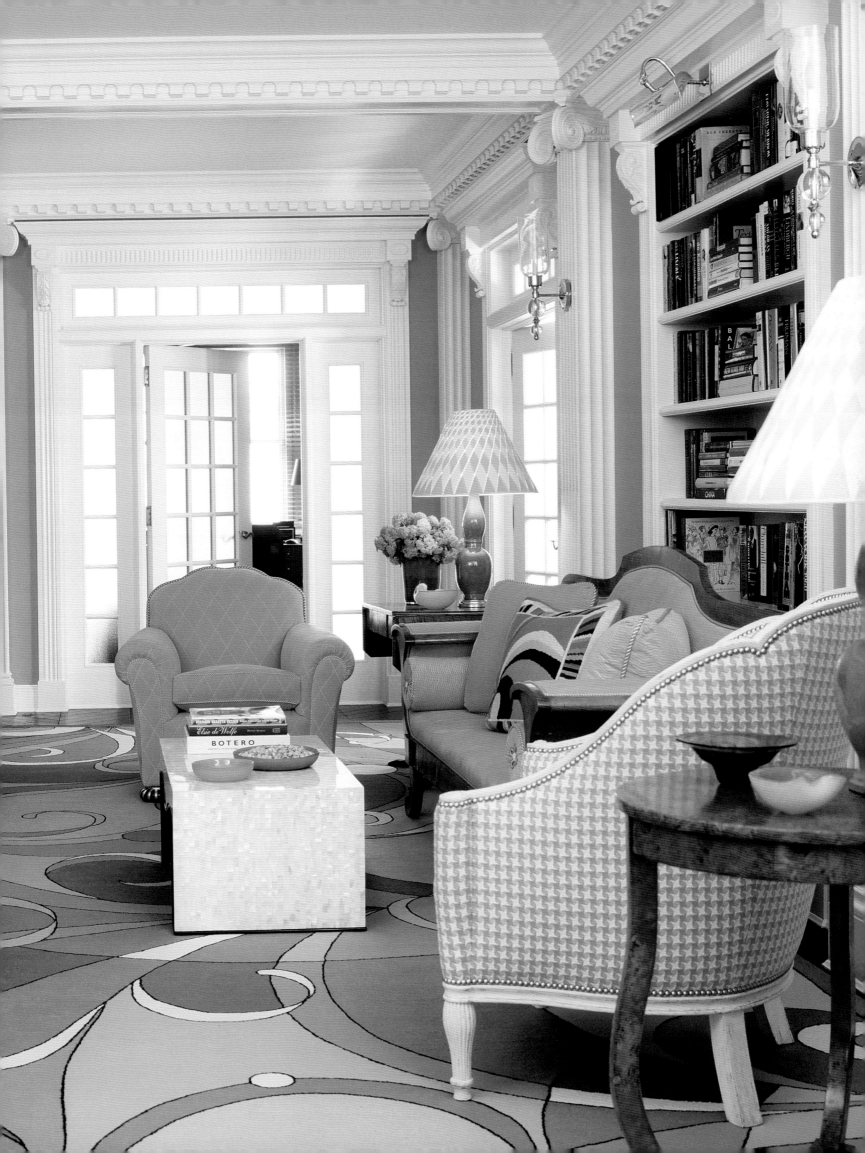

MY INSPIRATIONS AND PASSIONS

What's your favorite . . .

Bill Diamond

Activity *Touring historic homes*
Artist *Matisse*
Car *BMW Z8*
Chair *Le Corbusier Grand Comfort*
Dessert *Berries*
Flower *Hollyhock*
Garden *Sissinghurst Castle*
Hobby *Jogging*
Hotel *Villa d'Este, Lake Como, Italy*
Ice Cream *Saint Ambreous Gelato*
Jewelry *Verdura cuff links*
Movie *Roman Holiday*
Scent *Diptyque L'Ombre dans L'Eau*
Toiletry *Kiehl's NonSoap Cleansing Bar "Pour Homme"*

Tony Baratta

Bar *Dylan's Candy Bar*
Book *Remembrance of Things Past, by Marcel Proust*
Car *Rolls Royce 1984 Camaroue*
Chair *Joe Colombo chair for Kartell 1964*
Coffee *Nespresso*
Garden *Thuya Garden/Mount Desert Maine*
Hobby *Drawing*
Movie *Cinema Paradiso*

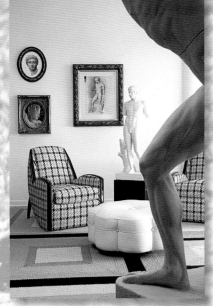

Henri Matisse

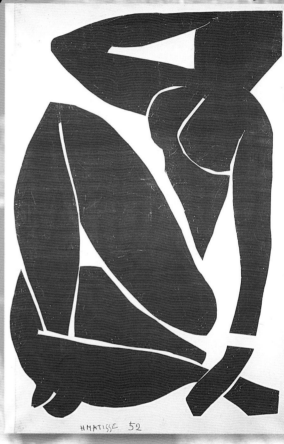

H MATISSE 52

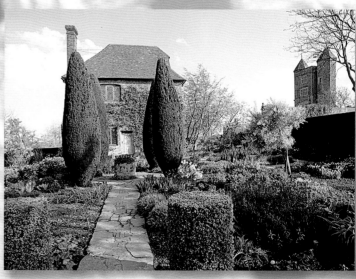

Sissinghurst Castle

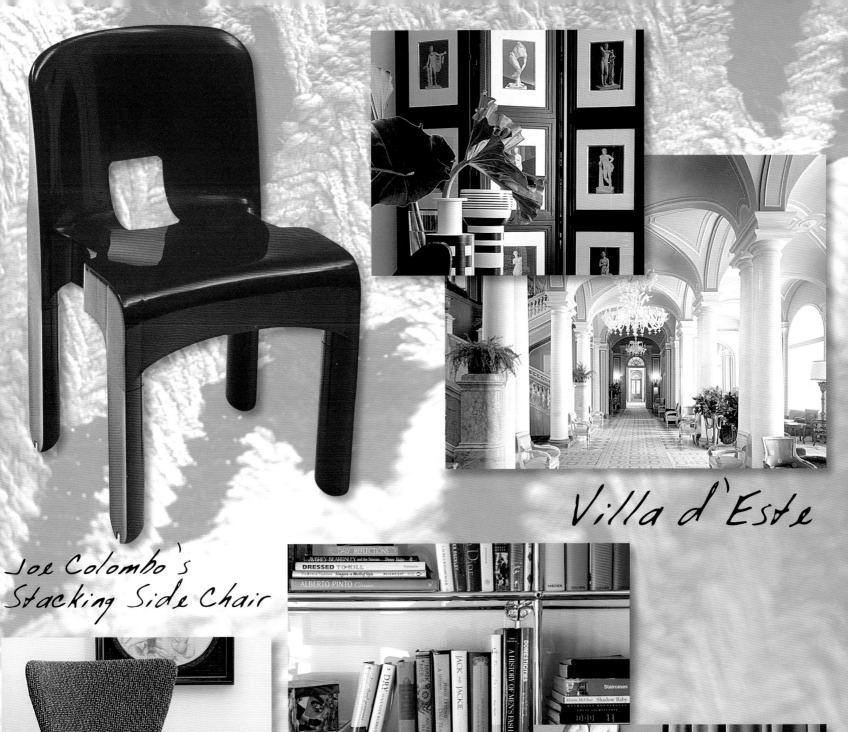

Villa d'Este

Joe Colombo's
Stacking Side Chair

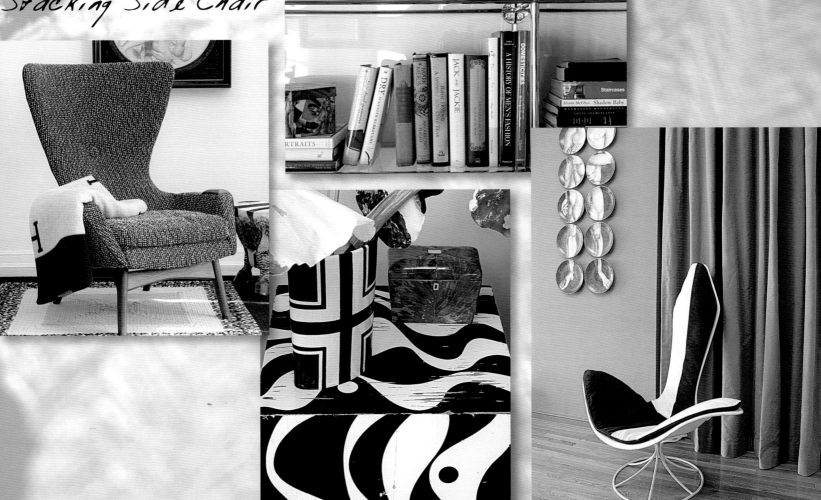

DAVID EASTON

In the past, inspiration came from travel, documentation, and going to every part of the world to buy. Tastes change, though, and that's the crux of the issue for design. All things are changing, always. That's the eternal issue of commodity, and it poses the inevitable questions: What's the material? How is it going to be used? Will it be accepted by the marketplace?

Accessing visual information, accessing any information, is like detective work. You have to think beyond the face of what's there. I've got more than 3,000 books in my library, and I'm constantly adding more. I've traveled all over Hell's Half Acre—as far north as Oslo, and as far south as you can go. I'm heading back to India, Bhutan, Tibet, Beijing, and Shanghai, and then on to Tokyo, and from there to Hong Kong. I do a lot of hotel work, and because of that I find myself in worlds where I might not have ventured otherwise and I discover wonderful ideas for furniture and fabrics.

Inspiration comes from every place. For me, it comes especially from England, continental Europe, and America. I've always been attracted to the neoclassical in its purest, almost modern form. Allusions to the past are harder to dissect and discuss: I can take scale, detail, from a period and abstract it and use it in a way that loses the direct allusion. Color is ephemeral, and it changes. So do texture and scale.

Certain things in life are both classical and modern: The English let loose on their great global journey the discovery of classical forms, clean and decorative. For centuries the grand tour was the canon, the watershed in terms of design and in terms of focusing on the past. That's all evolving now, as Asia is coming to the fore. This shift in perspective may have something to do with the sense of what we felt until 9/11, or it may not. We used to feel that life went on forever. Today there's a sense of fragility. People are making decisions differently—and they don't live in one place anymore.

I have a lifetime of architecture, decorating, landscape, and history. I have had to change, to learn, to move on. After years of living in traditional environments, I'm building a modern house in Charlottesville, North Carolina, on a sloped lot. The design is based on Schinkel, and we're using modular construction. It's a unique thing, when you think about it, to be able to build a house, decorate it, and do landscaping and textiles.

Moods alter, and so does the cultural consciousness. So much of inspiration today comes from technology. Just think about what's possible with digital imaging—and how this technology has displaced the notion of drawing. Then there are today's green sustainable fabrics, which are no longer just wool and cotton. It boggles the mind that there are synthetics that are green. That's the kind of thing that technology at its best can do. I expect our access to knowledge will change the way we think and feel. I think we now place great emphasis on simplicity and sustainability, and on being in the world. We take a much broader view than our parents and grandparents, and certainly than people did in the eighteenth century. Today's view, our view, includes every culture across the world. Who knows? Maybe the future will eschew all design. Maybe, as people's values change, there will be no more design as we know it. If design does survive, here's what won't change: The first ten percent of every project is wonderful, creative, exciting. But when it ain't fine arts, it's applied—and the application is blood, sweat, and tears.

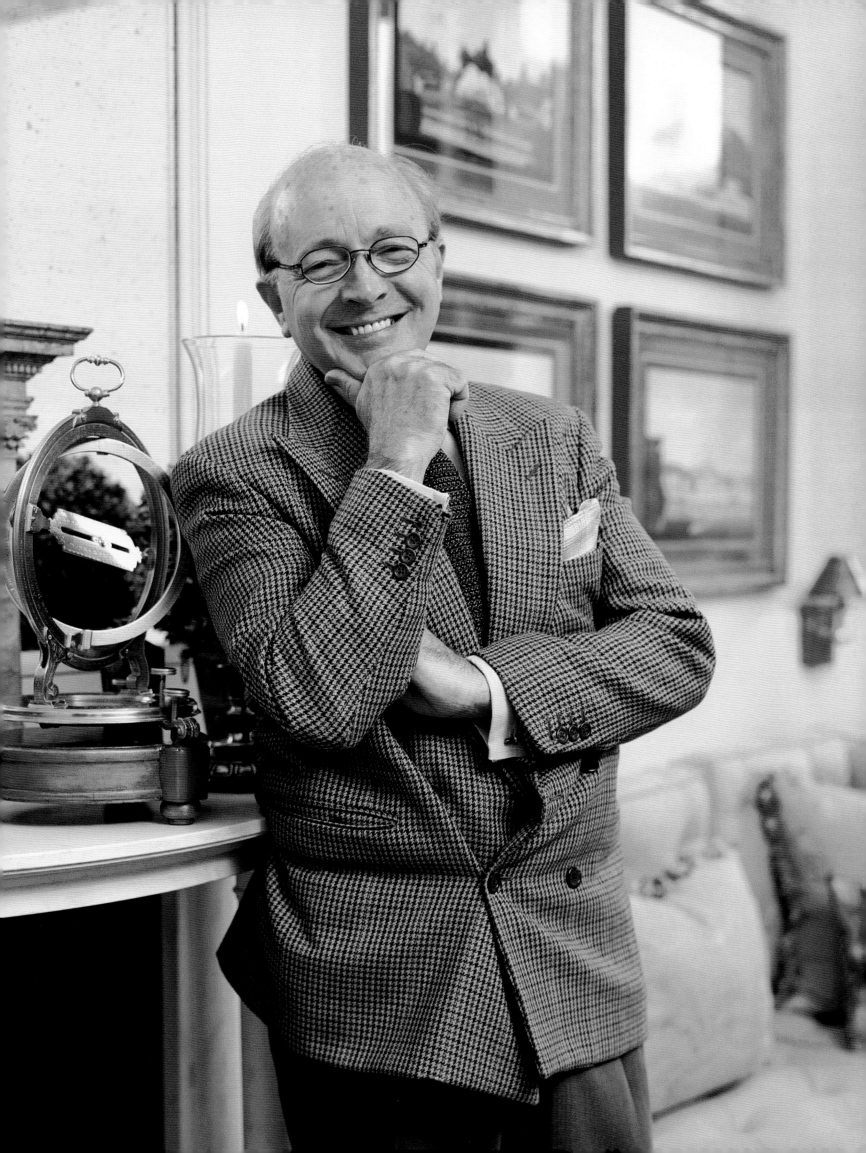

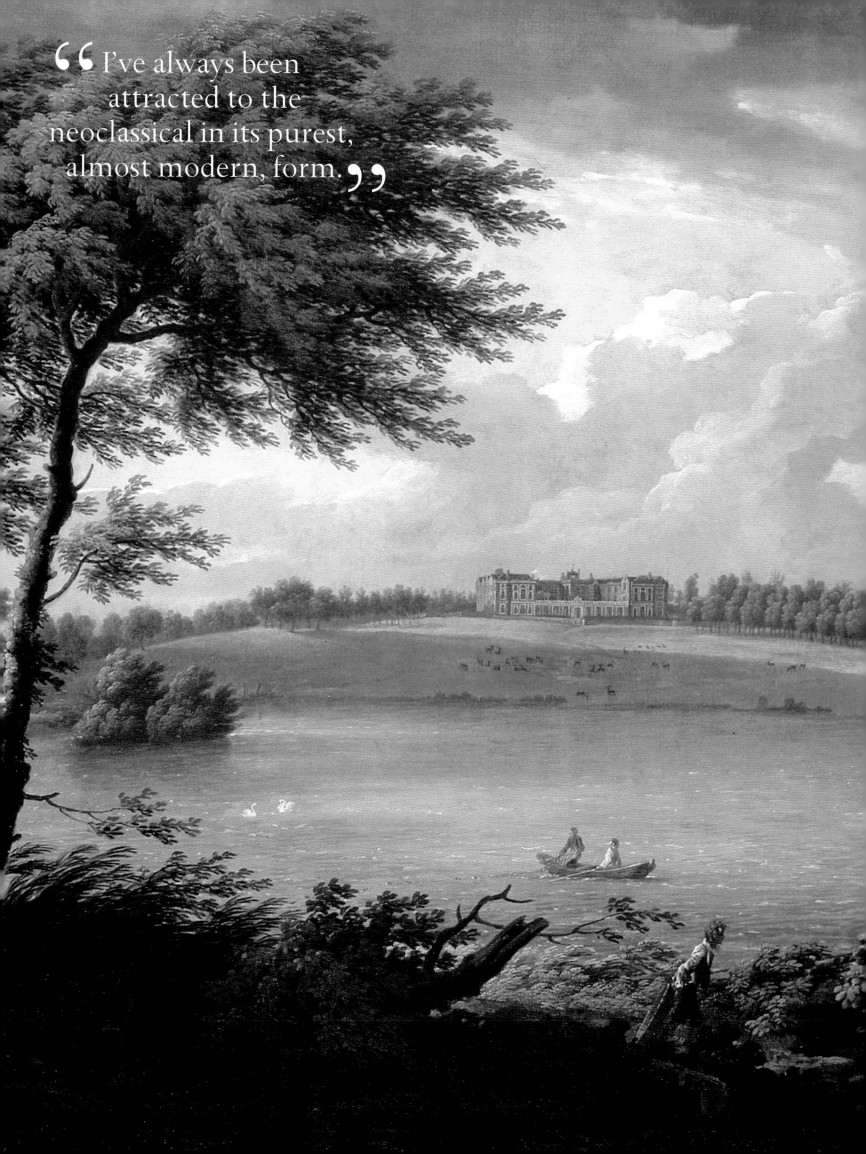

“ I've always been attracted to the neoclassical in its purest, almost modern, form. ”

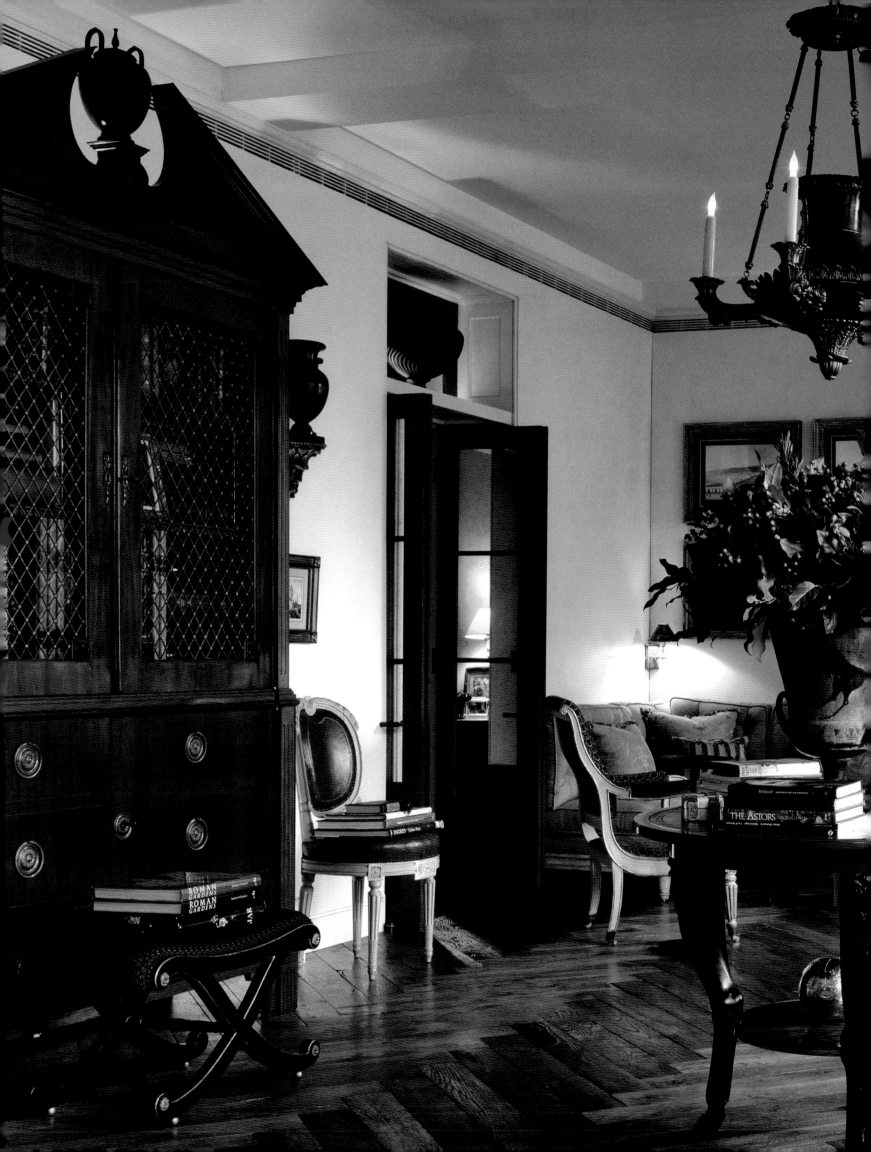

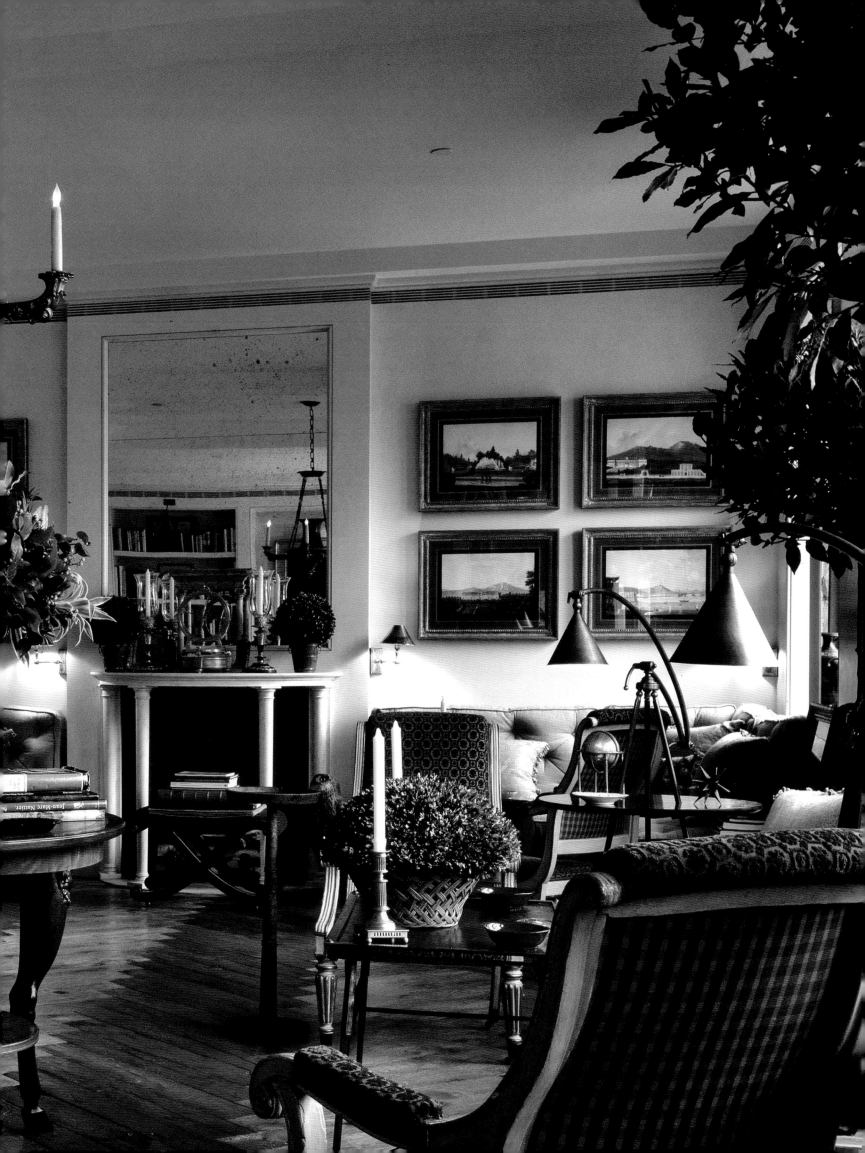

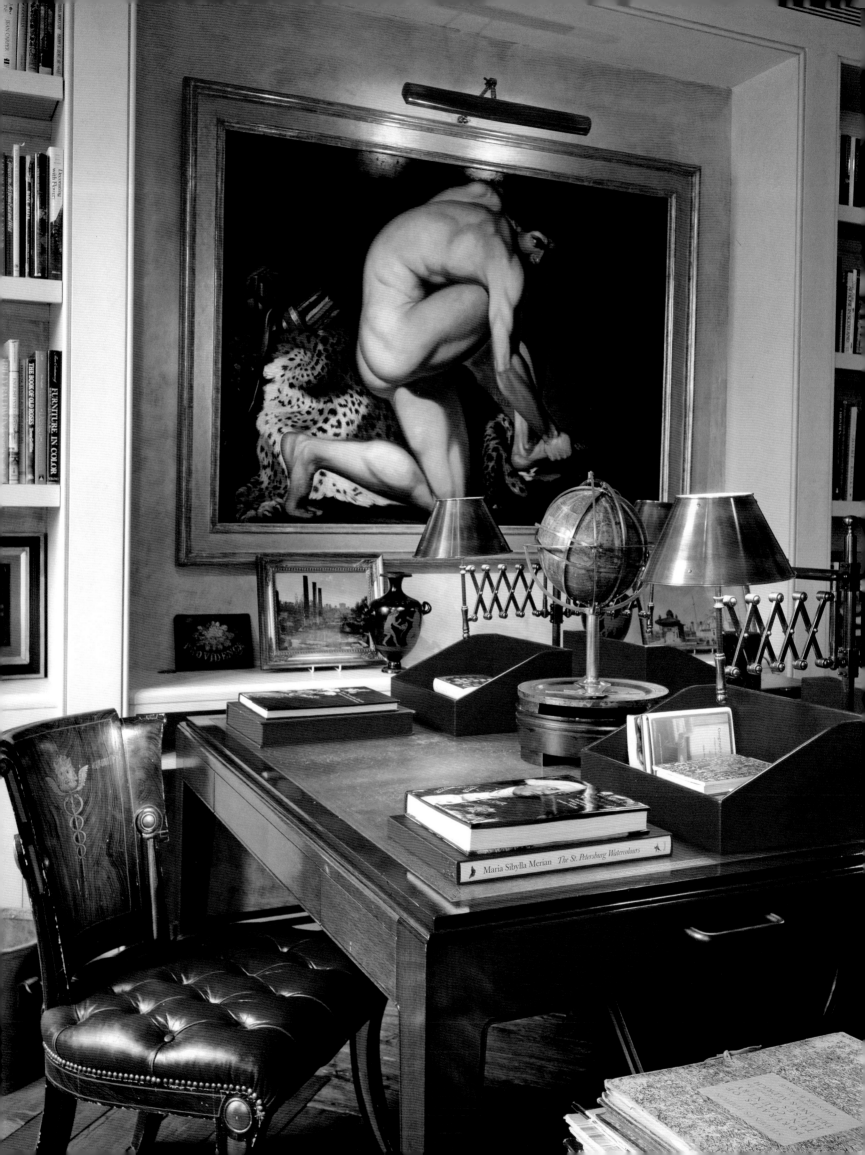

Maria Sibylla Merian · *The St. Petersburg Watercolours*

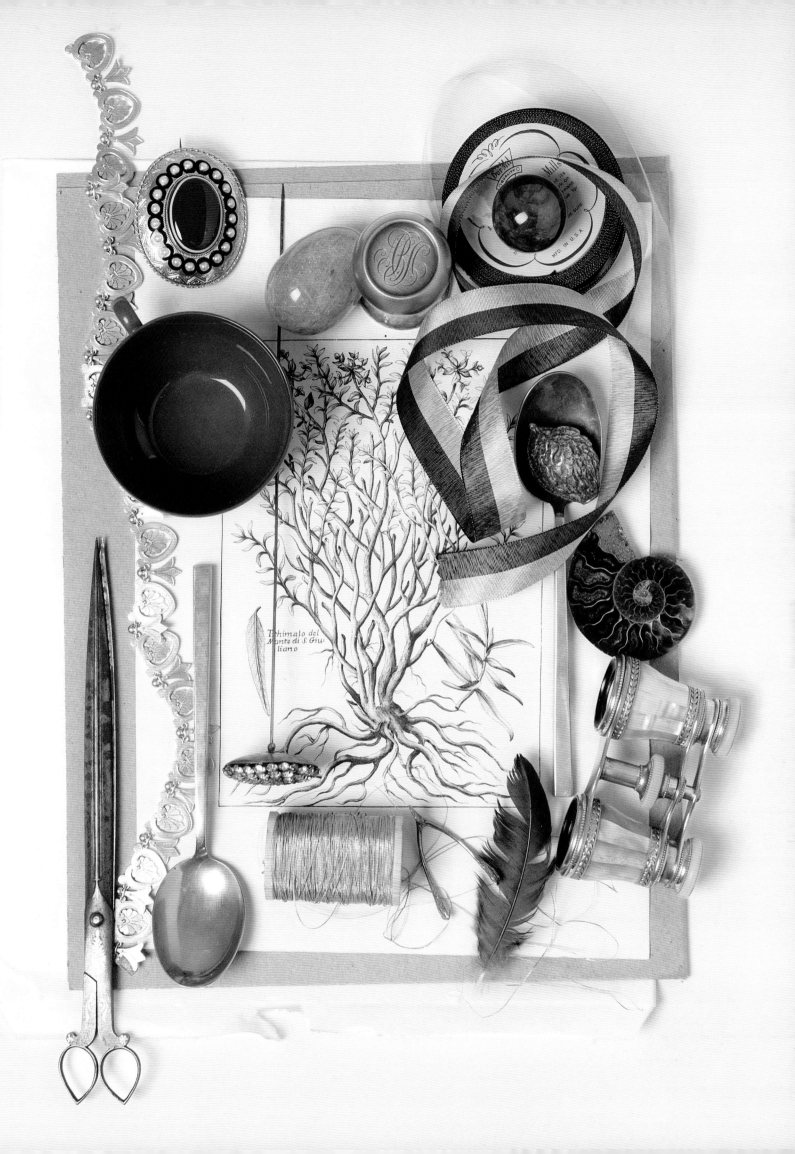

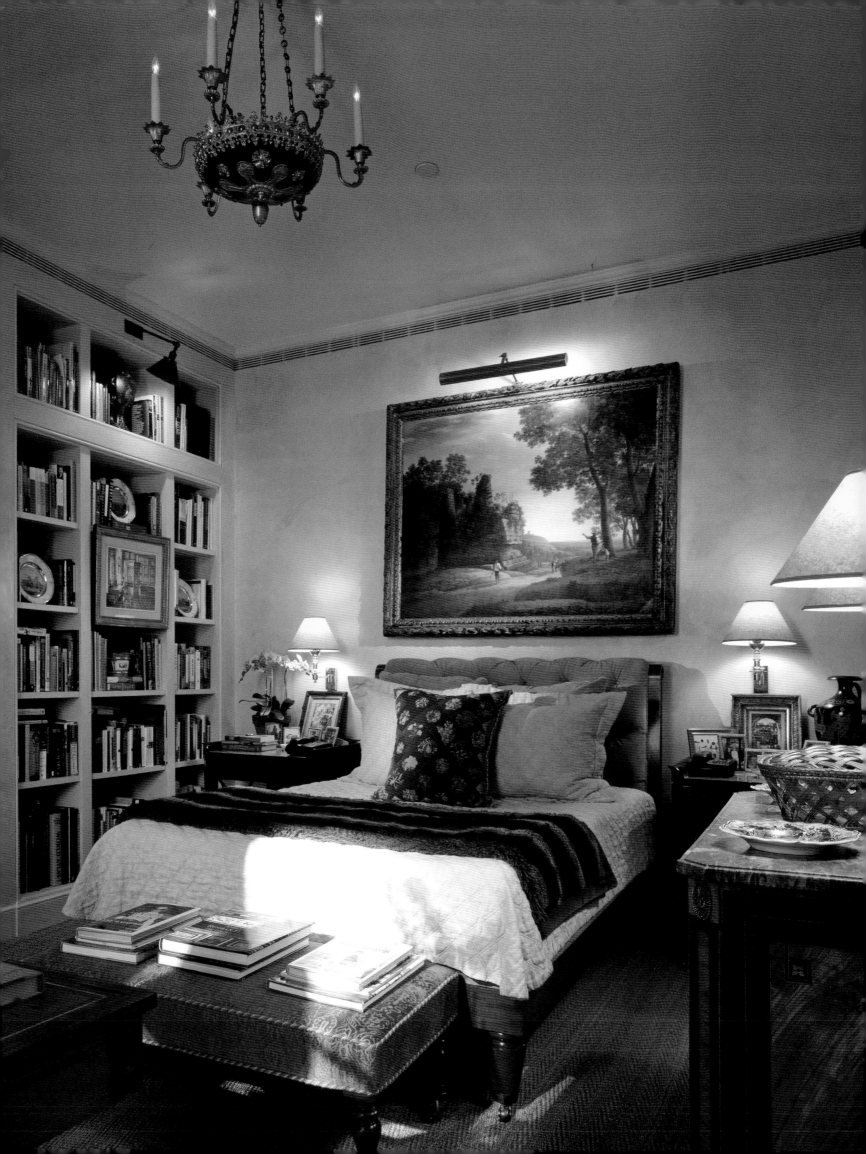

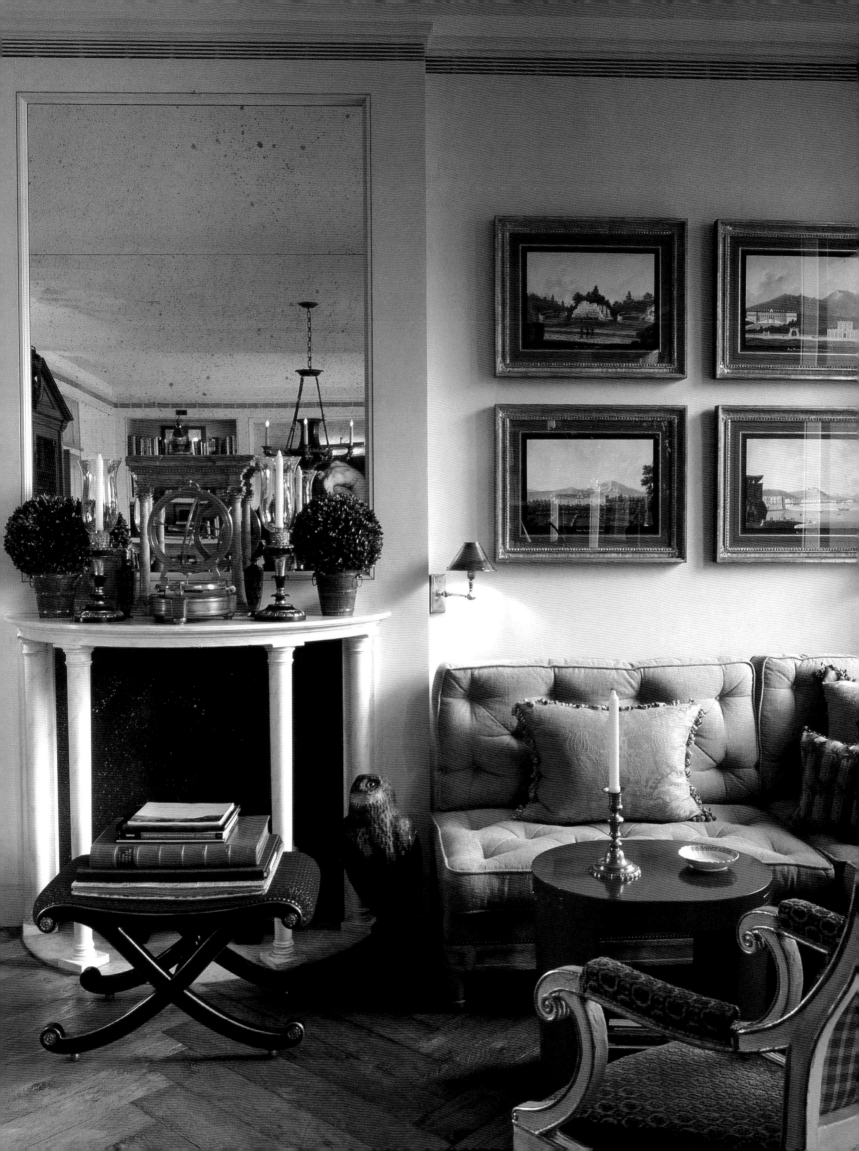

MY INSPIRATIONS AND PASSIONS

What's your favorite . . .

Actor *Hunter Foster*
Airport *Hong Kong Airport*
Artist *Danish Neoclassic painter Nicolai Abildgaard*
Bar *On the terrace with a view of San Marco, at Cip's Club
(in the Hotel Cipriani in Venice)*
Bed sheets *Linens from Ann Gish*
Car *Ford Woody Station Wagon, 1947*
Chair *Greek Klismos chairs*
Chef *Sally Clarke of Clarke's Restaurant, London*
Chocolate *Soufflé*
Color *Terra-cotta red*
Drink *Never touch the stuff*
Flower *Sunflower*
Food *Macaroni & cheese with salad*
Guilty pleasure *Long baths with a good book*
Hobby *Books, books, books!*
Hotel *Villa Feltrinelli, Lake Garda, Italy*
Jewelry *My Andrew Clunn cuff links*
Luggage *My solar backpack, and Longchamps luggage*
Museum *Villa Borghese, Rome*
Perfume/cologne *Acqua di Cuba, by Santa Maria Novella*
Pet *Lizzie, our Norfolk terrier*
Restaurant *Le Grand Vefour, Paris. The Connaught, London.
Balthazar, New York.*
Room in the house *The big room with a desk and views of the
Manhattan skyline*
Singer *Andrea Bocelli*
Time of day *Early morning, anytime after 3:30 a.m.*
Wine *Always red, Pinot Noir especially*

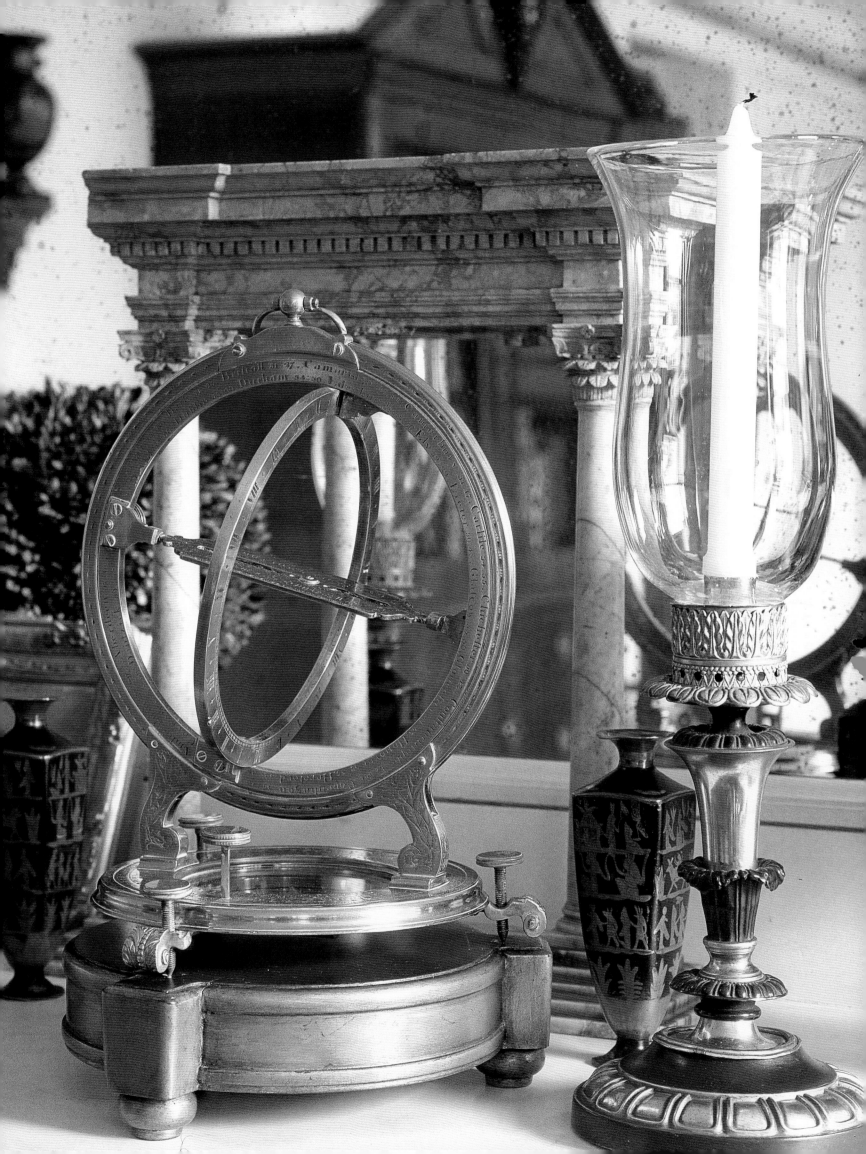

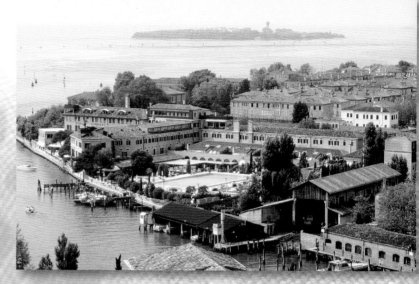

Hotel Cipriani

Nicolai Abildgaard

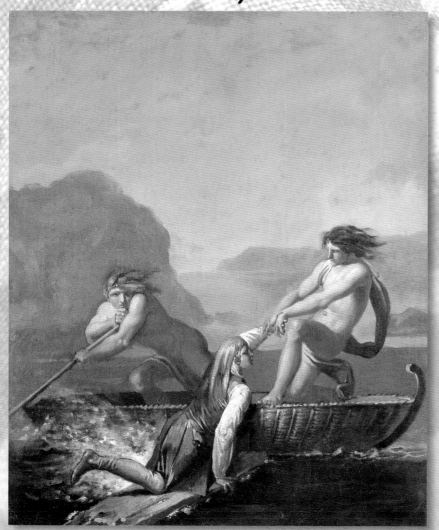

Lake Garda, Italy

ALEXA HAMPTON

Design is all about the editorial eye. Because I draw, I see things composed. I look at a wall and see it as an elevation. When I look at a table, I see a composition. It's almost as if my mind puts together a picture that allows me to add and delete.

I'm looking all the time, cultivating my eye over the whole gamut of things from the most lofty to the truly mundane, from great big things to silly things. I look at buildings, at friezes, at the world around me. The egg and dart, the acanthus, the ornament and detail I can see looking up from a taxi, all that influences me—and my line of trims.

When you have a visual vernacular, you constantly refer to it. If you have a background of looking, you register problems that may exist—and you can figure out where and what they are and fix them. I've seen enough Sir John Soane, Palladio, Sir Edwin Lutyens, and Stanford White that my sense of scale is almost innate. It's the same with the modernist architects: Their work is completely dissimilar to the classical designers, but their sense of scale and proportion are common ground. These are elemental values.

I use a lot of reference materials to keep learning and refining. I like to glean the "eureka" moment, to find the thing that sets off the lightbulb. I'm influenced by people alive and dead, by designers working right now, and in the past. Certainly, my father was an enormous influence, as were David Hicks, Albert Hadley, and Bill Blass. Oscar de la Renta's apartment and houses influence me, as do lots of others. These designers make you want to do better work. Right now I'm on a two-year Karl Friedrich Schinkel moment. I've been a fan for years. I've pored over books about this great German neoclassicist, and I thought I understood his work. I only realized how much I didn't really get it when my husband and I went to Berlin a couple of years ago and visited as many of his houses and museums as we could. The buildings completely blew me away.

I don't want to be out of fashion, but I don't want to be dictated to by it. Context and appropriateness definitely matter: Building a Georgian house in Bali is perhaps not the best idea. Yet I like to work in all different styles, to exorcise those particular demons and to flex those muscles. So the more free a design is from fashion, the better.

Much as I love wit in people, funny enough I don't like it in rooms. I'm always amazed at how much my own home doesn't go with my personality. I'm loud and hyper and boisterous, and my work is calm, soothing, and in its way stark. I always have a bit of a mess around me, yet I love tidy, ordered, and comfortable spaces.

I used to think that, professionally, the best work ends up being a product of a dialogue. Now I'm not so sure. Interiors are negotiations between your own and someone else's sense of style. The best spaces have intelligence and rhythm or are full of opposites: tall and short, light and dark, rough and soft. When things become monotonal, the eye grows bored, and it stops.

As a designer, you always ask yourself, "How am I going to make it work?" You always struggle to crack the code of a room: Where's the storage or the deer head going to go? What do you do when you love a person's sense of style, but hate his or her artwork? You've got to try to figure out the point of view. That's why designers love working with people who have collections. Everybody thinks that designers inspire clients, but really the clients inspire us. We take on a new character with each new client. You put yourself in their shoes, and you take on that role.

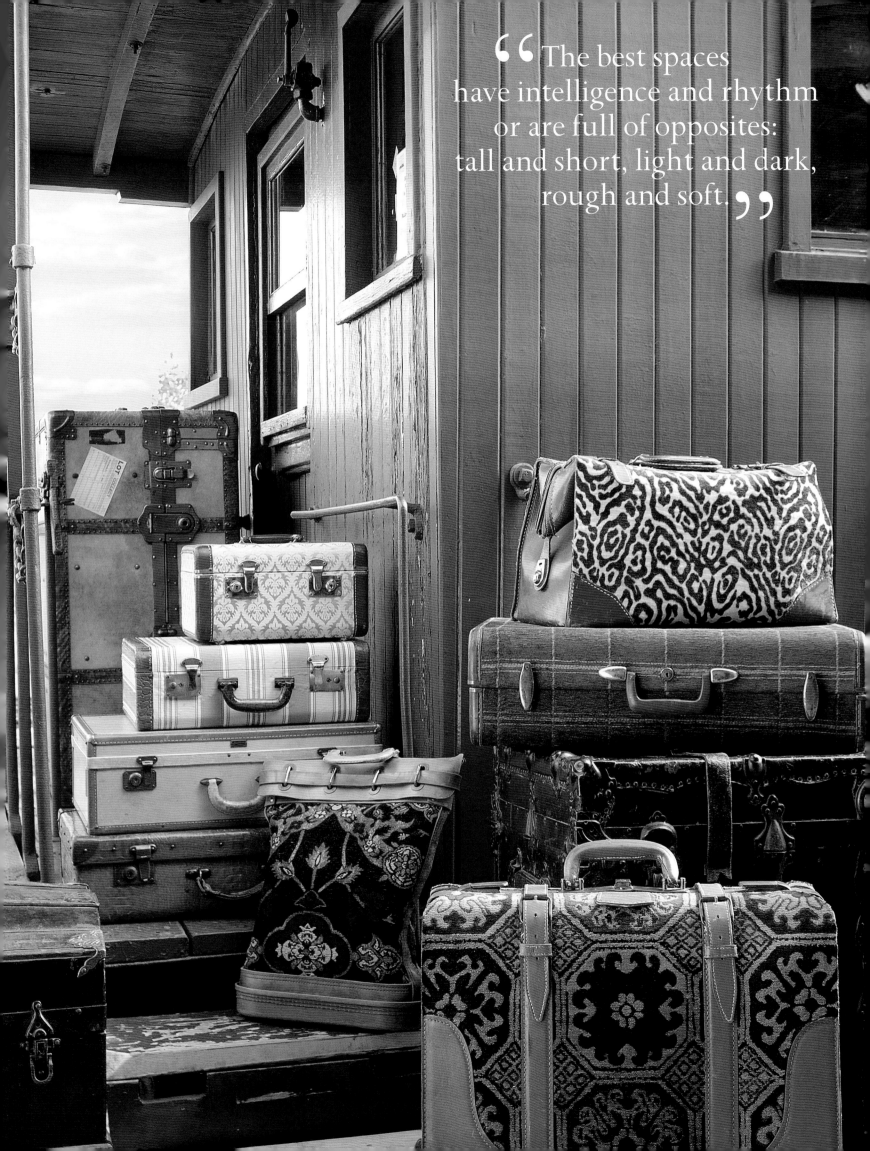

" The best spaces have intelligence and rhythm or are full of opposites: tall and short, light and dark, rough and soft.**"**

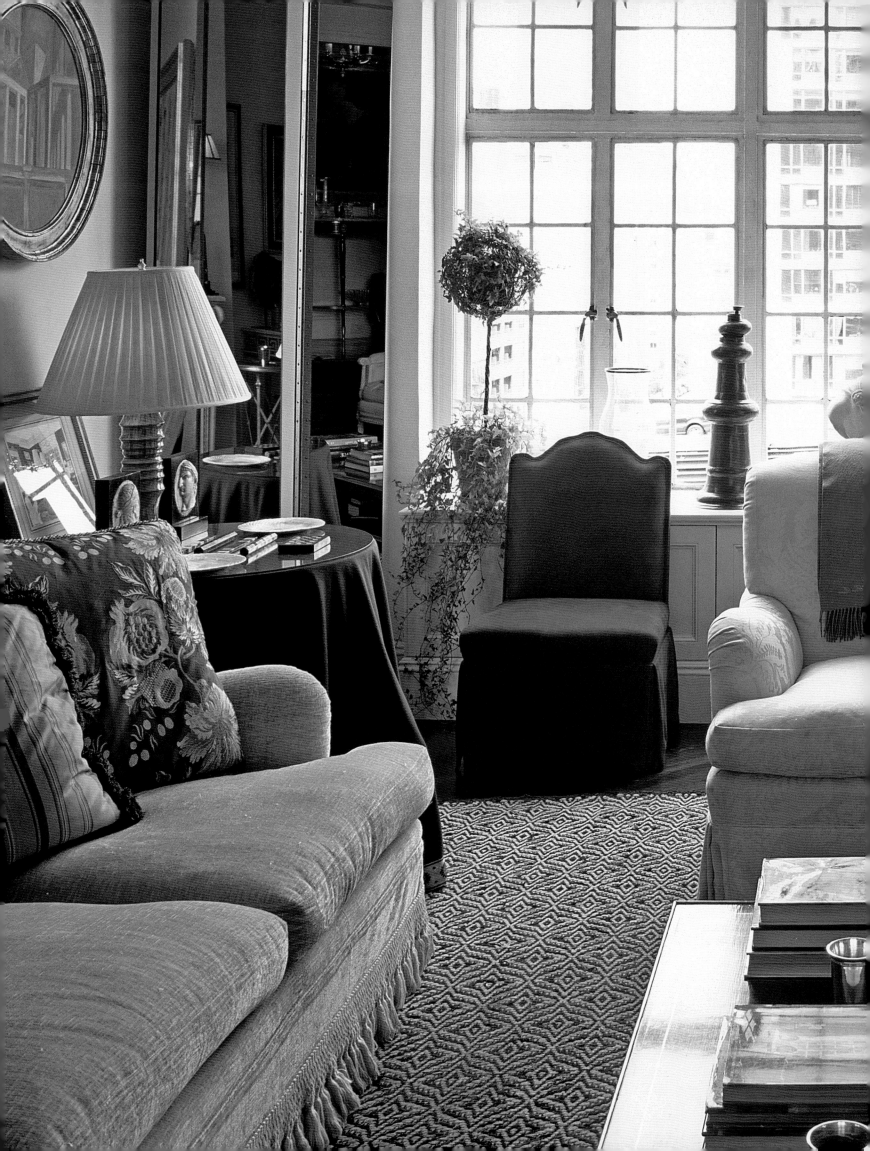

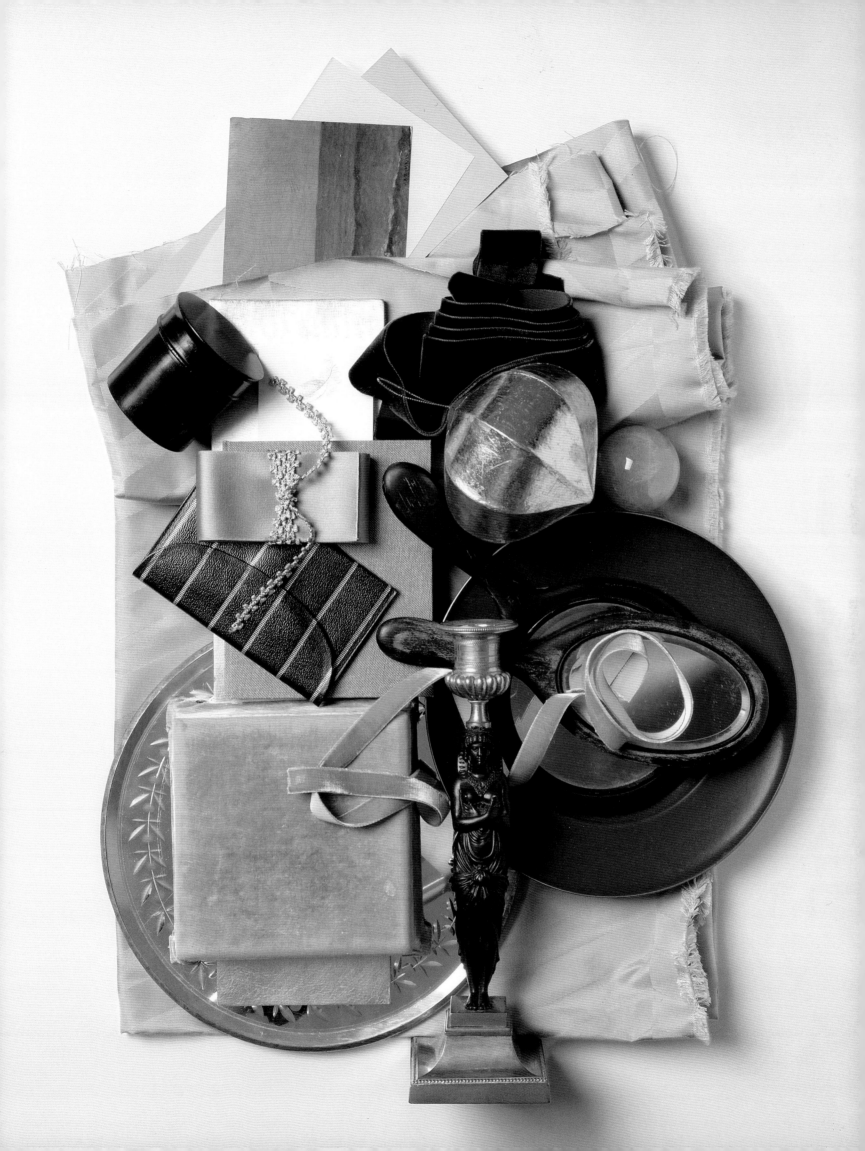

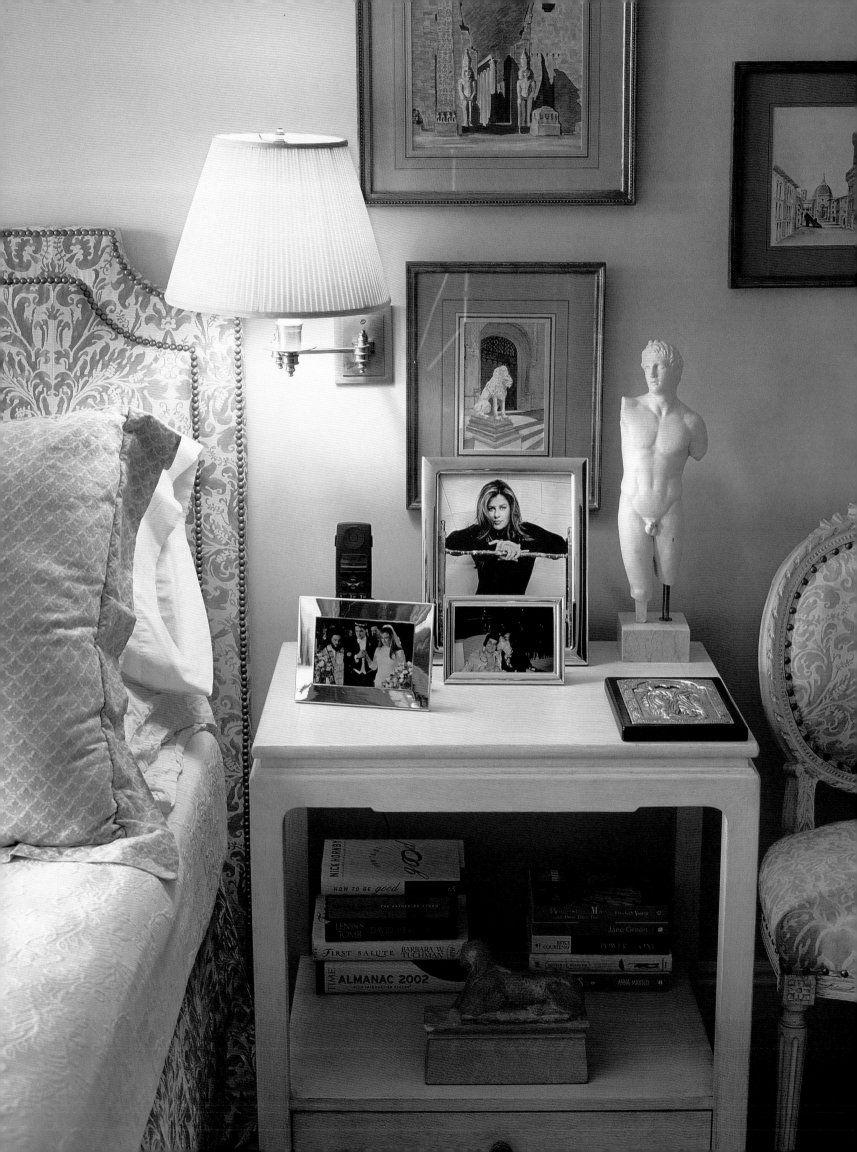

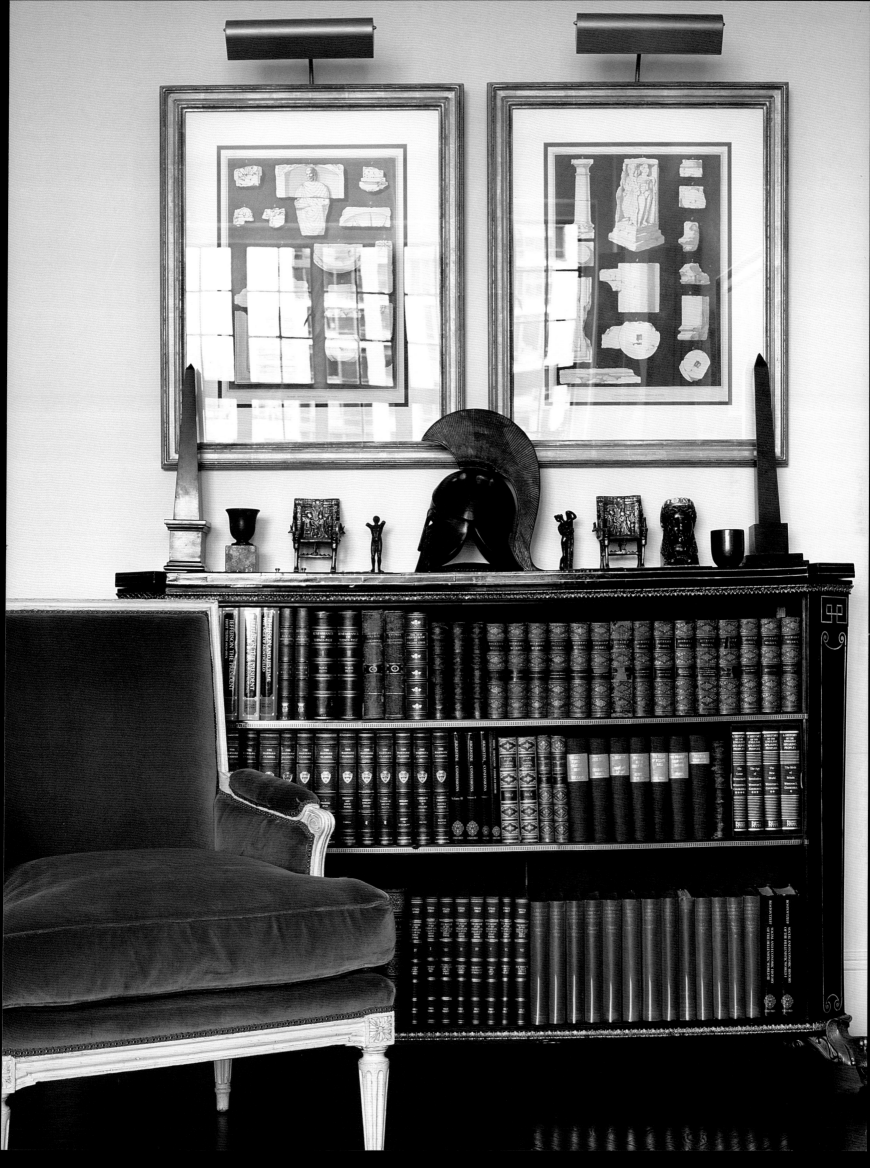

MY INSPIRATIONS AND PASSIONS

What's your favorite . . .

Actor *Kate Hampton*

Airport *The new Athens Airport*

Artist *Titian, Velázquez, Sargent, Manet*

Book *The Last Lion, by William Manchester, and Dreadnought, by Robert K. Massie*

Broadway show *Proof*

Chair *Klismos*

Chef *Joel Robuchon*

Drink *Scotch and water*

Flower *Anemone*

Garden *Harold Acton's at La Pietra in Florence, Italy, and The Linnaeus Garden in Uppsala, Sweden*

Guilty pleasure *Sleeping late*

Hobby *Sketching*

Hotel *Gritti Palace, Venice*

Ice cream *Baskin Robbins Peanut Butter 'n Chocolate*

Jewelry *JAR*

Memory *Hearing my sons' heartbeats with Pavlos for the first time*

Movie *David Lean's Great Expectations (1946)*

Museum *The Uffizi Gallery in Italy and the Frick Collection in New York*

Perfume/cologne *Givenchy's Ysatis*

Person in the world *My husband and children*

Room in the house *Living room*

Singer *Stevie Wonder*

Wine *Tignanello, 1998*

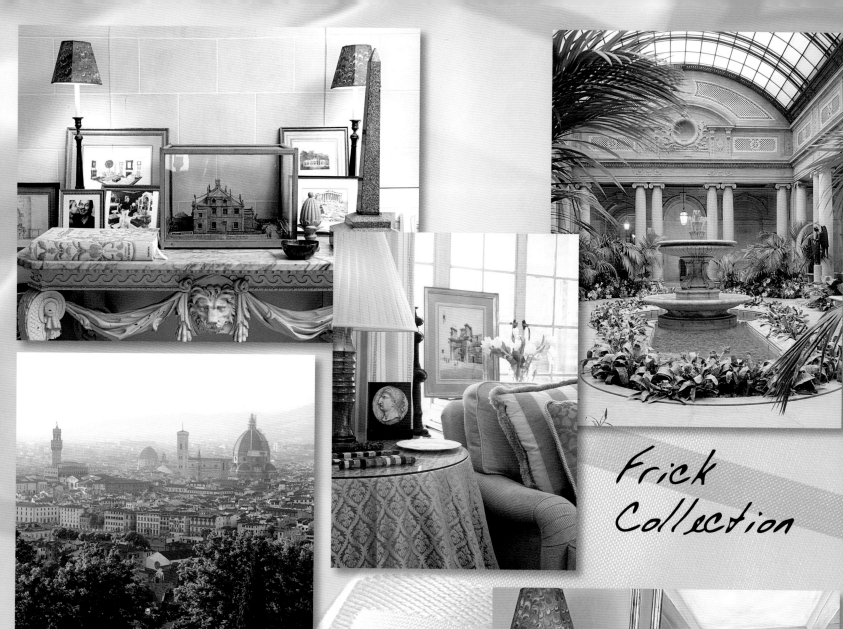

Frick Collection

Florence

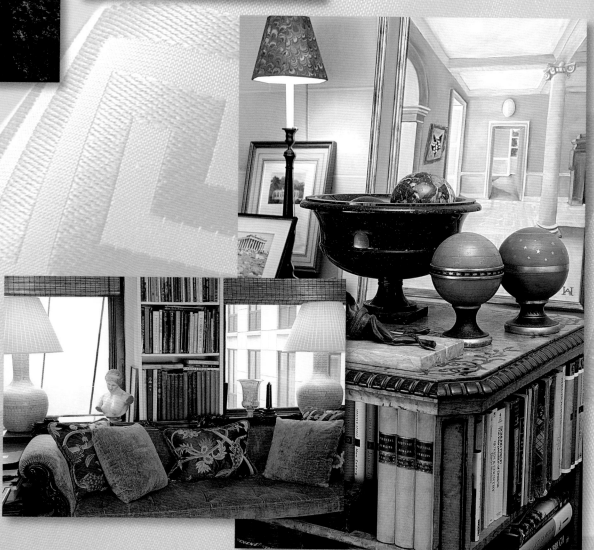

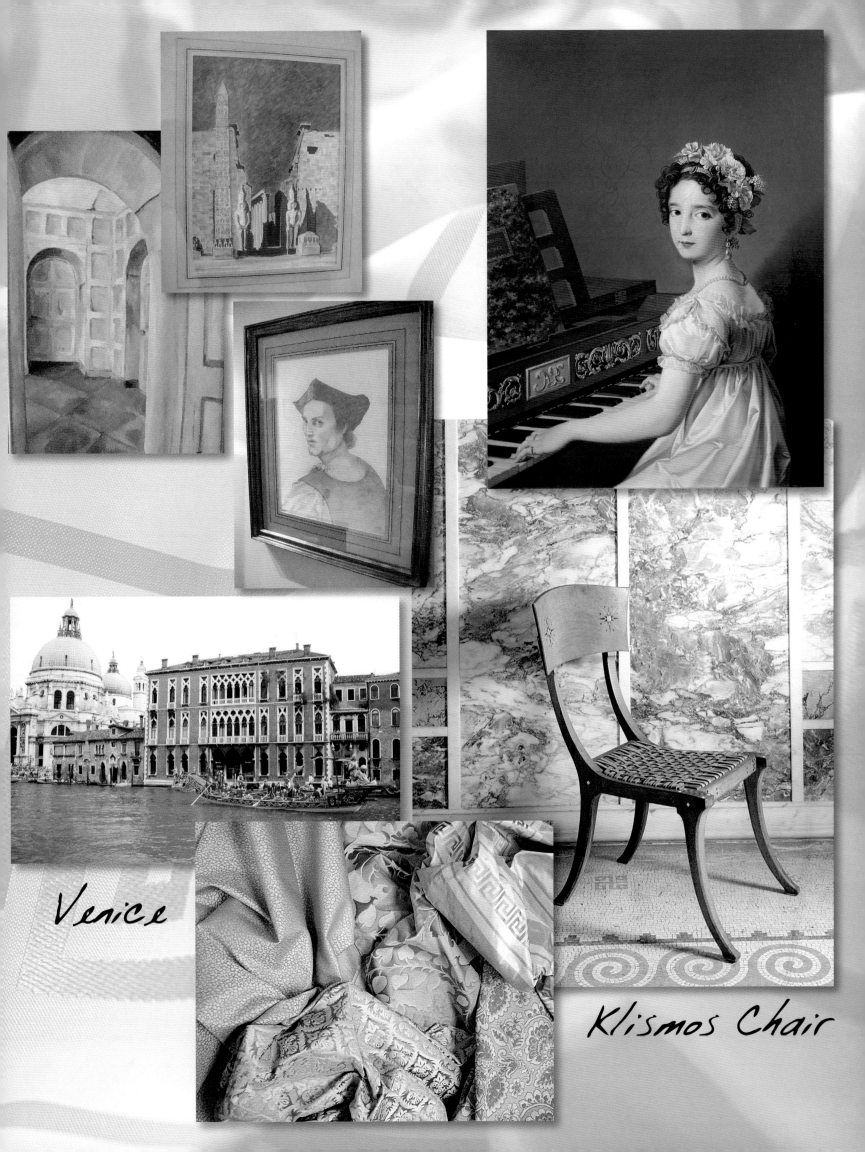

Venice

Klismos Chair

ALLEGRA & ASHLEY HICKS

Allegra Hicks

An aesthetic of design is like an aesthetic of life, an organic way of being with very few fictions. Your signature has to be yours. The process of finding it is like when you happened onto language, or that moment when you found the alphabet—and then mastered all those letters and realized everything you could make from them. Of those few designers I take inspiration from, certainly David Hicks is one. I've breathed in his aesthetic—his chocolate rooms, for example. It's quite different from the Italian modern aesthetic I grew up with. My parents had a modernist house, filled with furnishings from the 1950s, '60s, and '70s by Gio Ponti, Franco Albini, and so on. My inspiration is just the mind working and the eyes looking. Suppose, for example, that ten years ago I saw a lot of Moroccan tiles. Those patterns are now in the back of my brain. Somehow they merge into the collective memory, and later they come out transformed. My design vocabulary comes from nature viewed at microcosm and macrocosm, and the relationship between geometry and nature. Scale can really change in my designs. Sometimes I begin with the smallest-scale elements, sometimes with abstractions, nature as if seen from far away. My palette becomes bigger and bigger over time, and texture is as important as color. I play with luxury in my textiles—cotton, linen, silk, cut velvet. I love rugs hand-stitched in wool or silk; they enhance a room. They become a plate where you put the food of decoration: They make everything warmer and more luxurious. There's a strong element of luxury that is not in your face, but that is the key to true style. Harmony of design and harmony in design are important—originality doesn't have to scream.

Ashley Hicks

I am obsessed with history, particularly the history of design and living. As a child, my father, David, steered me around museums and books. I spent endless afternoons alone in the clean, modern rooms of our holiday house in the south of France studying his huge calf-bound volumes of Claude-Nicolas Ledoux's ideal city. At fourteen I was given a book of plans of eighteenth-century Parisian houses—complex plans, endlessly inventive, supremely practical—the beginning of my life-long fascination with the harmonious division of space. Ten years later, studying at London's Architectural Association and reacting against the school's dogmatic modernism, I would bury myself in the library of Sir John Soane's Museum. Tribal art from Africa to Oceania, with its extraordinary hereditary art forms and primitive, organic motifs began to intrigue me. I lived next to London's Museum of Mankind (now, sadly, gone), and I well remember the excitement of seeing, at eighteen, the Met's Michael C. Rockefeller Wing on my first trip to New York. All the while, I was living amongst my father's designs, first so brightly modern, then gradually gentler and more traditional. Having grown up in the slightly intimidating atmosphere of my father's rooms, I like to create places that are more relaxed, easier to live in; to make a gentler, more comfortable environment. I also work in a slower, more considered fashion, starting with a furnishing plan, with the architectural bones of the room, rather than launching straight into color as he might. I begin with architecture, building from scratch or replanning rooms to achieve symmetry and good proportion. The clients' style of living informs the space-planning process, and their tastes inform the next stage, of decor. I like to include references to the past, without taking a labored or dogmatic approach. It may take an educated eye to see, but these references build to something.

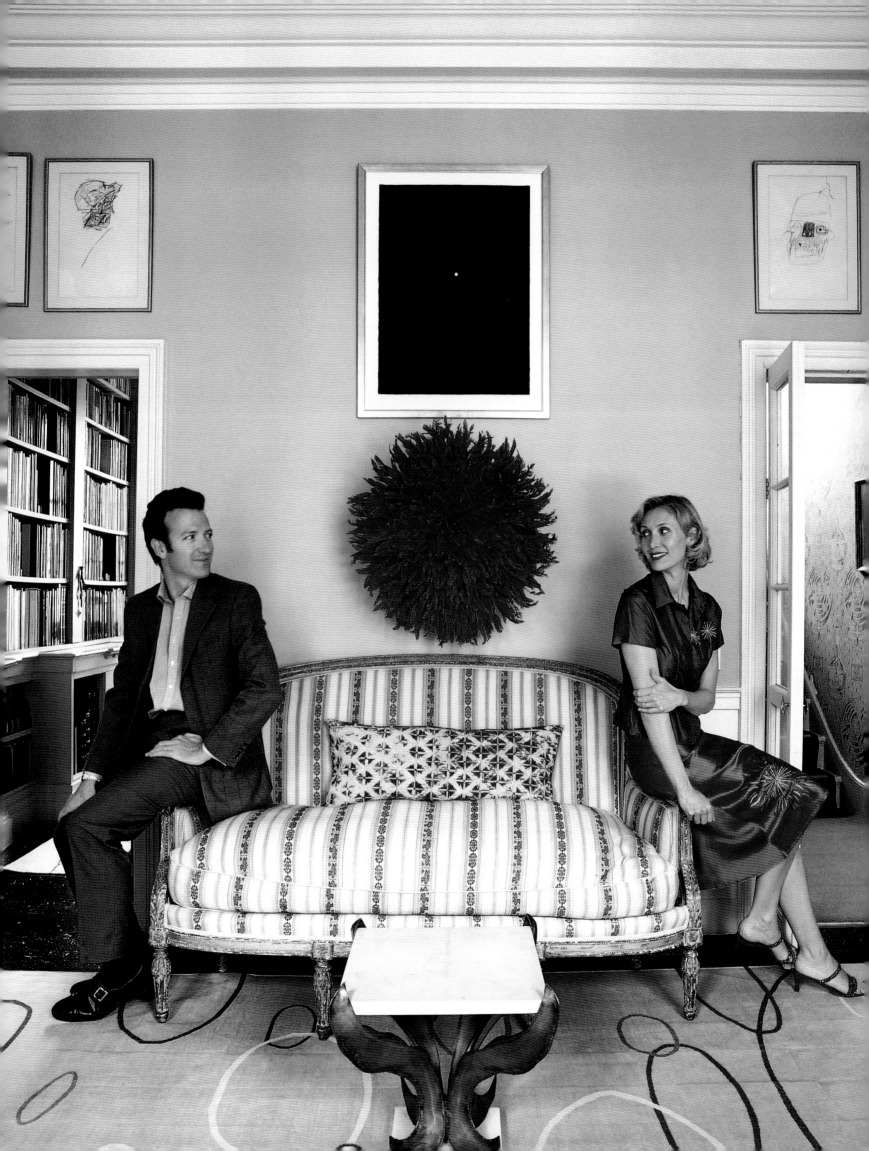

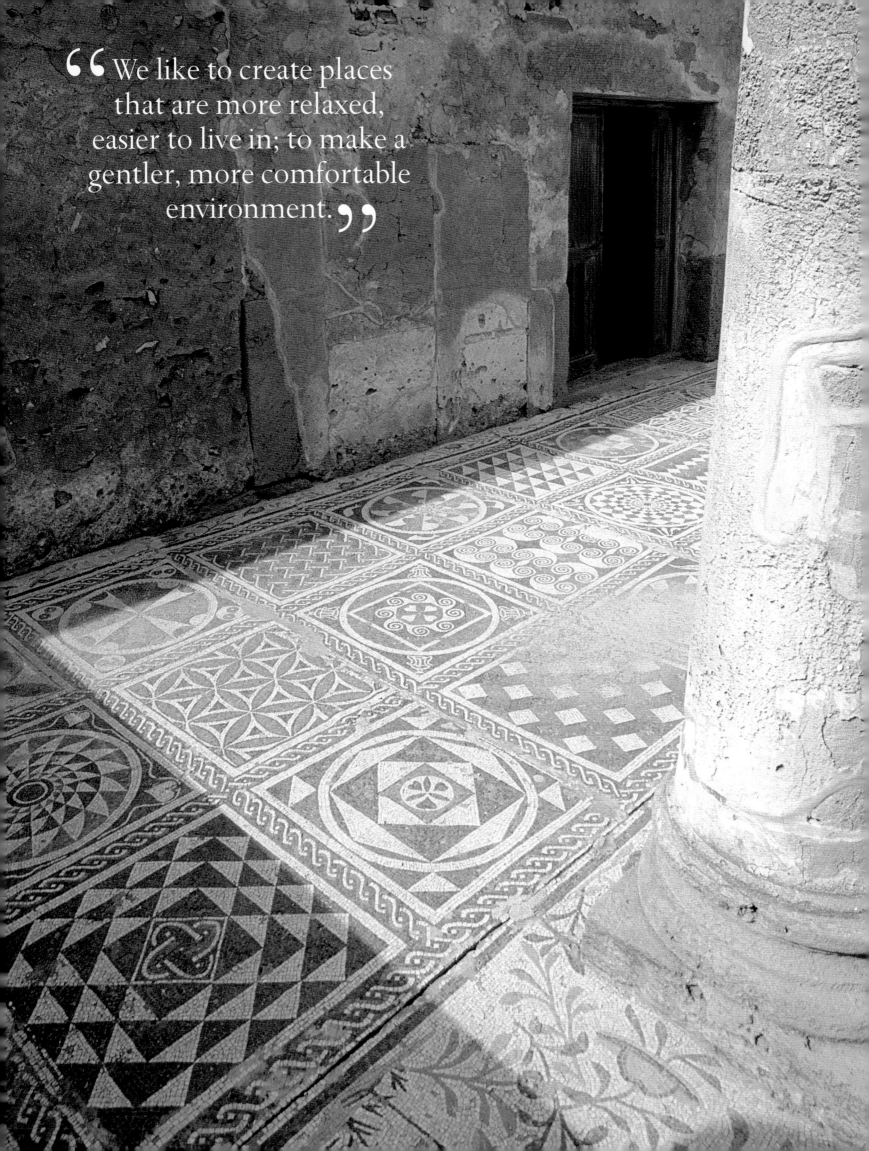

"We like to create places that are more relaxed, easier to live in; to make a gentler, more comfortable environment."

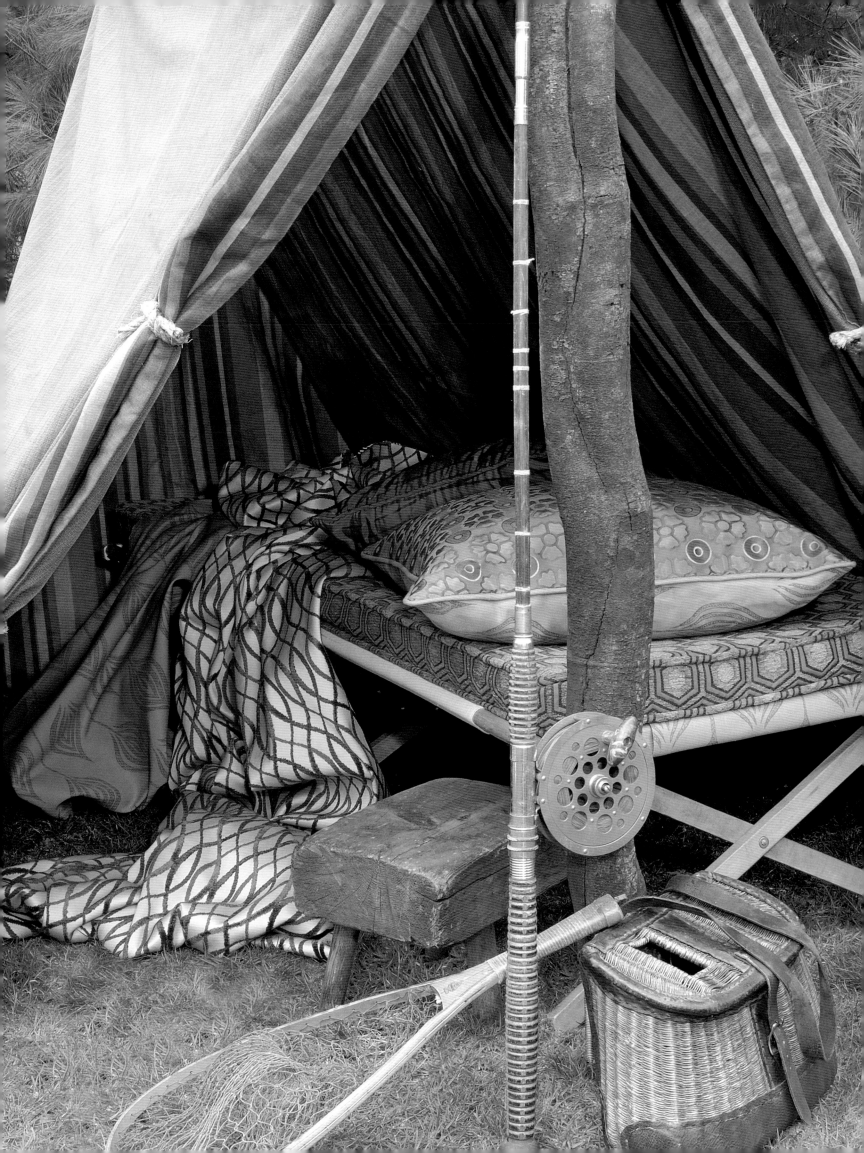

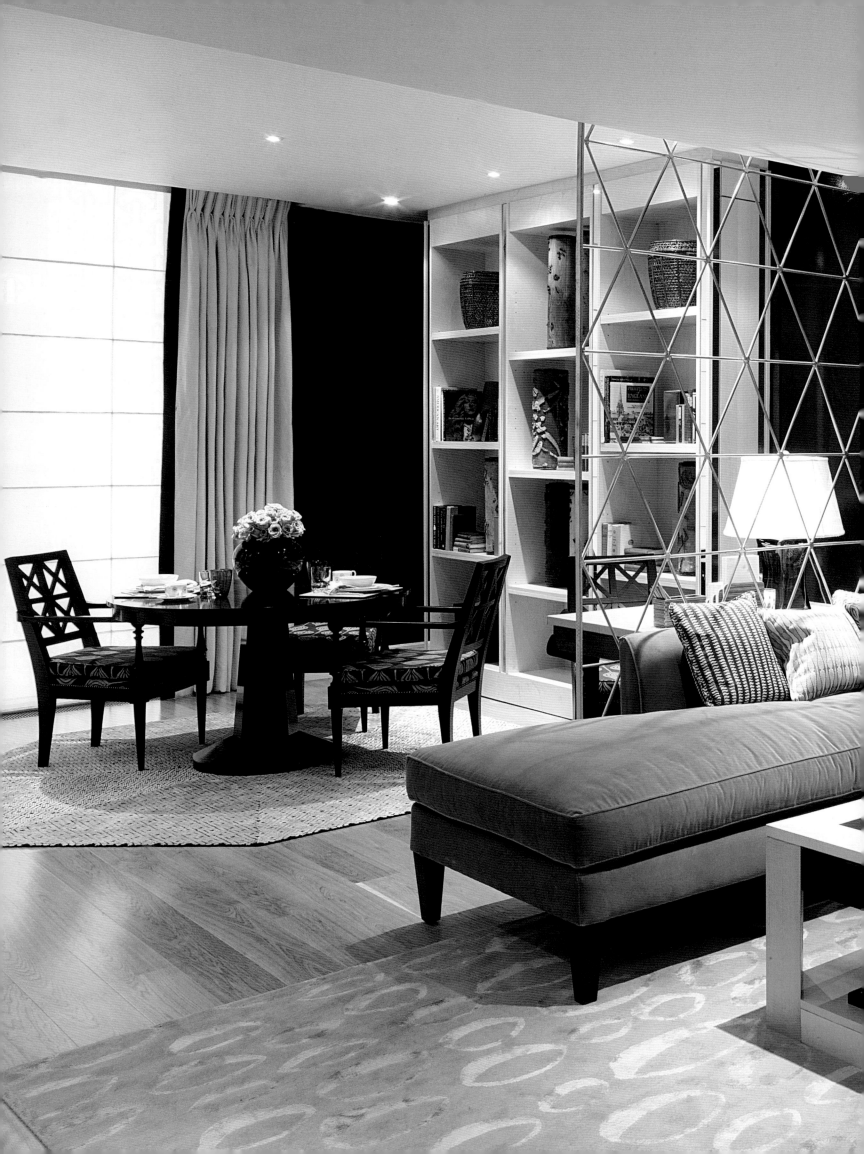

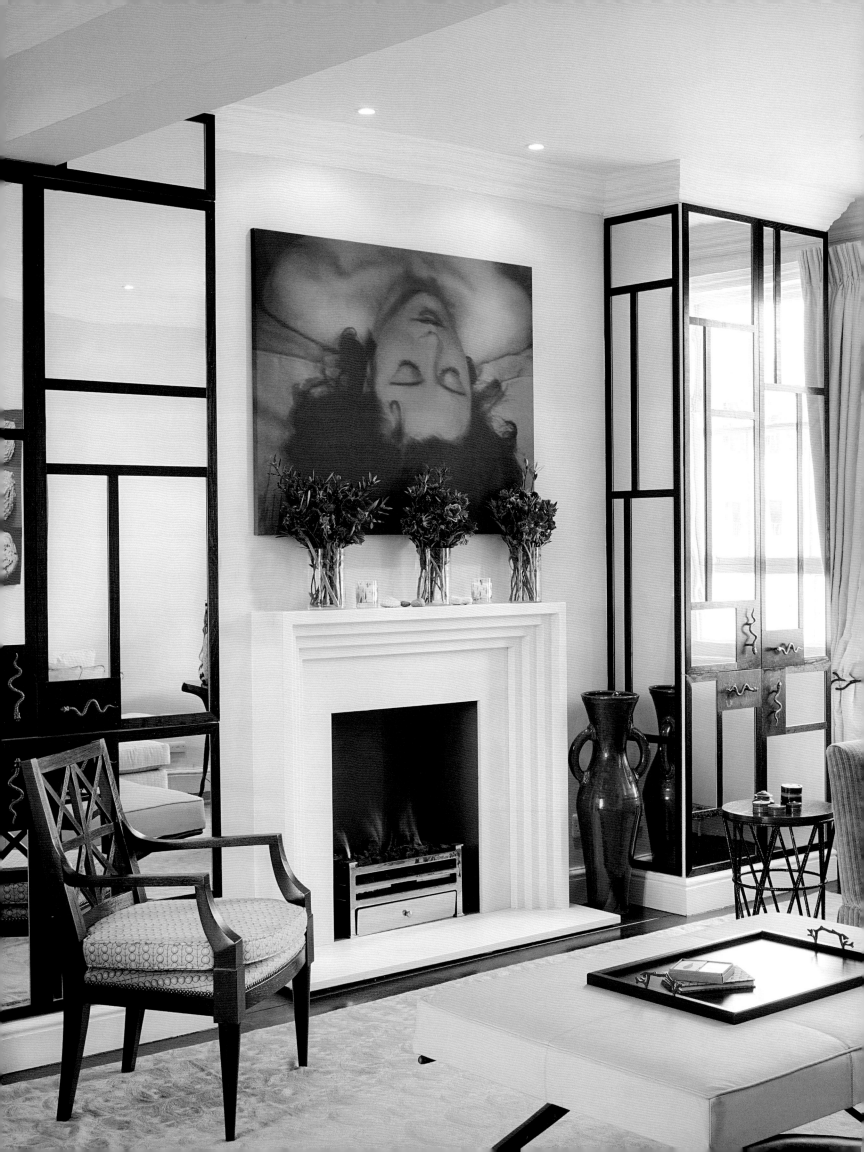

MY INSPIRATIONS AND PASSIONS

What's your favorite . . .

Allegra Hicks

Chair *Ancient Greek Klismos*
Chef *Sushi chef at Shogun, London*
Color *Aqua*
Country *India*
Food *Sashimi*
Gadget *iPod filled by my husband*
Garden *Villa Lante*
Guilty pleasure *Sleeping in the afternoon*
Lamp *Bagatelle by Objet insolite*
Memory *Dawn in Varanasi, India*
Room in the house *Bedroom*
Wine *Dolcetto d'Alba*

Ashley Hicks

Accessory *Namiki Capless fountain pen*
Actor *Dirk Bogarde*
Airport *All are ghastly*
Bar *Harry's Bar, Venice*
Book *Memoires du Duc, by Saint-Simon*
Chair *Greek Klismos*
Chef *Allegra Hicks*
Chocolate *Gobino in Torino, Italy*
City *Rome*
Hobby *Book buying*
Hotel *Amanwella, Sri Lanka*
Luggage *Ugly & tough*
Memory *Dancing with my wife*
Movie *Vatel*

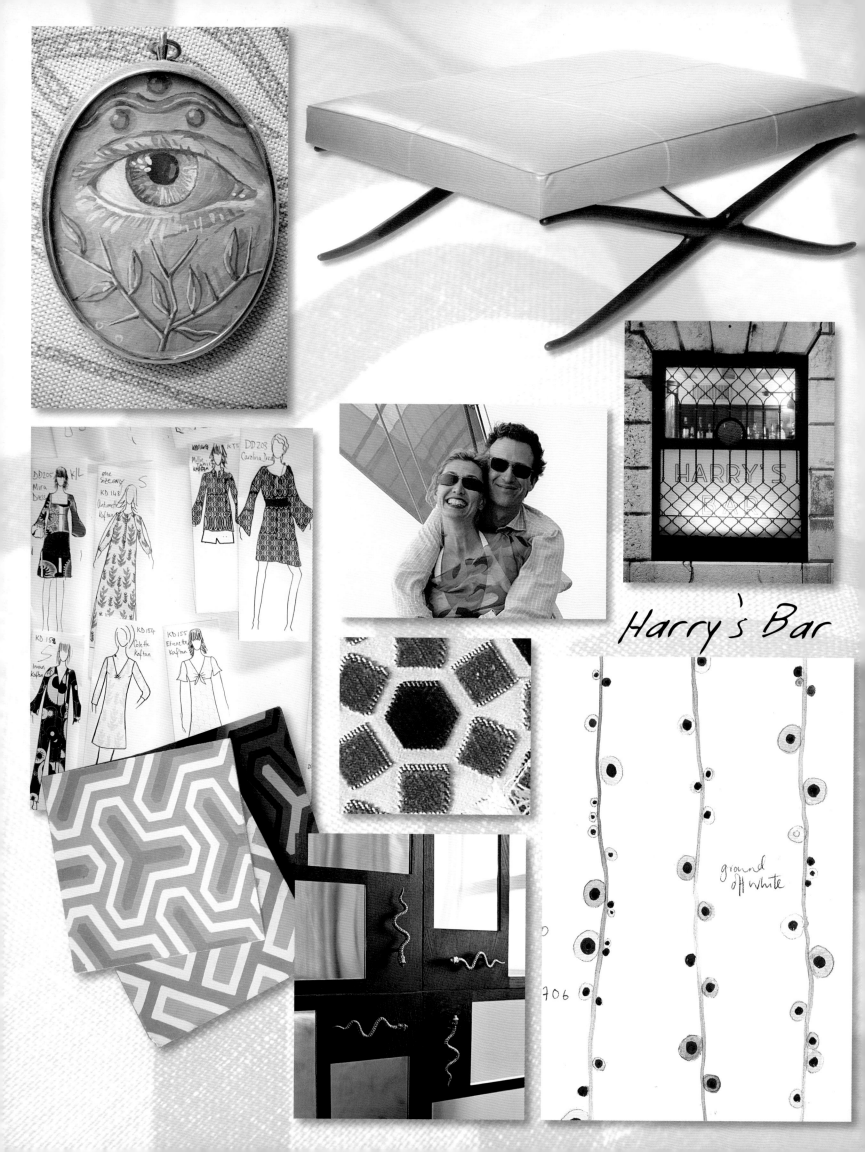

Harry's Bar

DD205
Mira
Dress
K/L

one size only
KD148
Antoinette
Kaftan
S

KD205
Carolina Dress

KD153
Iman
Kaftan
S

KD154
Colette
Kaftan

KD155
Etiennette
Kaftan

ground off white

706

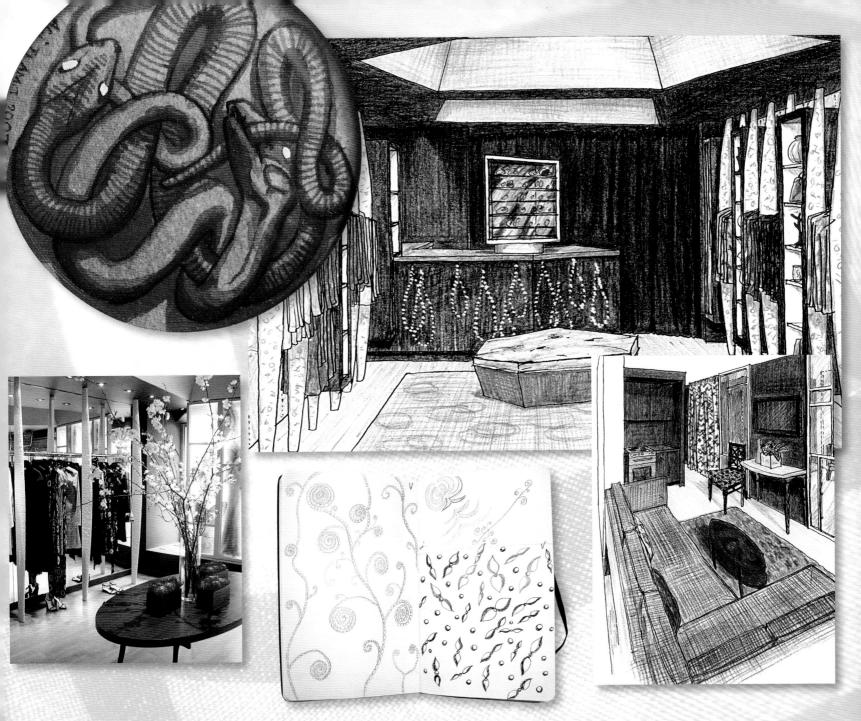

Trevi Fountain, Rome

AUTHENTIC DECOR
THE DOMESTIC INTERIOR
1620-1920
PETER THORNTON

LE SIÈGE EN FRANCE
PIERRE DEVINOY
PARIS
MACMILLAN

LUBELL TEXTILE COLLECTIONS OF THE WORLD
VOLUME 3 · FRANCE
VAN NOSTRAND REINHOLD

LES SECRETS DU LAQUE
Andrée Lorac-Gerbaud

SURREALISM desire unbound
EDITED BY JENNIFER MUNDY
TATE

The Wormsley Library

THE SEARCH FOR A STYLE
JOHN CORNFORTH
ANDRE DEUTSCH

David Hicks on decoration—5

David Hicks
on decoration

Memoires du Duc

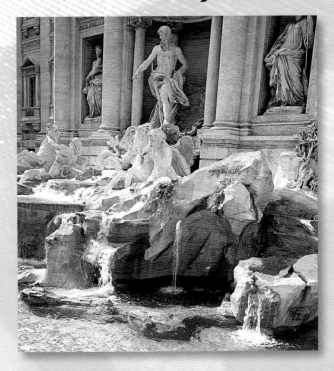

THOMAS O'BRIEN

Designers put together collections of ingredients for the home and for life. I'm very involved in the idea of home, and I tend to retreat to my own. What I do for my own house influences everything I do professionally, from the store to the design studio. I love designing things, and I love being a merchant—when I was little I liked to pretend that I owned a store. I'm always designing and taking things from my personal life into my business, pulling up in front of the store at night to drop things off from my house. Collecting fascinates me, and I shop all the time. All sorts of things catch my eye and spark my interest—suggesting color palettes, or details, or just the germs of ideas. I have always been a shopper; it's a running joke between my mother and me. When I was four, I had a tweed coat and hat that I called my "shopping" coat.

People collect things for what they know about them. eBay is a perfect example. There's so much stuff for sale on eBay that doesn't have any real intrinsic value. Yet so much of it is special and gains value because of what somebody knows, or wants to know, about it. The truth is that people want to learn. Certainly, that's my goal, because if you don't learn something every day you become bored. I started going to auctions with my father and my grandmother when I was about ten. American modern from 1900 to the present interests me, especially the 1940s and '50s, and I also love American antiques from the 1830s and '40s. I collect textiles, prints, wovens, and apparel. Inspiration can come from anywhere and anything. I'm always looking for prints, and for things to translate into prints. It's interesting to look at everyday things from a different perspective, so I often transpose an idea from one medium into another—say, a leather tooling pattern into a fabric print, or a print into a leather tooling. A vintage T-shirt from my collection may spark a color idea. My abstract watercolors from the 1960s influence my fabric designs.

Functional objects, things that were designed for use, that have survived and been taken care of, draw me in. That may be why I collect so much dinnerware and silver and crystal. I respond to items first emotionally and then as a designer. I also tend to accumulate lots of contemporary printed material. Every so often I'll do a magazine marathon: sit down for three days with the stacks, tear out the pages that interest me, and file them away. It's a kind of recycling, both of ideas and paper. This process comes from my years at Cooper Union and from design education's longstanding tradition of the critique—which, at its best, is a conversation that serves as a method of testing, developing, refining, and editing ideas. People will always tell you more about what they don't like than about what they do like. So over a series of different meetings—critiques—you hone in on what's important, and reveal what works and what doesn't.

In the studio, we draw everything we design—from every angle. We do all our own pattern work. This helps us explore different directions—and edit. We file all those drawings, even if we don't use them, because an idea that didn't work on one project may be helpful in the future. In fact, for us, the process is the same whether we're designing products or interiors: you collect, you look, you sort. Then you edit, listen, question, and learn. Eventually, the solution appears. I never want what I design to overwhelm.

I'm drawn to the past, and I try to create things that have a quality of serenity, of peace, that are authentic. Whether it's an interior or a product, it should feel natural, easy, and calm—and look as if it had always been there.

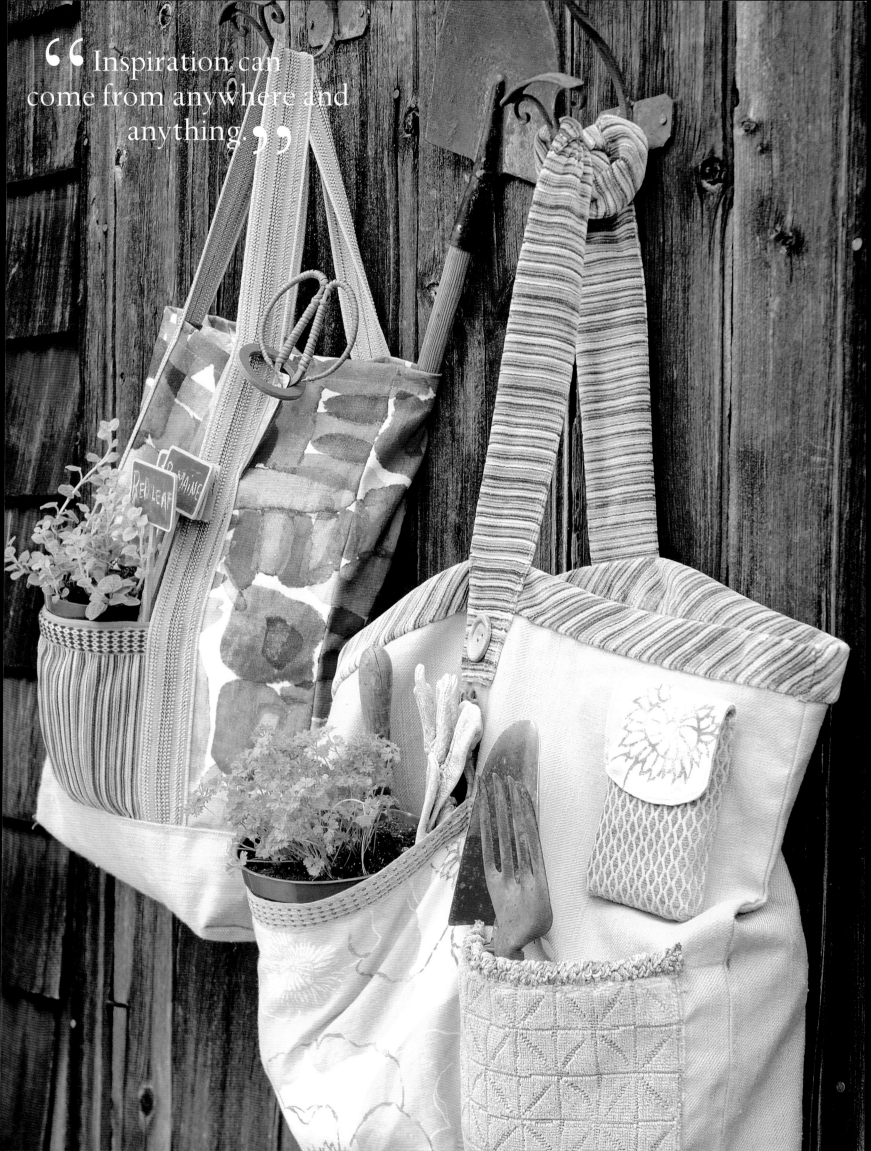

"Inspiration can come from anywhere and anything."

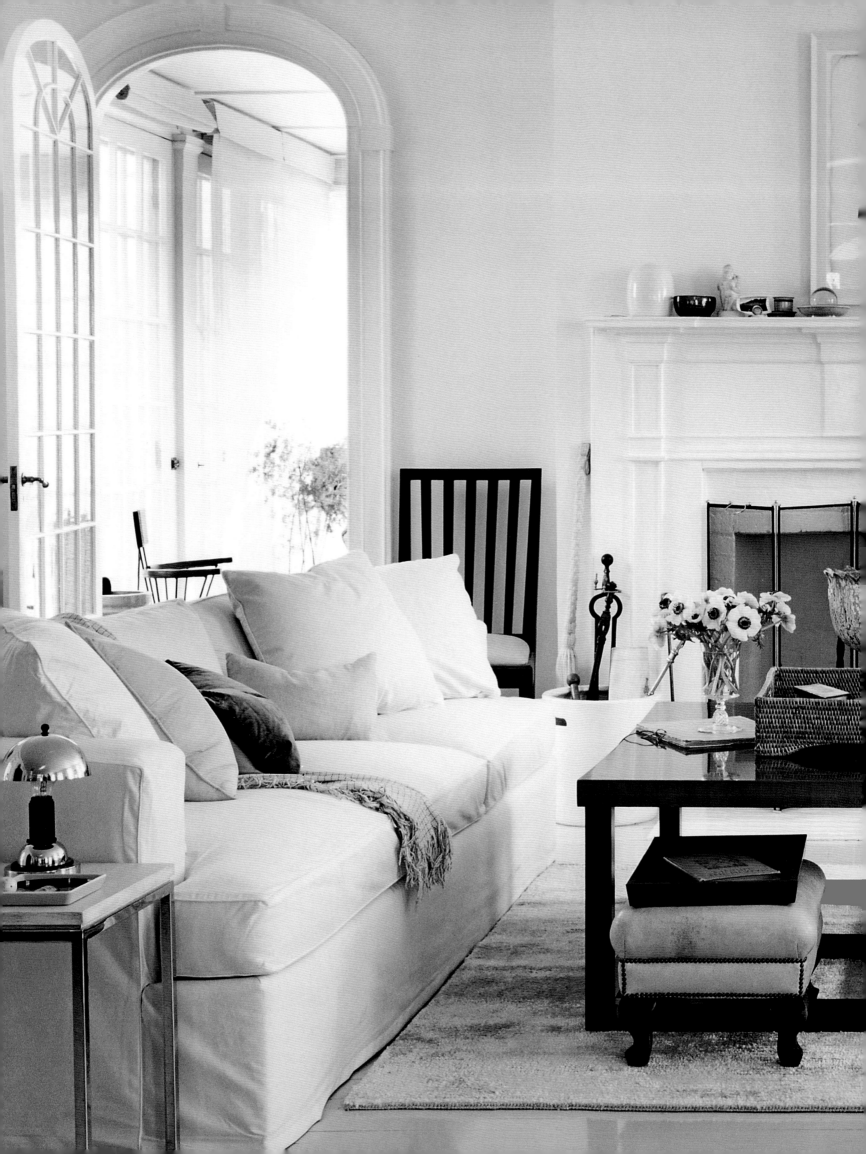

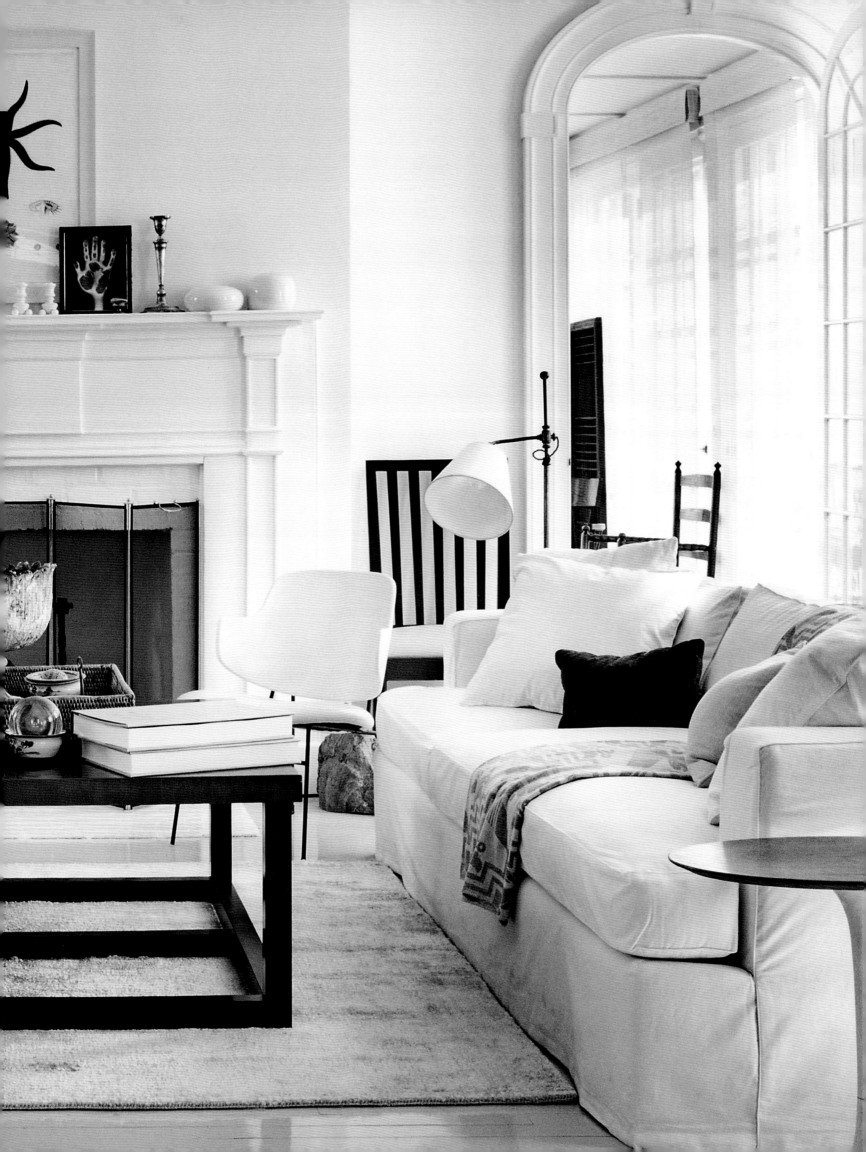

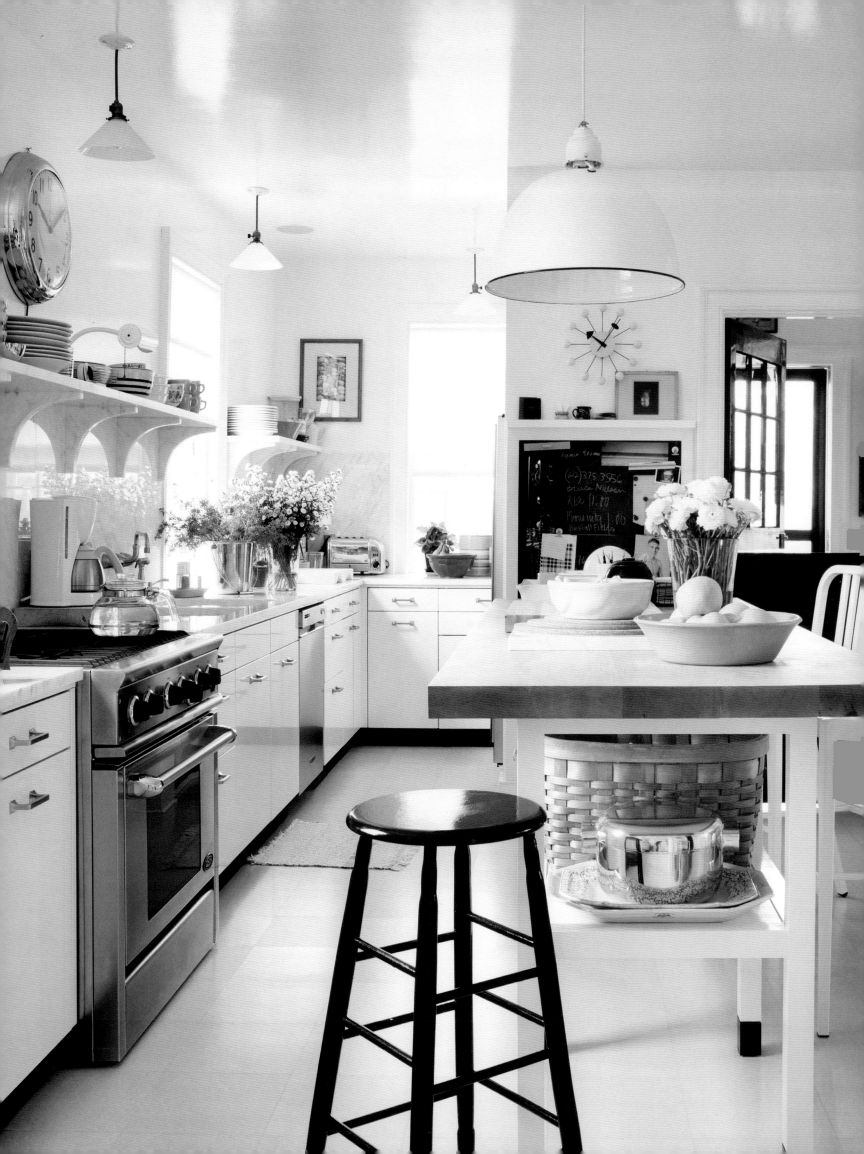

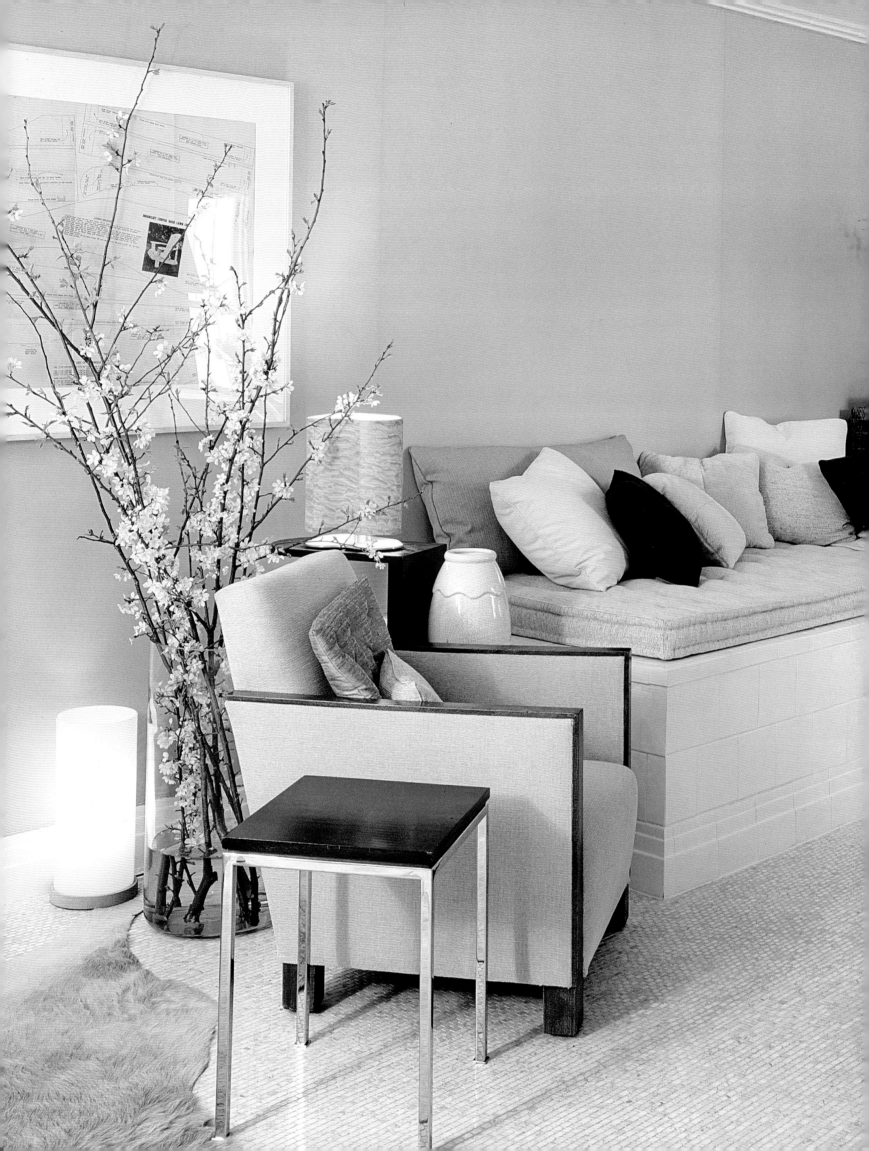

MY INSPIRATIONS AND PASSIONS

What's your favorite . . .

Artist *Brancusi*
Bottled water *Poland Spring sparkling lemon*
Car *Jaguar*
Chair *Emmett upholstered side chair*
City *New York City*
Color *Pale blue*
Flower *Wild strawberries*
Gadget *Mini scale ruler*
Garden *My garden in Bellport, Long Island*
Guilty pleasure *eBay*
Hobby *Antiquing*
Jewelry *Hammered silver ring by Joshua Dotson*
Luggage *T. Anthony Ltd.*
Memory *My grandmother's house*
Museum *Metropolitan Museum of Art, New York*
Newspaper *New York Times*
Perfume/cologne *Terre d'Hermès*
Pet *Maltese dogs and cairn terriers*
Room in the house *Living or dining rooms with large tables*
Season *Spring*
Shoes *Wing tips*
Singer *Jimmy Scott*
Time of day *Dusk*

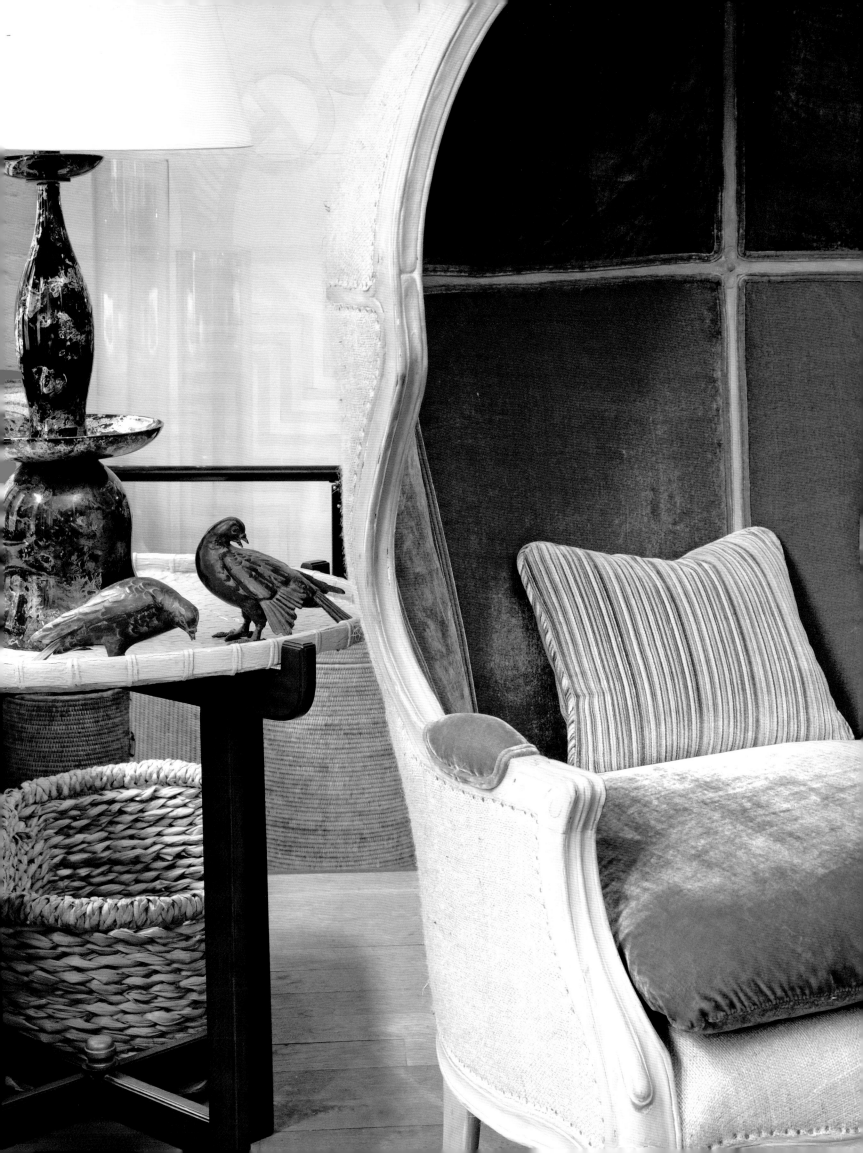

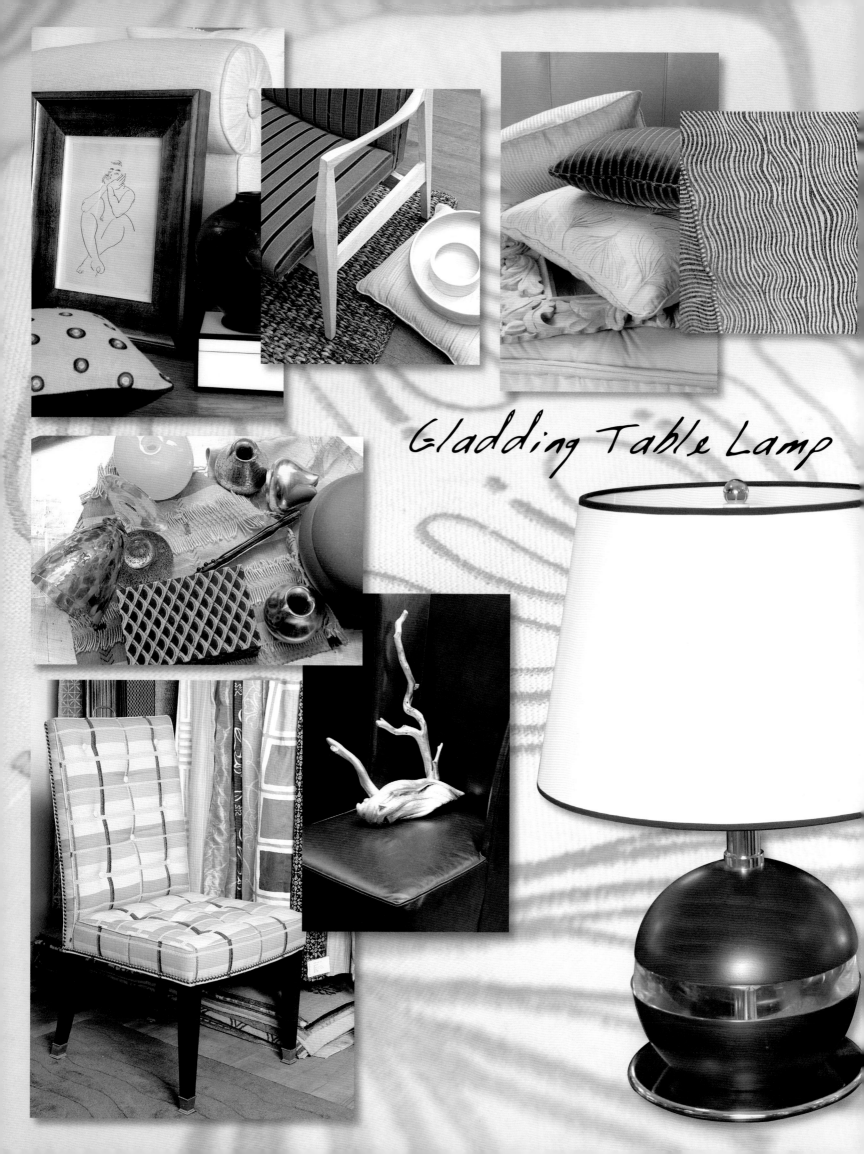

Gladding Table Lamp

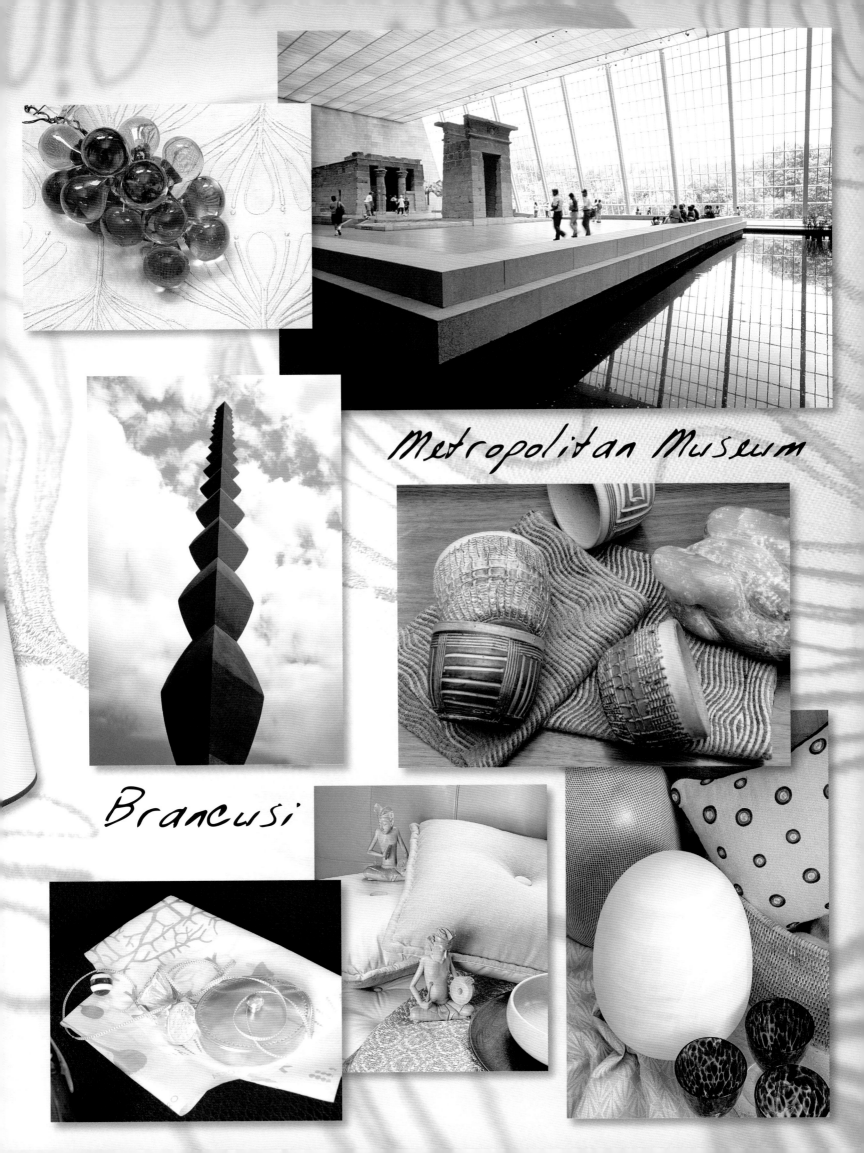

Metropolitan Museum

Brancusi

CANDICE OLSON

If I had to define my own design style in one word, it would probably be *eclectic*. Eclectic is certainly not eccentric—it is refined and made up of a careful balance of contrasts. I love the contrast of materials in a space, such as pairing a distressed leather chair with a polished chrome side table. Or the contrast of color and textures found with a sleek cream-colored sofa set upon a heavily patterned Persian carpet. And even the contrast of periods—like a Lucite interpretation of a Louis XVI chair—can really bring a room to life. My signature is to take serious design pieces and give them a sense of humor and personality by mixing them in an unconventional way. I like to take the best of classical design and stylize it with a modern twist. I'll use traditional design elements such as scrolled arms or a nailhead trim and put them onto a contemporary sofa. For my fabric designs, my starting point is always the form of the piece. Taking a sleek silhouette and covering it in a rich stylized pattern can bring a simple chair to life.

I love bringing in unexpected elements to a design—it gives a space a sense of play and light-heartedness. I'll interpret a traditional paisley or damask motif by supersizing it or using pearlescent inks—this gives it a cheeky element that one wouldn't expect to see in a traditional design. Dramatic lighting is one of my signatures, and I pay careful attention to it in all forms when I plan a space. The effects of light on fabric can be inspiring: Sheen, shimmer, and sparkle can all be achieved in an understated way through the application of innovative fabrics. I envision each room as a stage and light it accordingly, placing emphasis on the "character" pieces in the room and allowing the light to play in a way that will enhance the drama of the design unfolding within. Light raking down a painted wall or swimming across silk draperies can be a dramatic story unto itself.

My color preferences are clearly inspired by my Canadian roots. I love the natural look of watery blues and greens, the warm comfort of burnt grays and dark wood tones. I like to use authentic materials like natural stone or reclaimed wood and juxtapose them against something man-made, like hammered metal. A contemporary space can often feel austere—bringing in natural materials is an easy way to soften edges.

There is an integral relationship between the arts and the crafts of the design world. Without the talented craftspeople who bring my drawings to life, all my ideas would be for naught. My mantra is simple: I make my team look good by devising the best design possible, and they make me look good by executing the designs with utmost skill and dedication. I love to push them with new ideas, and they love it when they push me with new building ideas or suggestions to better execute the design. This symbiotic relationship continually keeps me inspired and challenged. I'm a realist at heart, and my designs reflect that. People don't live in magazine-photo homes—they live in houses that have kids and pets, and sacrificing function for style is simply unrealistic. I'm constantly challenged to come up with interior designs that work for all types of families—and still look fantastic. The clever use of washable fabrics, double-duty furniture, and hidden storage furthers the function of a family home, and I have a blast coming up with new ways to make it look spectacular. I always start with function first, then choose the form—after all, rooms are for living in, not looking at! As a wife, a mom of two kids under the age of three, an interior designer, and a TV host, I know about the realities of a busy life! I need my home to both function well for my family and offer a beautiful landing spot for me at the end of a long day.

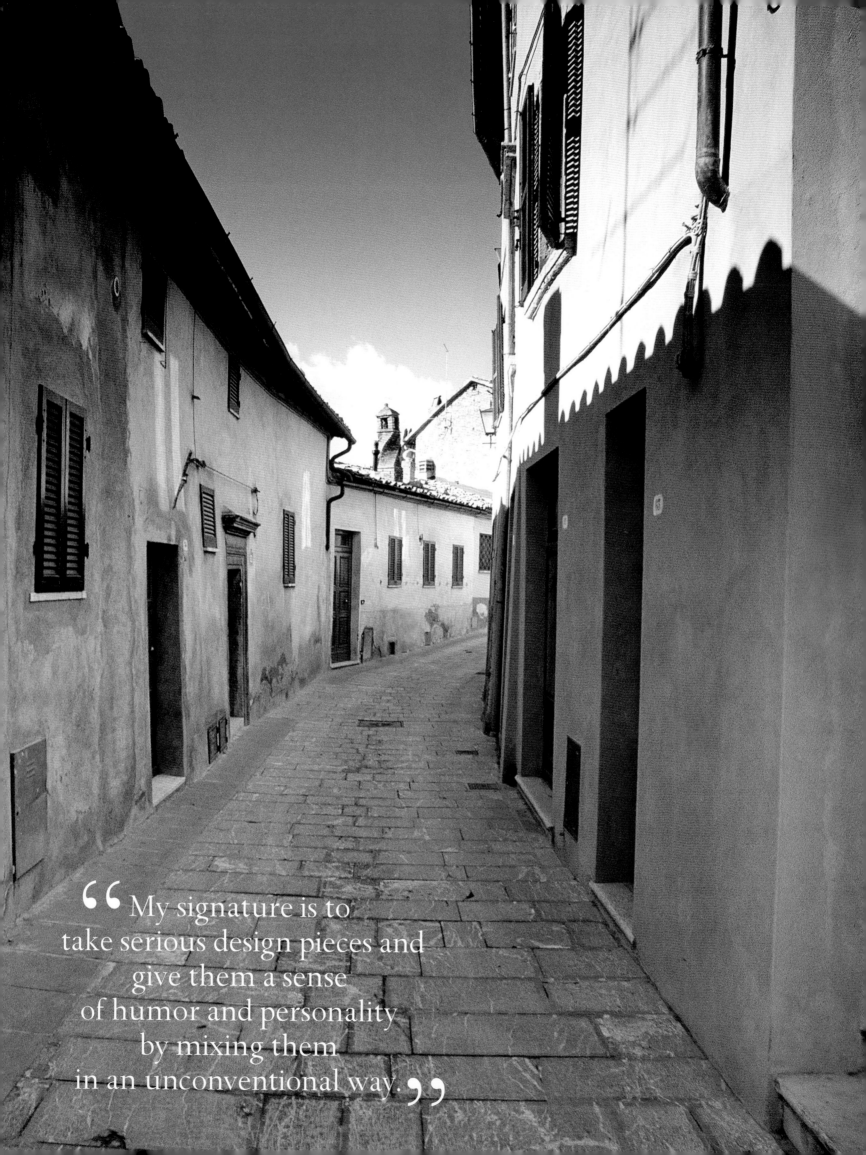

"My signature is to
take serious design pieces and
give them a sense
of humor and personality
by mixing them
in an unconventional way."

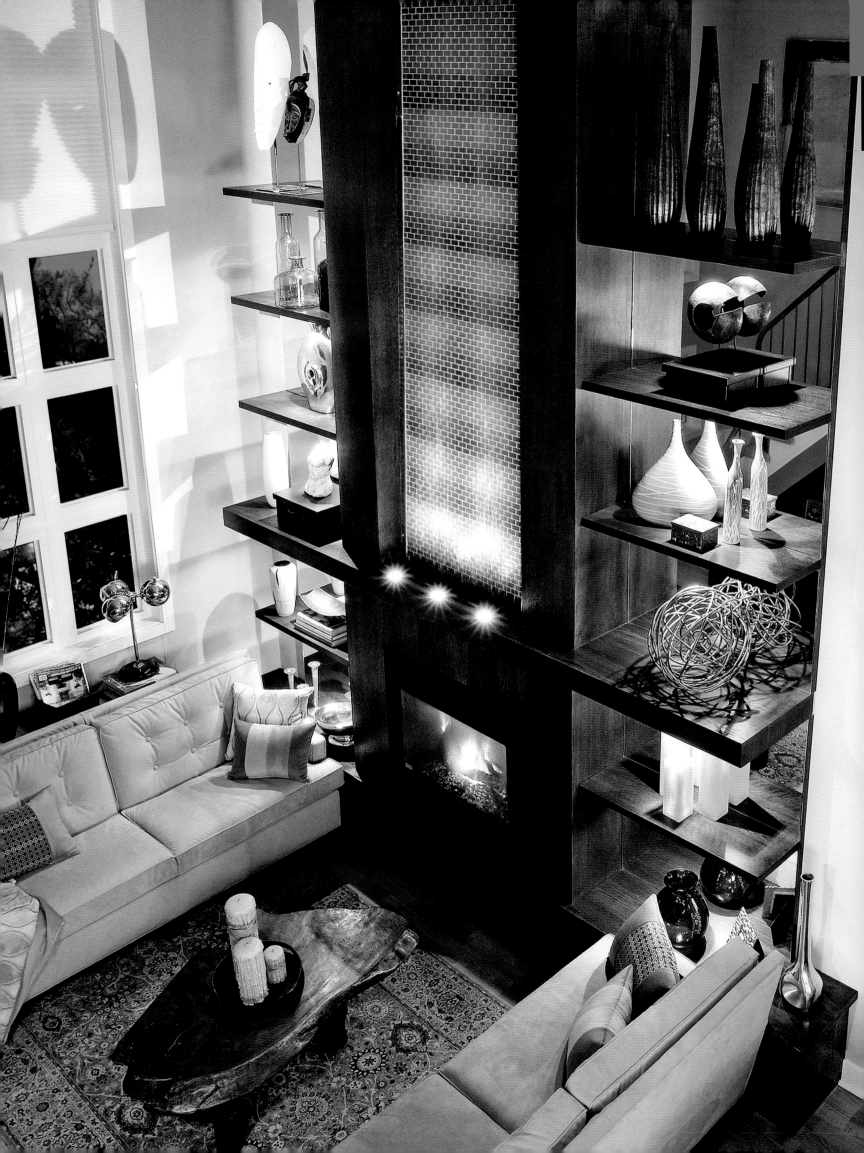

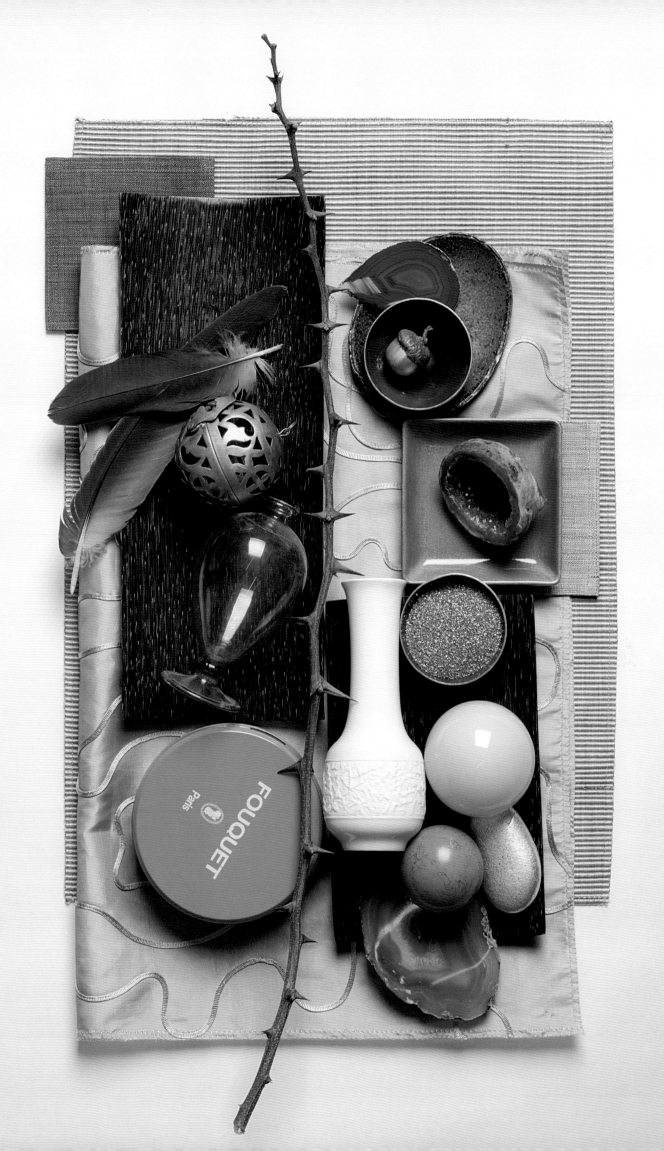

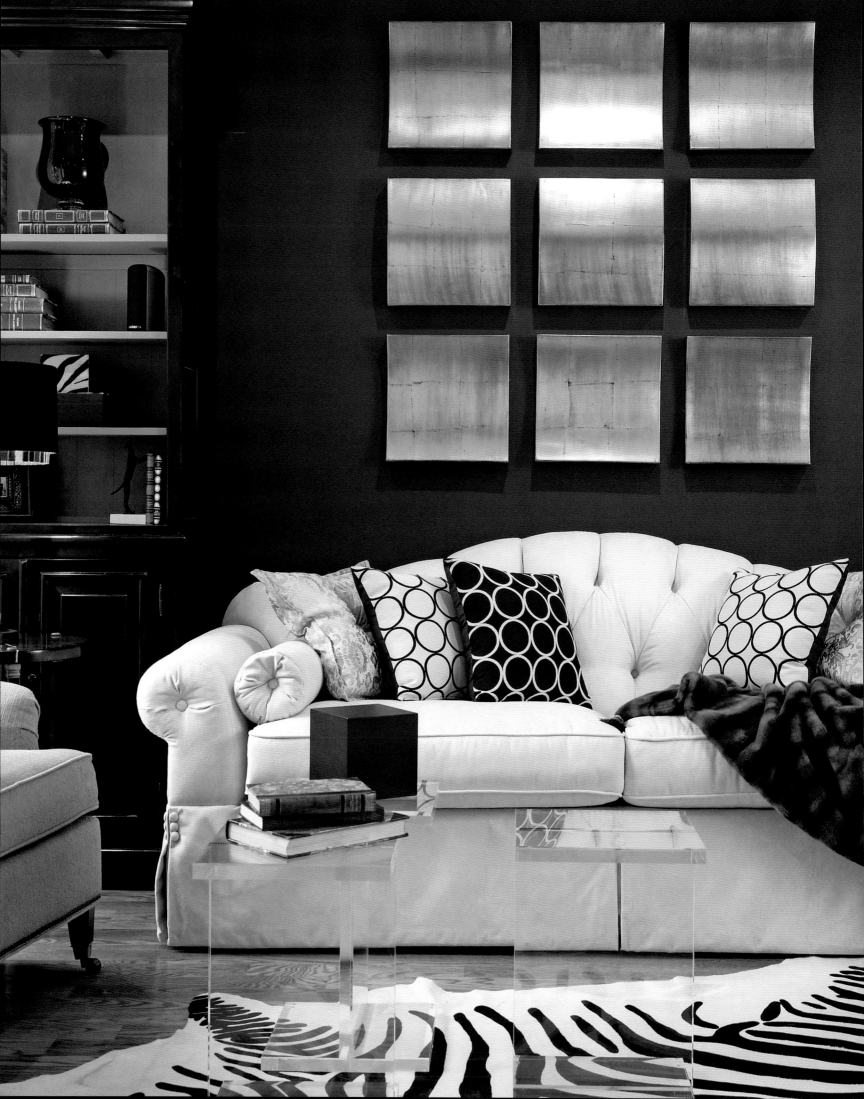

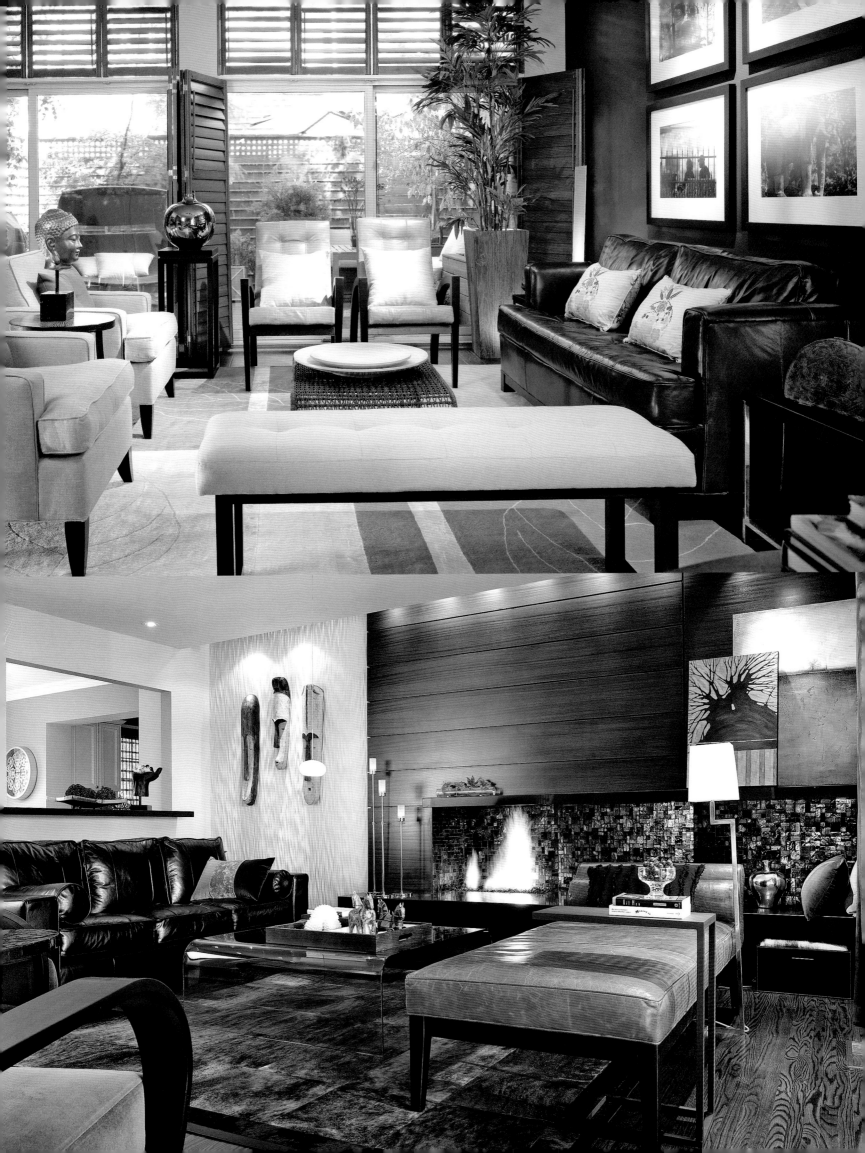

MY INSPIRATIONS AND PASSIONS

What's your favorite . . .

Artist *Ric Santon, a Canadian artist. Stylized, serene landscapes. I have a birch tree painting of his that I just love.*

Bar *The Aureole restaurant at the Mandalay Bay Resort & Casino, Las Vegas. Order a bottle of wine and an acrobat scales a four-story wine tower to deliver it to you.*

Car *1957 Mercedes Benz 300SC Coupe*

Chair *My Beckett Chair (for Norwalk), inspired by mid-century classics and named after my son*

Chocolate *Saxon—we just did this Belgian chocolatier's house and we all couldn't get enough.*

City *Florence*

Color *Benjamin Moore #2122-30 Cloudy Sky*

Food *Flammkuchen—we often visit my husband's hometown of Baden-Baden, Germany where they serve this Alsatian specialty, a thin crust pizza topped with crème fraîche, onion, and bacon.*

Hotel *Basico, Playa del Carmen, Yucatán Mexico—an ultra creative use of industrial and recycled materials were used to build this modern, high-style hotel.*

Lamp *My Zane lamp (for AF Lighting): clean, classic lines with the use of contemporary materials*

Movie *The Wizard of Oz*

Museum *The Guggenheim in Bilbao, Spain*

Restaurant *Perigee, Toronto. No menu . . . for each patron, the chef creates a personalized menu that absolutely wows!*

Singer *The late Jeff Buckley*

Spa *Friedrichsbad, Baden-Baden, Germany. Germany's most prestigious and historic thermal spa. A traditional Roman-Irish bath house whose healing effects have been enjoyed since Roman times.*

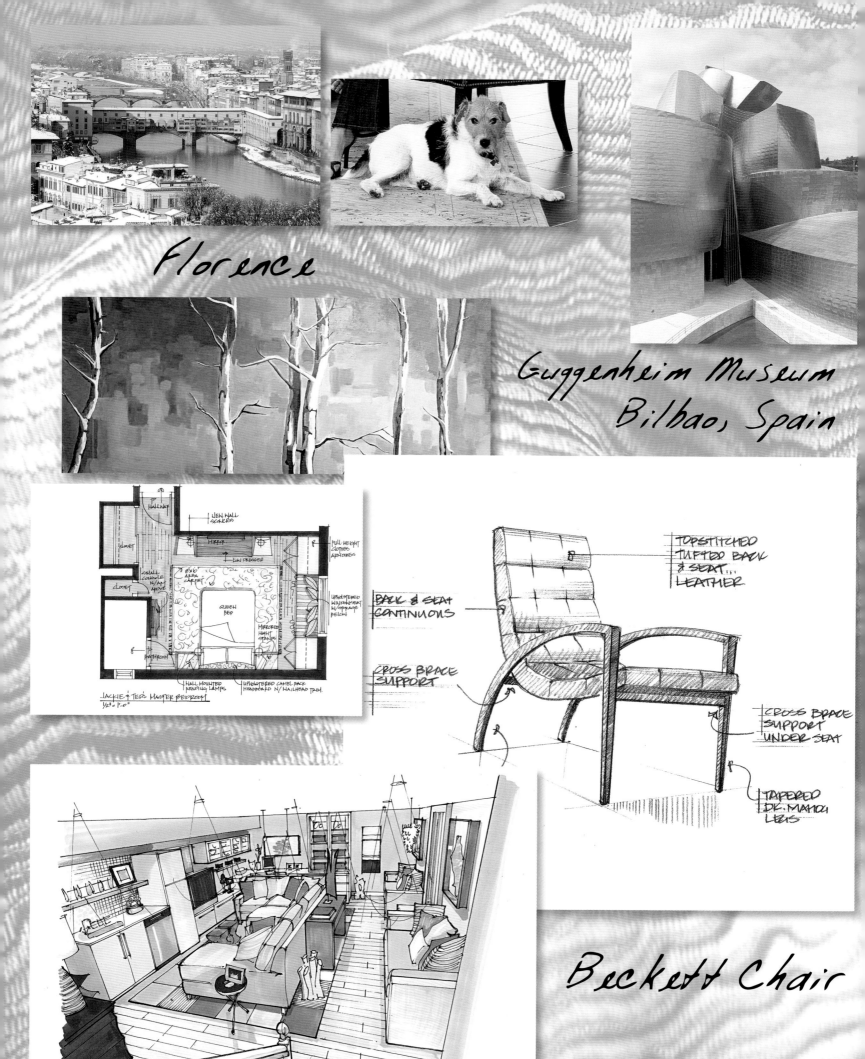

Florence

Guggenheim Museum
Bilbao, Spain

Beckett Chair

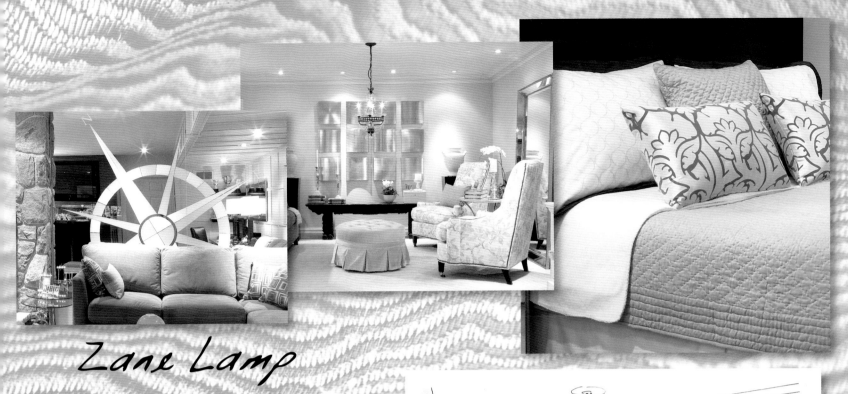

Zane Lamp

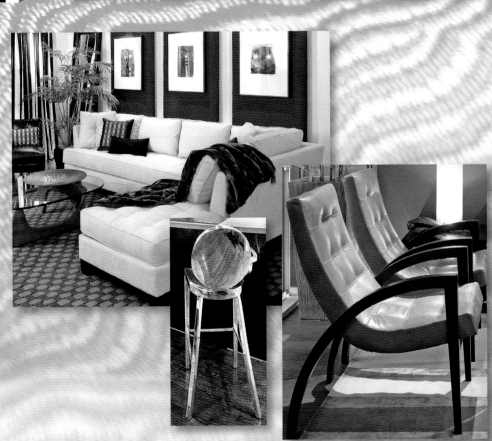

SUZANNE RHEINSTEIN

I'm fortunate to live in a beautiful house with a beautiful garden. It's not designed to look great all at once—things in it turn, just as they do in life. My garden is mostly an exercise in living architecture, and the view is not loud. It's very much about shapes, in shades of green and gray. We designed it for calm, and for wonderful surprise. Colors change, quietly. Right now there are some fantastic amaryllis blooming—very fine stripes of chartreuse and a reddy black.

I've been mad about gardens for a long time, and had so many different ideas about what I wanted. When I planned this one, I invited my friend Judy Horton, the garden designer, to work with me on it. To be able to trust your ideas to someone with great skills is a wonderful gift, as is the pleasure of working with that person. The garden is off-center and asymmetrical, but it feels logical. I love lots of common plants, and we've used many of them. Among the treasures are a gorgeous old single-petal rose—Rosa californica. The bloom is simple, and the petals, white. We've espaliered white camellias against a trellis. And there are also bulbs, native species and others, in pots: Right now there are Iris cressida, which looks like butterfly wings; black tulips; and splashes of yellow clivea.

I think gardens are about memories, and maybe that's why I've always cherished them. When I was a little girl in New Orleans, I helped in my mother's and my grandmother's gardens—for me, childhood is the scent of Osmanthus (sweet olive). My father had camellias, as I do here. The color palette of the garden influences me enormously. I've never met a green I didn't like: blue greens, yellow greens, gray greens, all their variations. From celery to aqua, greens are the foundation of my palette, along with so many neutrals, the taupes and the grays, plus coral and more. I tend to take a color or a print and surround it with a thousand shades of neutrals.

I'm fascinated by the play of light and by the shapes. The quality of light in Southern California is very special, the way it slants and dapples and dances. In a way, that's what my garden is about: shade and light and gradation, nuances, shapes, lots of species but little show. It's something to return to constantly, and to rediscover. In a garden, I believe in structure and bones. After that things can go whichever way they want, but there has to be a definite order. The same is true with interiors. I love to place things in a slightly quirky way, just a little bit off. I came to design through a love of architecture—and a love of literature. I majored in Victorian poetry in college, and I love nineteenth-century novels, novels that are narrative and character-filled, because I enjoy reading about people's lives.

We do a lot of trekking and a lot of traveling, and my eyes are always open. We just came back from Argentina, and the highlight of the trip was the view in Patagonia. Our room had a picture window that framed the most spectacular panoramic view of the front of the Perito Moreno Glacier all the way to the Upsala Glacier. I can still see the blues and grays, and the browns with purples—the glacier endlessly changing color with the light. I believe in hospitality as a way of living. I think it's important to have graciousness in life, so comfort comes first because comfort is luxury. I believe in having beautiful things around, and simple things, too. I wouldn't care to live in a house where everything is grand. Things should be chosen with care, no matter what they are. Ever since I was a little girl, I've always liked having fewer things but always better things.

"The color palette of the garden influences me enormously."

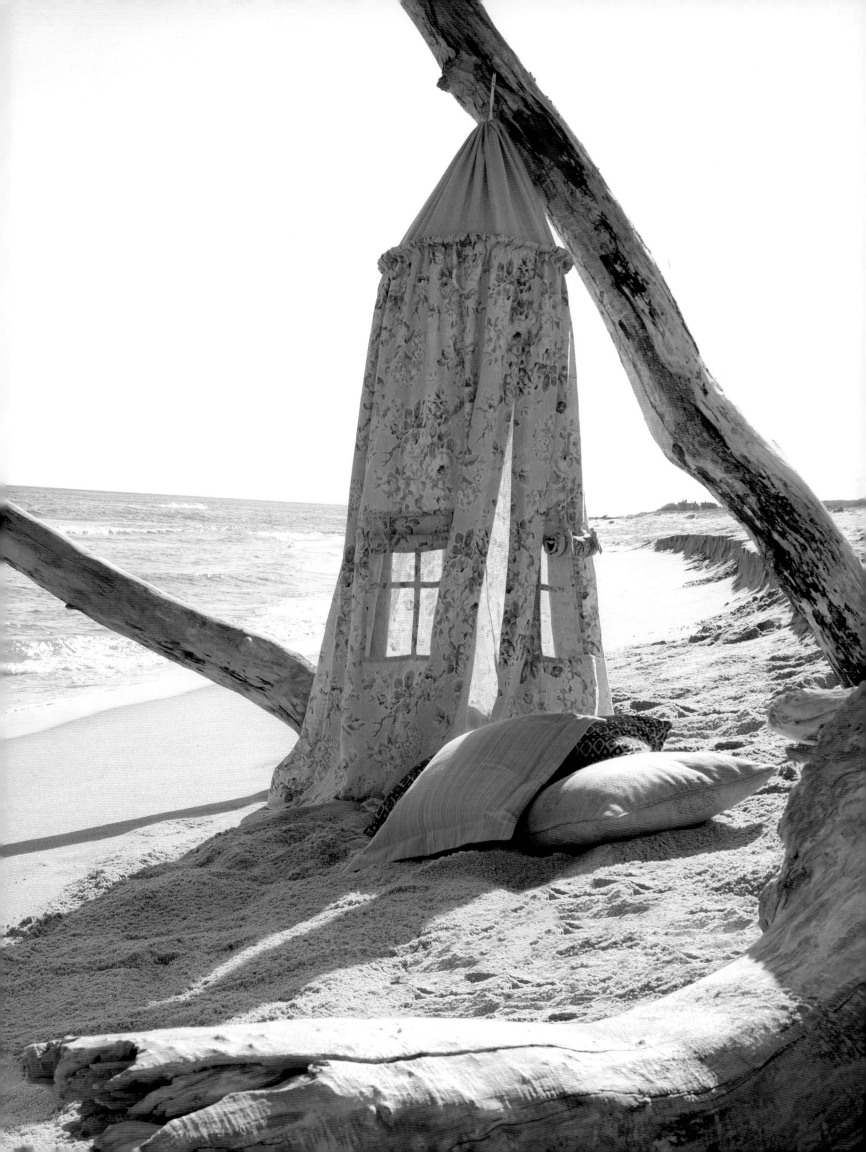

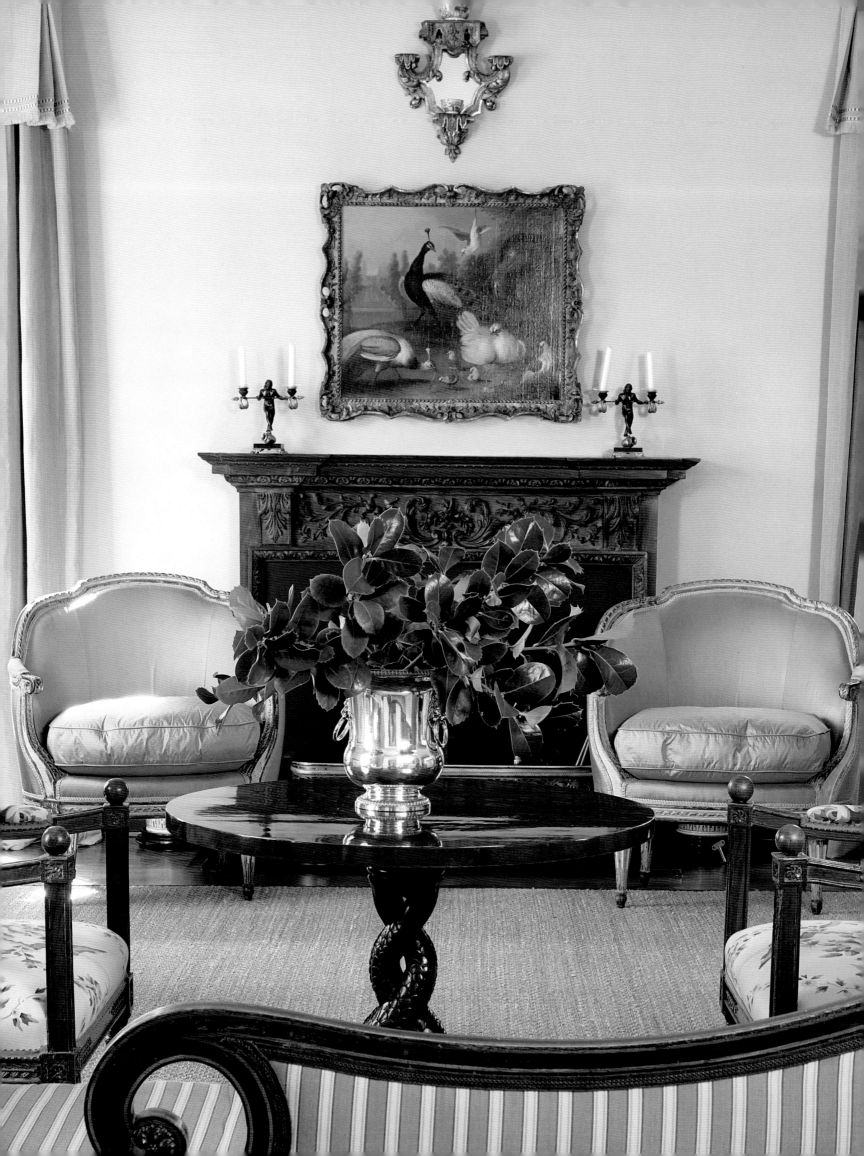

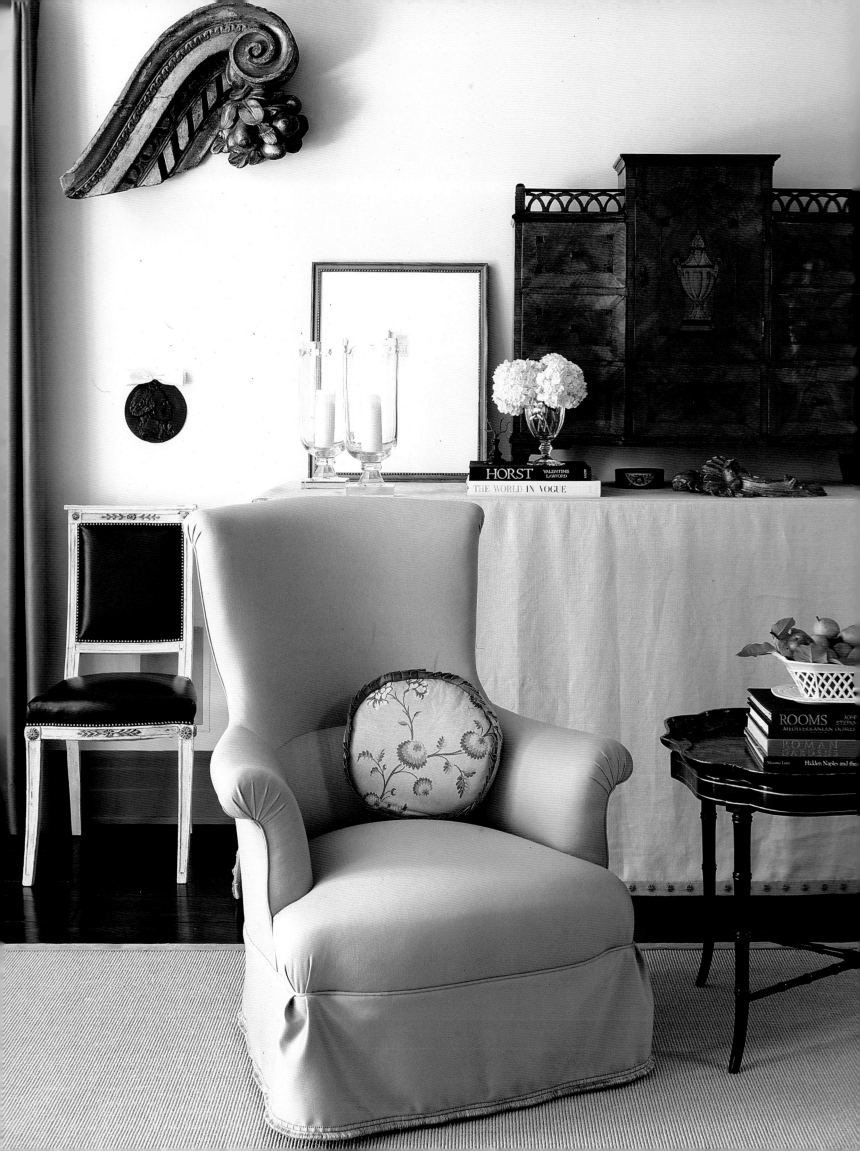

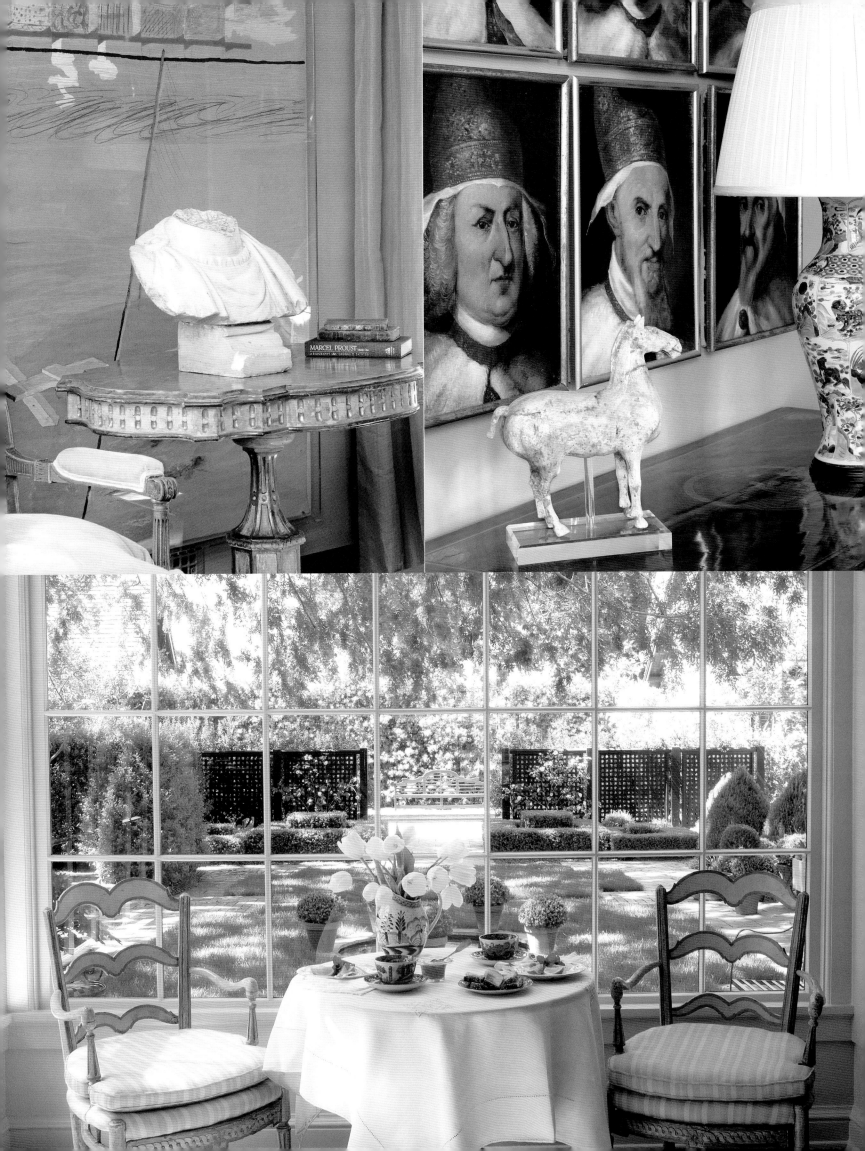

MY INSPIRATIONS AND PASSIONS

What's your favorite . . .

Accessory *Vintage crocodile handbags*

Activity *Walking, gardening, reading, traveling*

Artist *Twombly, Zurbarán, Vermeer*

Bar *The old Napoleon House in the French Quarter of New Orleans*

Book *I love classic nineteenth-century novels.*

Chef *John Besh of Restaurant August in New Orleans*

Chocolate *Bitter, flavored with hot peppers*

Flower *Old garden roses, especially blowsy buff-colored ones*

Garden *I have seen so many beautiful gardens—but for seeing everyday, ours.*

Hobby *I love to garden, to read about gardens and to dream about them.*

Hotel *Voyages Lizard Island by the Great Barrier Reef—the most deliciously simple and sophisticated place I know, surrounded by aquamarine water*

Ice cream *Strawberry sorbet, made in our kitchen*

Jewelry *Mish New York for the new—he is an artist! Kentshire for the old . . . a marvelous selection, from Georgian jewelry to the 1950s*

Memory *The Perito Moreno Glacier in Patagonia, just before daybreak and just after sunset . . . the colors and shapes are indelibly printed in my memory.*

Perfume/cologne *L'Eau by Diptyque and Lavender and Ginger by Jo Malone*

Restaurant *La Grenouille in New York—especially on a snowy February day when you enter and see the burst of color from the towers of flowers that Charles Masson has arranged everywhere*

Room in the house *Back porch*

Singer *Frank Sinatra, Renée Fleming, Muddy Waters*

Sport *Spectator sports!*

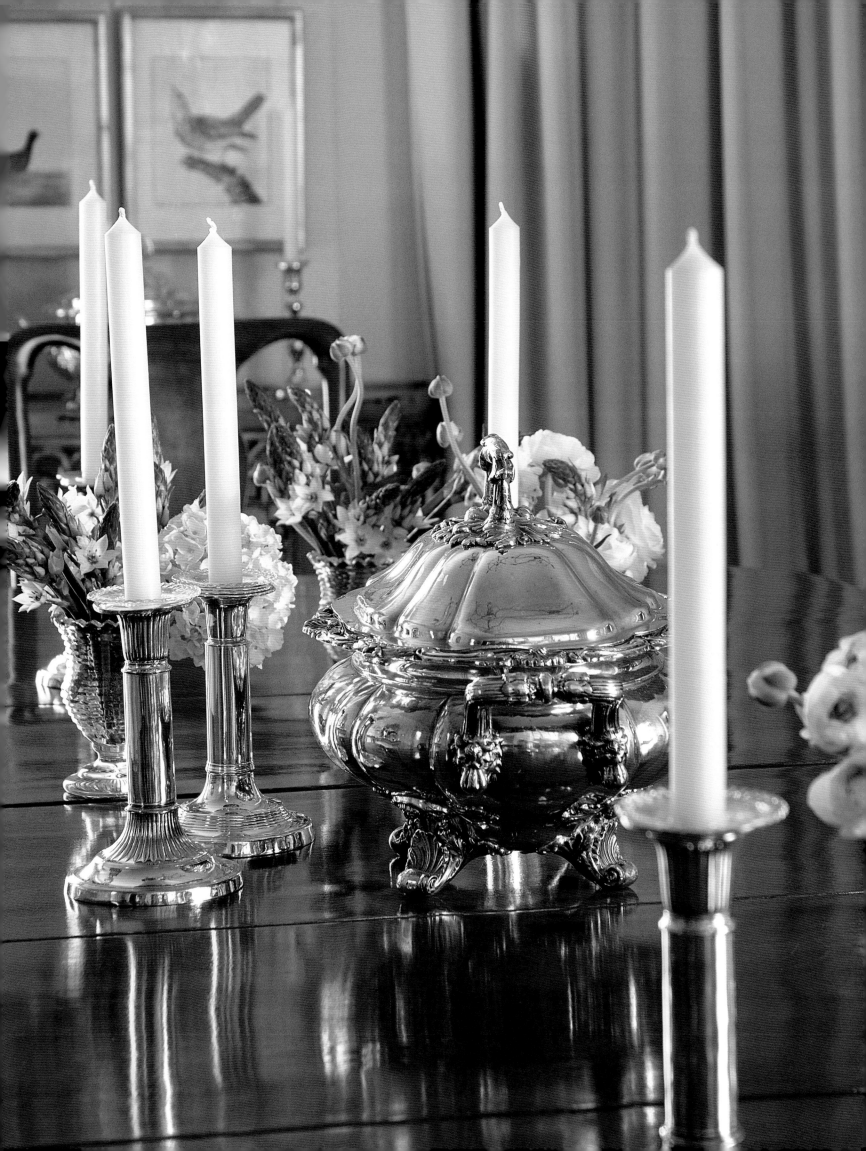

French Quarter,
New Orleans

Johannes
Vermeer

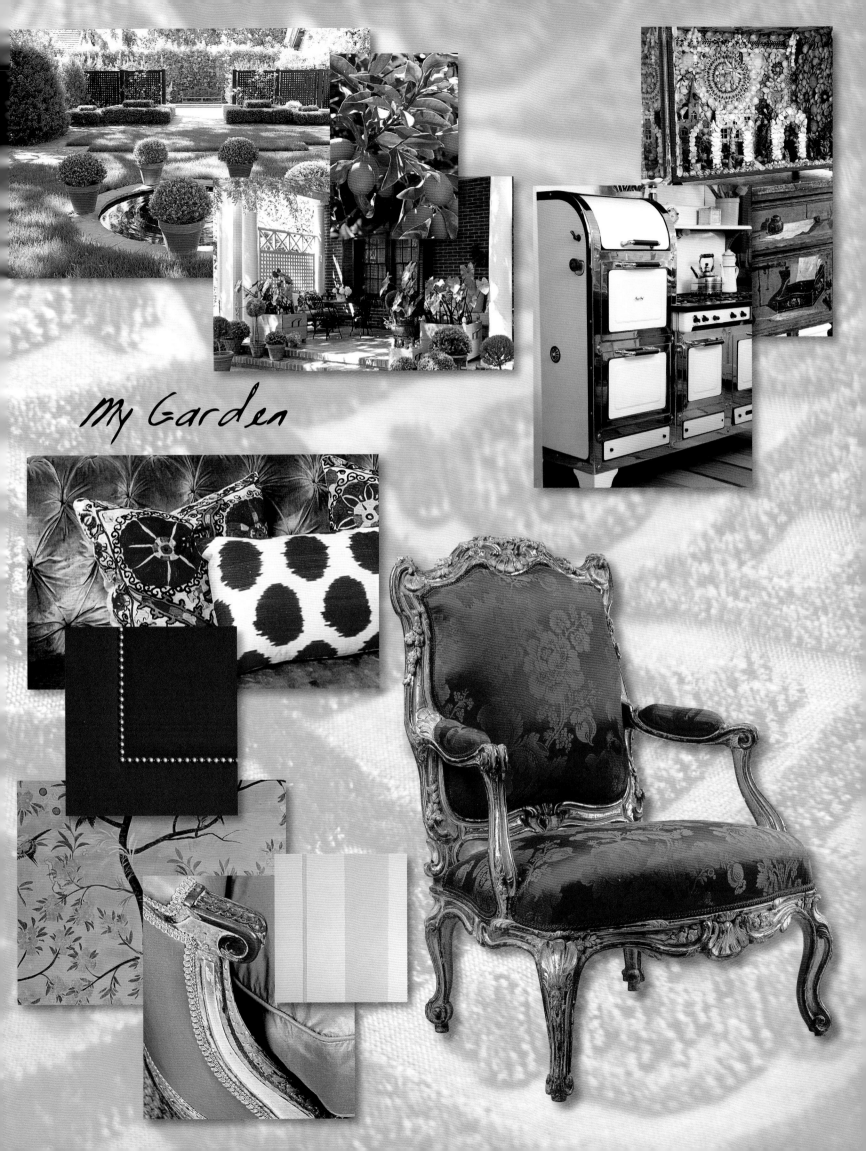

My Garden

WINDSOR SMITH

My taste is eclectic, and I'm attracted to many different things—but color comes first. I use lots of it, from strong, unusual combinations to noncolors, the shades you really can't define. I try to pick off-palettes, ones you wouldn't think would work but when you see the colors in combination, you see the palette is great. When you apply that aesthetic to a traditional space, it gives it a mystical quality. Perhaps that's why I relate to anything with an Indian or Moorish feeling, or with a blocked or printed pattern—and why I find Doris Duke's Shangri La inspiring.

Every home needs a history and a strong vision running through it. Collections instantly make a home feel like it's been there for a long time. It doesn't matter whether it's sterling silver boats or Chinese export porcelains, gondolas or gorgons, fish, pottery, whatever. You have to get people to try to pick up something so that there's some history in the house. Books are important for the same reason. I like a house that looks lived-in, not buttoned-down, a place where each piece has been consciously chosen and collected. I come from an antiques background, and I love the eclectic in interiors. I mix a lot of different things so that nothing's on the nose—Hollywood Regency, for example, with English and mid-century modern. I'm also endlessly curious about the elements of collections, shapes throughout art history, and color. I'll take pencil and ink drawings of the human form and line thirty or forty of them down a hallway. I love opulence, especially fabrics that are rich but comfortable—silk velvets, wools, linens. I use lots of leather and colored leathers. I would never do a room in silk velvet without linen, because I don't believe in putting any part of the house on restriction: Linen combined with silk pulls you in, it makes the space livable.

I live in Brentwood and in my kitchen I have a twelve-foot dining table. In fact, I built the kitchen around that table. It's extremely contemporary, with a white statuary marble top on a steel base. Around it are 1940s Regency chairs, lacquered white, with Kelly green seats—not very Brentwood.

I love things that are classic: color on white, things that are easy, graphic, tone-on-tone, seersucker walls, curtains, headboards. I cherish the blues: anything watery or silver blue or deep lapis, you'll find it somewhere in my spaces. I use cool colors, but I tend to stay away from primaries. That may be because I worked at a corndog stand in a food court in the mall when I was in high school. It was red, yellow, and blue, and I had to go to therapy to get over the experience. Actually, all the big franchises use primary colors—so I don't. I also love black, and I do lots of black with white wainscoting.

I'm strongly influenced by fashion and by what's in the media. I learn all sorts of things through vintage design books. I recently read a volume of Horst's interviews, which was all about color and proportion. I get a lot from the magazines: what's in the background, where the place is, what mirror and andirons are used. I love to custom-make furniture, and I tend to buy great old pieces and reproduce them because it's so hard to find the perfect chair or the absolutely right table. Antiques make a space pop, and important pieces give it a lift. Basically, I like to be an enthusiast of life. That's actually how I use the elements of design and decoration. For instance, when you mirror the walls or sections of the walls, you reflect life all around you. When you create a room, you create a lifestyle—and you fill it with life.

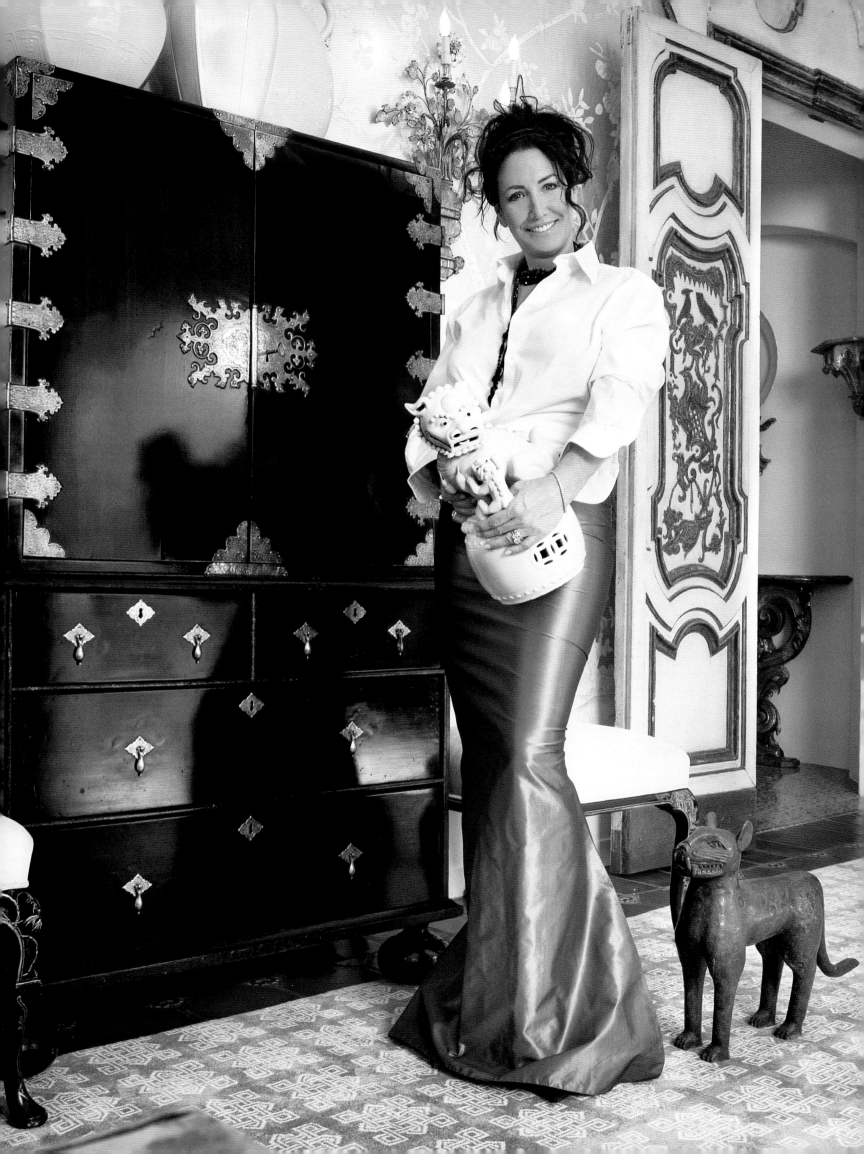

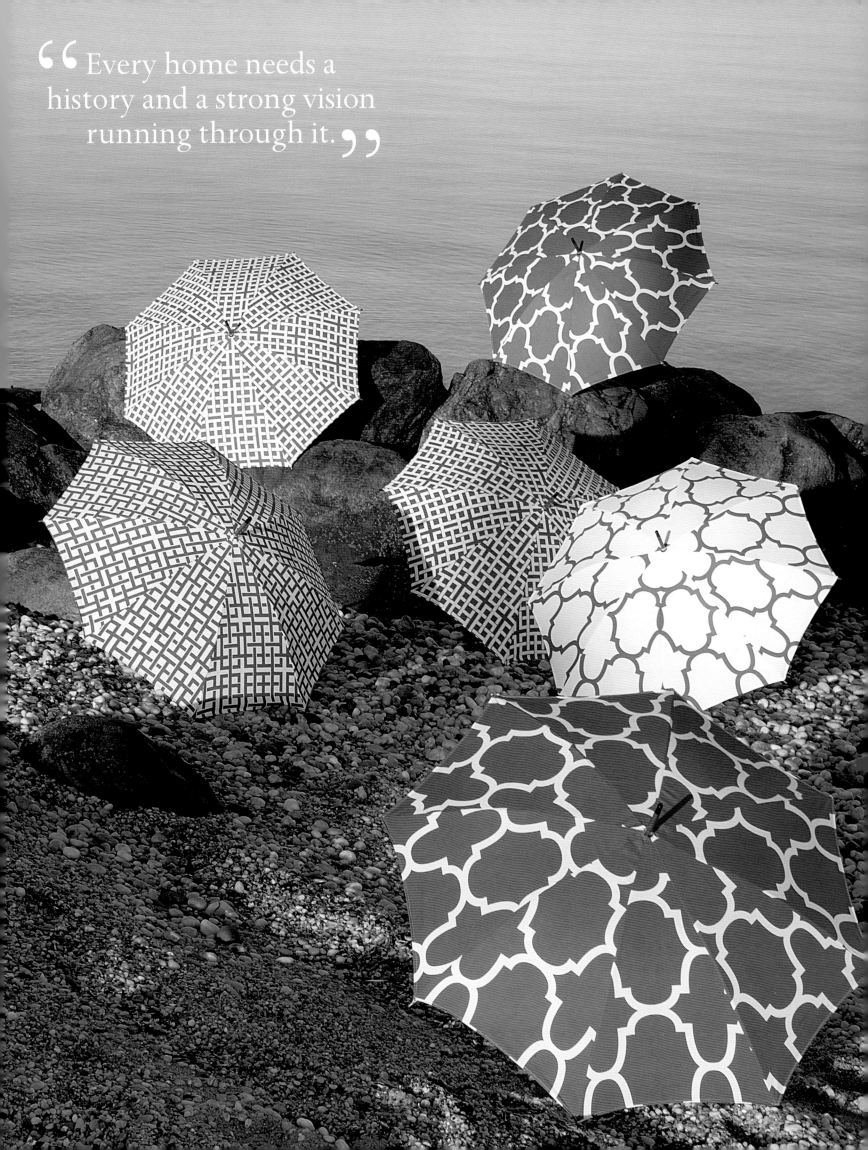

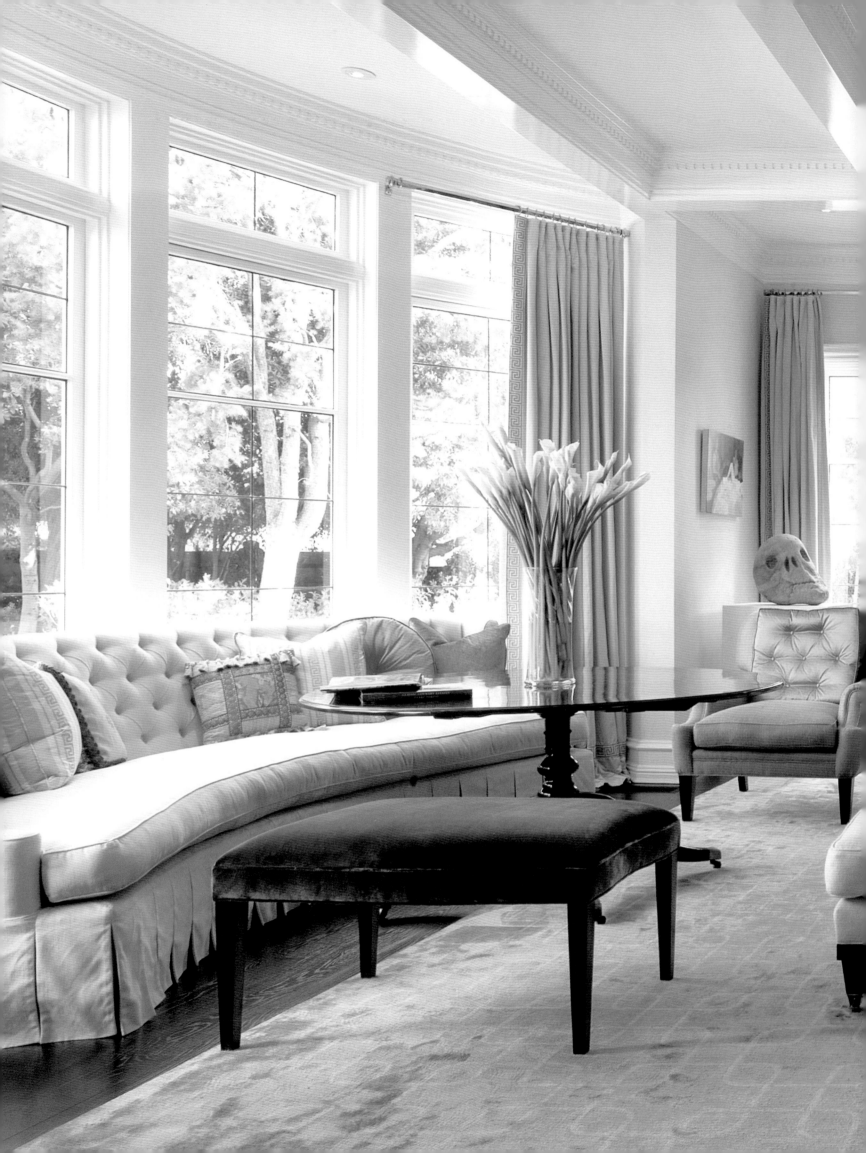

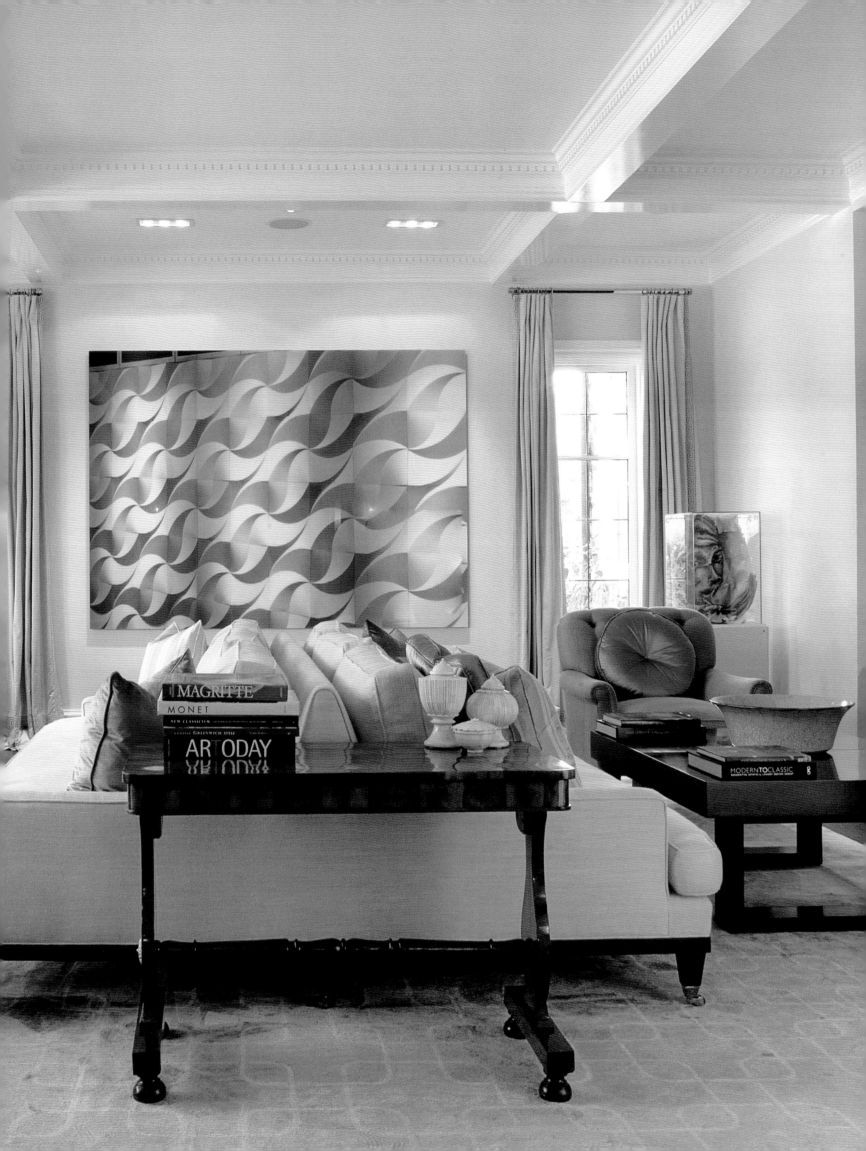

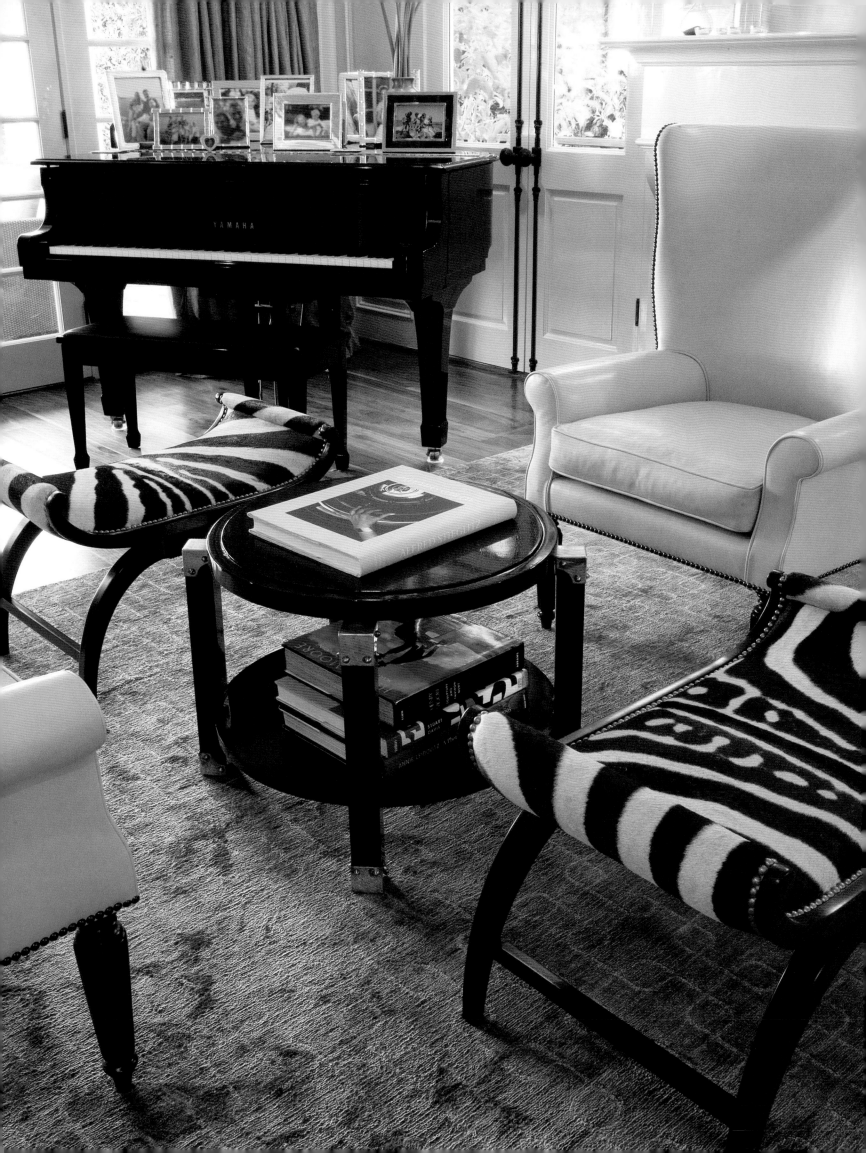

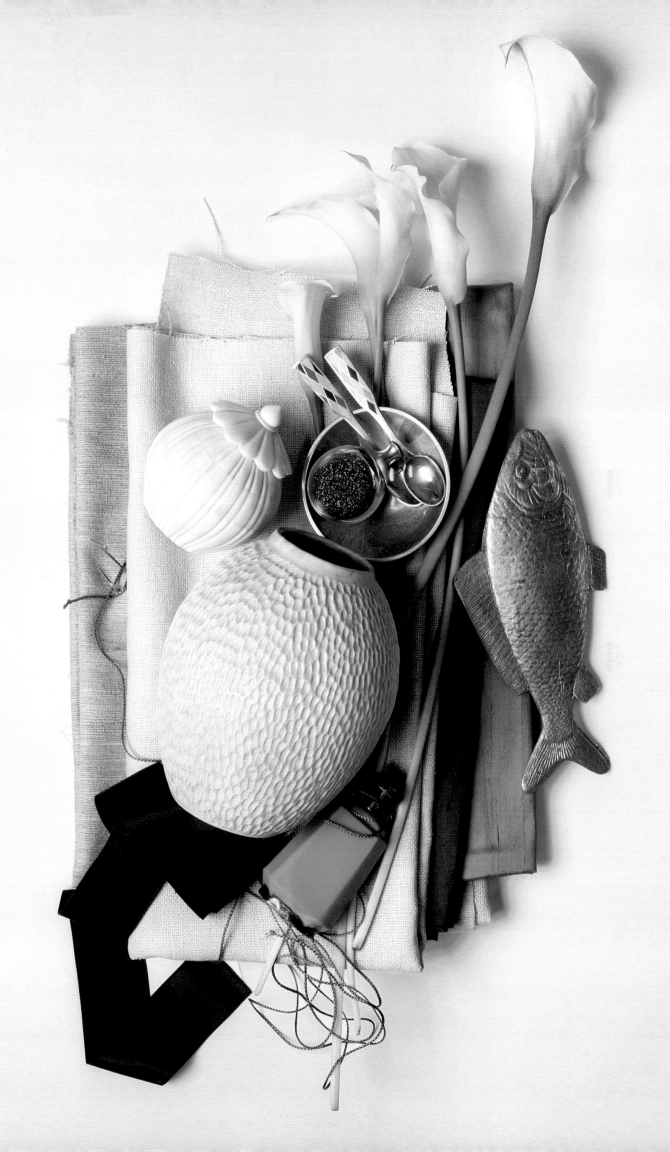

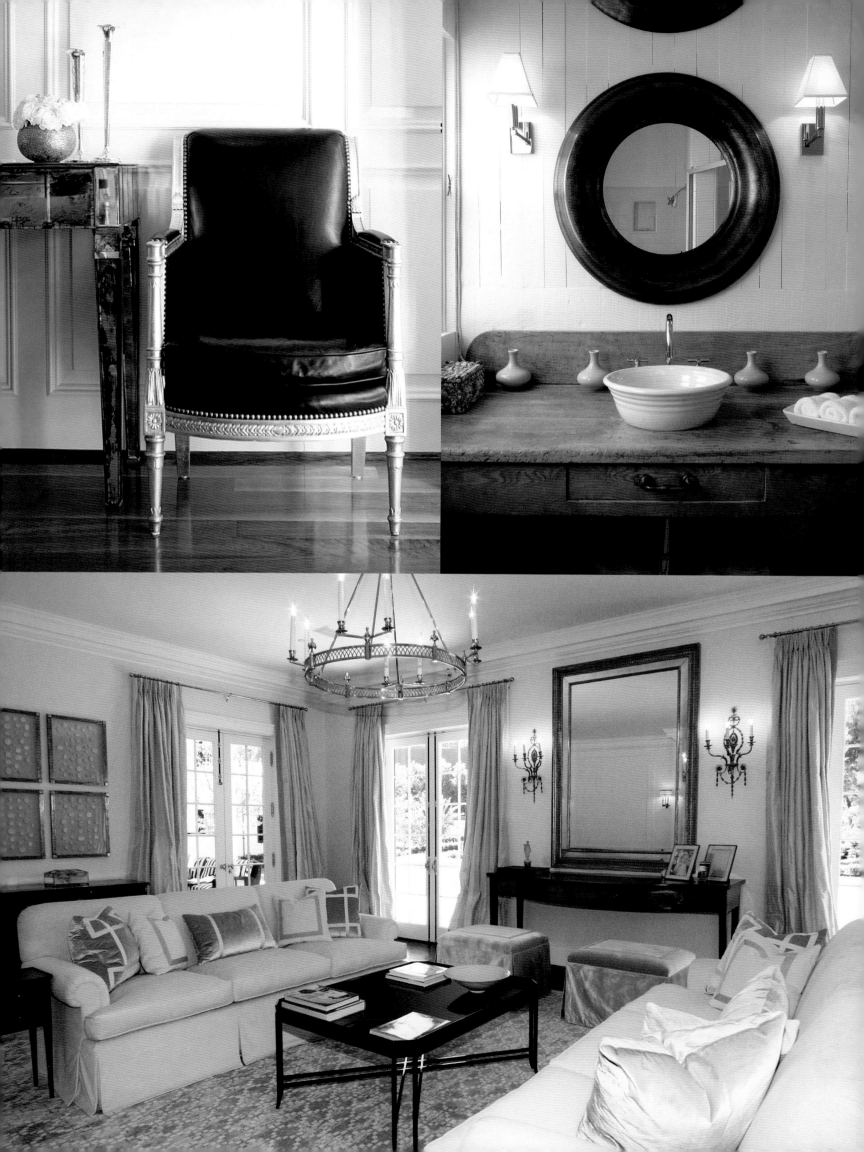

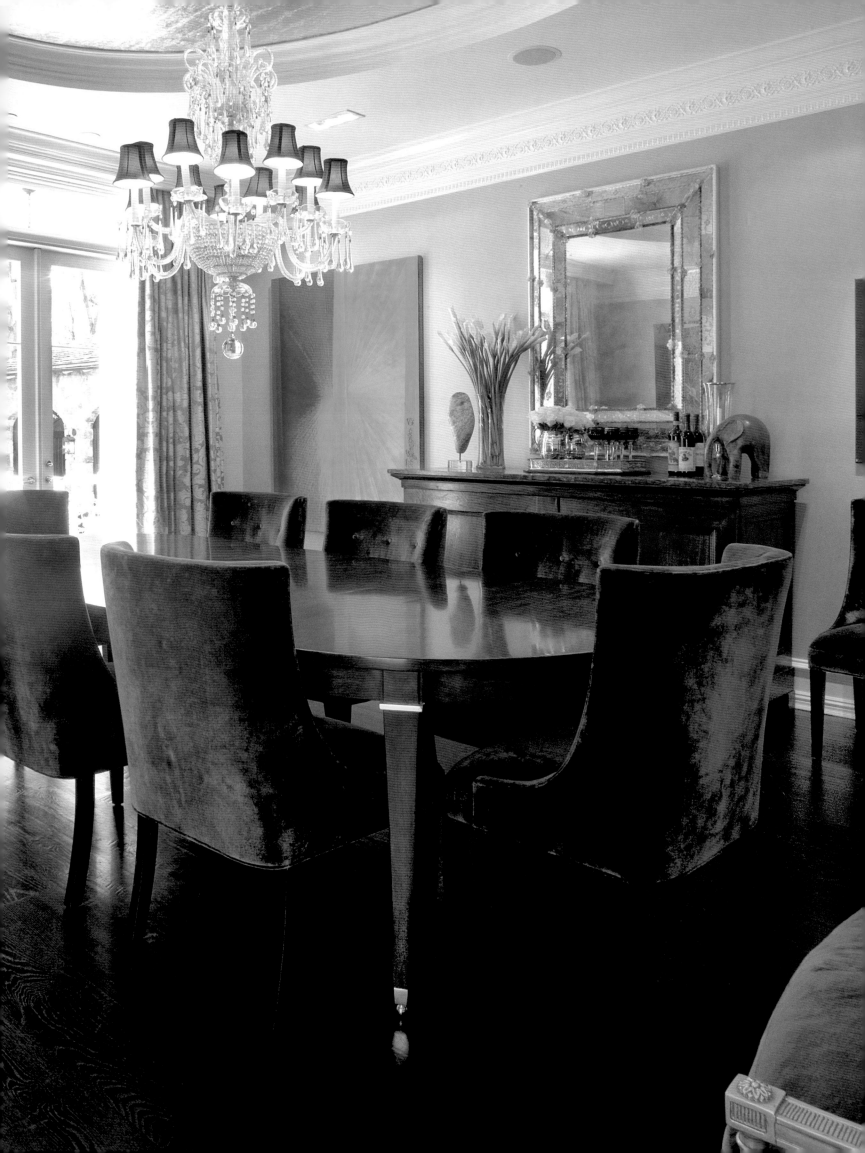

MY INSPIRATIONS AND PASSIONS

What's your favorite . . .

Actor *Richard Harris in Camelot*

Artist *Picasso, Horst, unknown artists of the mid-century, Rodin*

Bar *The bar at the Hotel Bel-Air, L.A.*

Book *Anne Lamott's Bird by Bird, Carrie Fisher's Postcards from the Edge, Tolstoy if I have to*

Chair *Our Medici chair. It's proportions are odd, and it is the perfect combination of great scale and history. It has an elegant heirloom feel to it.*

City *Monte Carlo*

Color *Any variation of blue, from deep indigo lacquer to palest silver. Oranges can come and go, but to blue I'm tried and true. It's mercurial and mystical.*

Fashion designer *Lanvin for a parent-teacher conference, Ralph for classic, Marc Jacobs for play, Marni for girly whimsy, Oscar de la Renta for texture, Gucci for handbags, and Richard Tyler for sexy, YSL for pure decadence—and by all means mix all of the above with jeans and ballet slippers for day. NEVER wear one designer from head to toe.*

Flower *Peony in any shade of pink*

Guilty pleasure *Trouble is, I don't really have much guilt.*

Hotel *Hotel du Cap in Antibes, France*

Lamp *Without a doubt, the sexiest lamps (I am partial to pairs) are the bronze hand-sculpted man and woman in the style of Giacometti by Therien Studio. With sleek oval shades.*

Memory *The moment my first child was born*

Movie *Shirley Valentine, Harold and Maude*

Singer *Michael Franks, Billie Holiday, MC Hammer, Enya, Gypsy Kings*

Sport *Snowboarding, bike riding, skeet shooting*

Time of day *Early morning for myself, dinnertime for family and friends*

Wine *I prefer Rose champagne, Veuve Clicquot Rosé with raspberries. I always have a dozen bottles in their pink boxes on my kitchen counter for emergencies.*

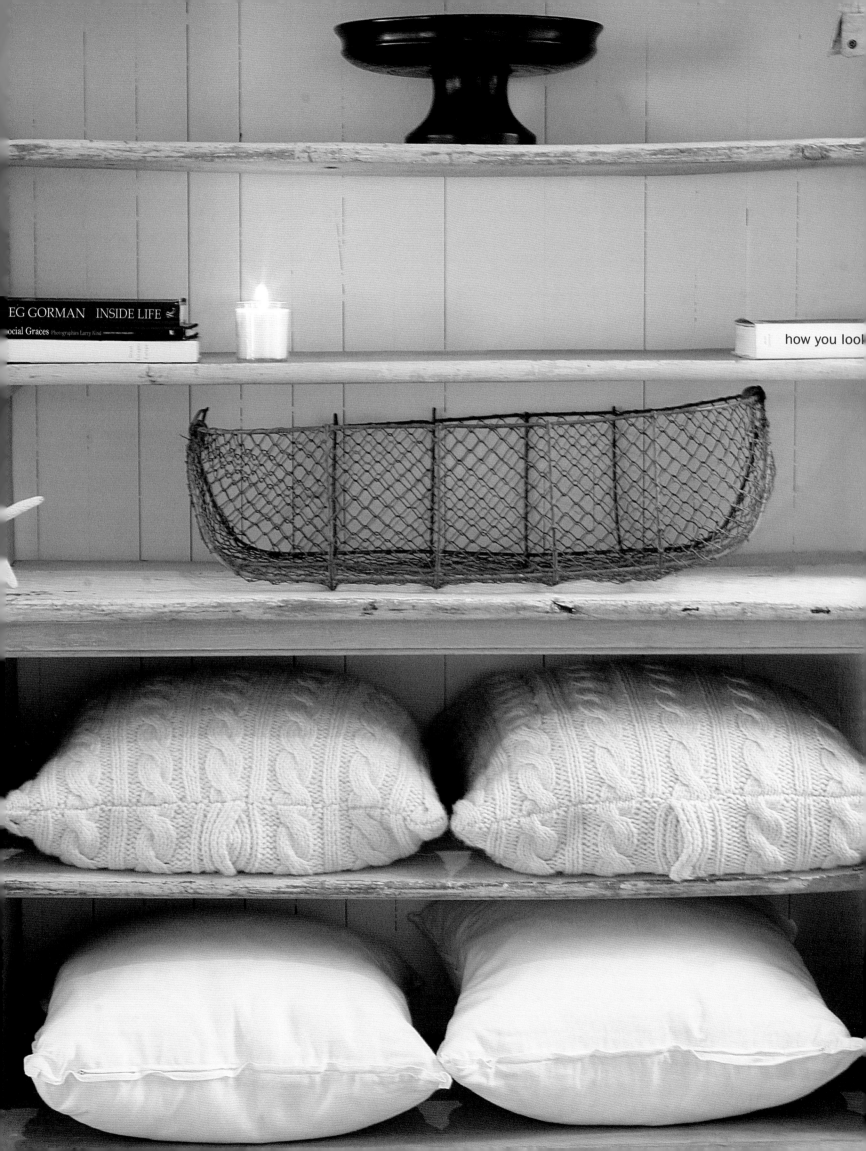

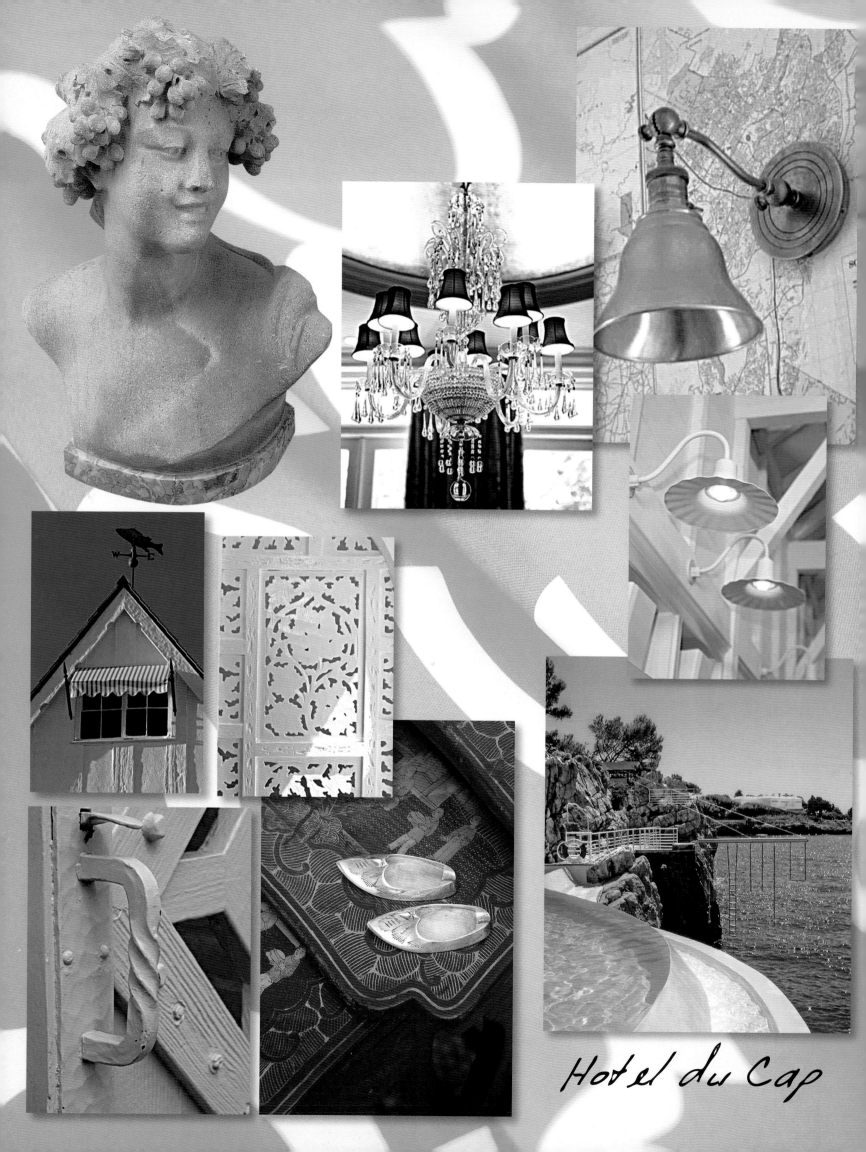

Hotel du Cap

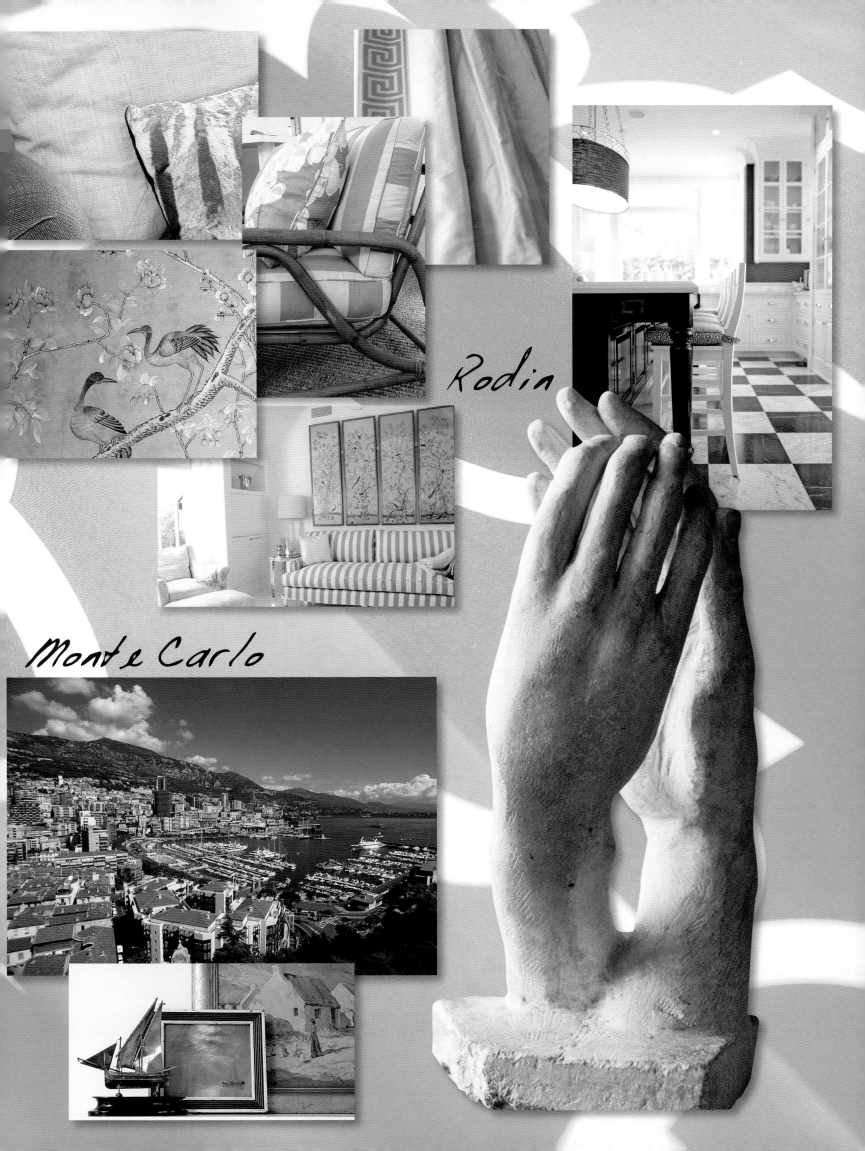

Rodin

Monte Carlo

KELLY WEARSTLER

My philosophy? There are no rules in interior design. I believe the best designs are born out of risk. Whether it comes from scale or color, I love the unexpected because it adds depth and personality to a space. Playing with scale and combining colors in unusual ways, such as pistachio and golden yellow, a soft gray with a vibrant purple or aqua with magenta, is also something I love to try. It is also fun to mix pieces from different time periods, like an eighteenth-century Baroque mirror with a colorful Ettore Sottsass sculpture.

What I think about when designing a space and determining where to place the emphasis completely depends on the object or medium at hand. In fabrics, for example, texture and pattern come first; the color palette always comes last. Although I got my start in interiors, I studied graphic design and architecture and honed my skills with hotels, so it's equally important to create something as beautiful as it is functional.

I'm constantly on the hunt for something that moves and inspires me, because it pushes me to try something new. How wonderful is it to encounter an innovative idea that is so fresh that you find yourself saying, "Oh, I never would have thought of that?" For example, I stayed at a hotel in India where you step off your patio into a huge pool—you swim right out of your room into the water! I might use an indirect translation of this idea in one of my hotel projects. In fact, we're working on an outstanding project in Mexico with Ricardo Legorreta where all the rooms are villas. Some are on islands, so we're playing with the idea of creating pools that cantilever over the larger body of water. Hotels are a blast because they tend to be more fantasy-driven than residences and everyday people from all over the world are enjoying the space I designed.

Every designer evolves. At the moment, I like more dramatic looks, playing with a larger scale, but that could all change tomorrow! Over the years, I've become increasingly sophisticated in my tastes, which has led me to be more willing to mix any and everything. Plus, as I travel and increase the range of items I'm exposed to, I'm game to try more. I've found that as an artist, with the right inspirational nutrition, you grow and become more confident over time. In my company, it is essential to be a team player. I especially enjoy working with those who have their own points of view—being open to experimentation and letting your imagination run wild are paramount. Plus, it's important to be able to take criticism and be willing to bend because, ultimately, the goal is to make your client happy. You also have to be a great listener to understand your client's program and needs. Design is a service job; you have to be ready to get your hands dirty!

I collect fashion, architecture, and design books as well as vintage and antique furniture. My interest in design embraces everything: fabric, carpets, bedding, tabletop items, crystal and furniture. Fashion is also on the horizon. However, my dream project is to be invited to freshen up the White House. I'd definitely make it a little sassier. Those interiors don't have to be so serious, because politics aren't. The people in rooms are the most important ingredient—you can design an incredible room, but if you don't have equally incredible people to populate it with, the design hardly matters.

"I take risks, and I believe you can do anything that your brain and your imagination can create."

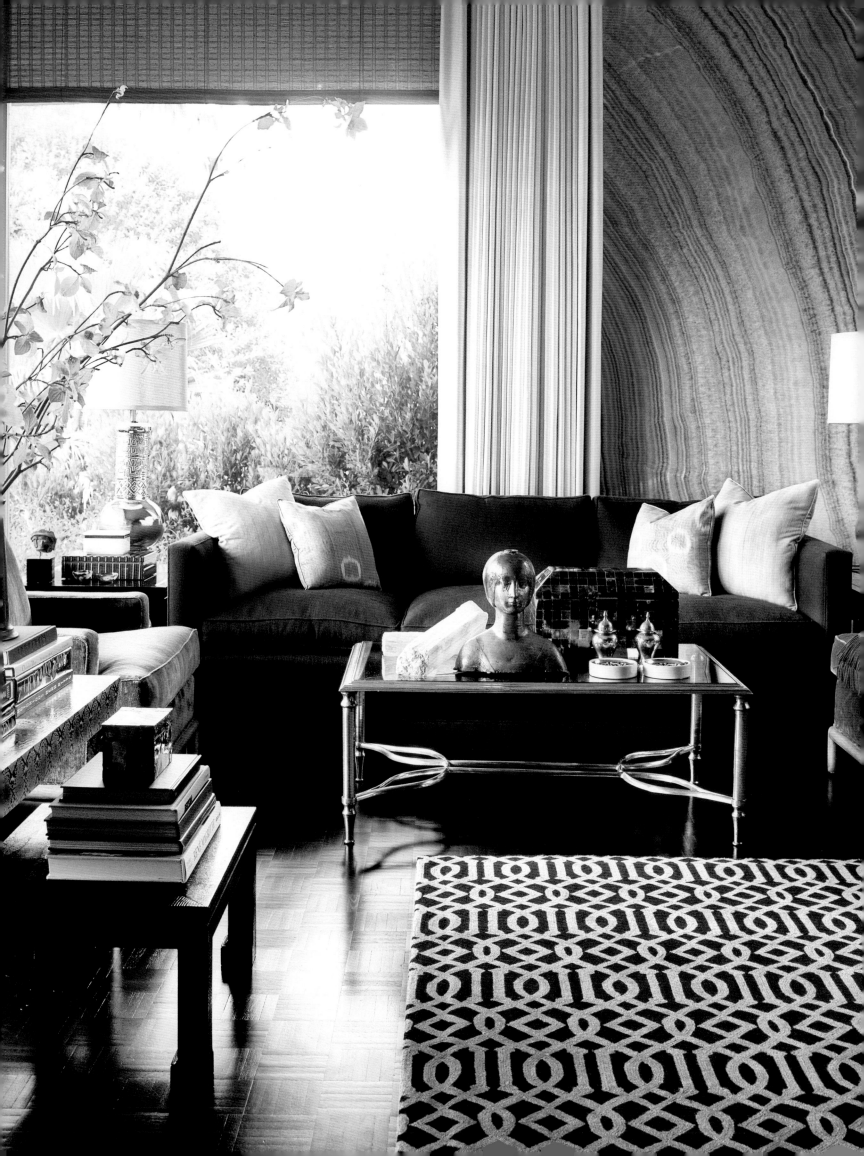

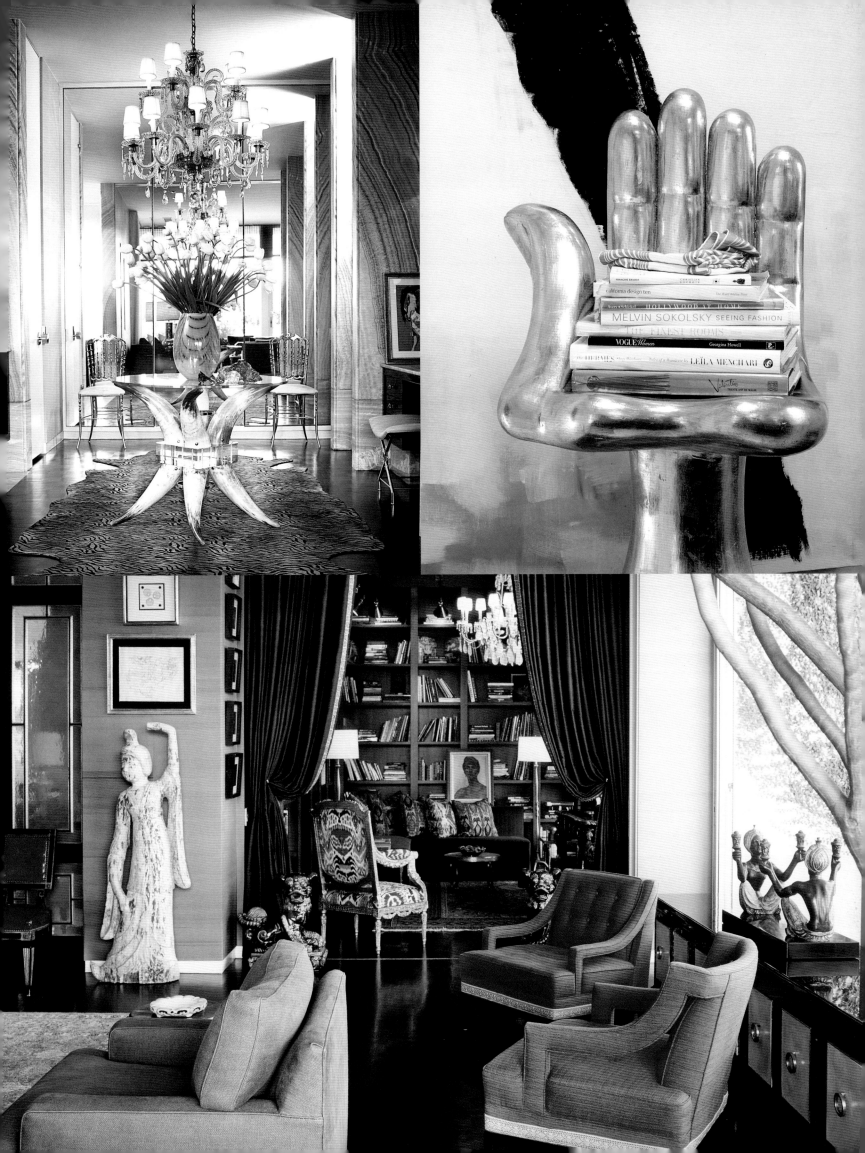

The book titles visible on the stacked books include:

FRANÇOIS BRAUDT · CHRISTIAN LOUBOUTIN
california design ten · The Island Interior Design
Avant-Soleil · HOLLYWOOD AT HOME
MELVIN SOKOLSKY SEEING FASHION
THE FINEST ROOMS
VOGUE Women · Georgina Howell
HERMÈS · Value of a Hundred by LEÏLA MENCHARI
Valentino · TRENTE ANS DE MAGIE

MY INSPIRATIONS AND PASSIONS

What's your favorite . . .

Accessory *Bronze and shell clutch by Celestina*
Actor *My friend Jeanne Tripplehorn*
Artist *Willem de Kooning*
Book *Chinoiseries, by Bernd H. Dams and Andrew Zega*
Broadway show *The Lion King*
Car *Maserati Quattroporte*
Chair *Pedro Friedeberg's Hand Chair in gold leaf*
Chocolate *Muscadines from French chocolatier Payard, a classic confection of dark chocolate ganache dusted with powdered sugar*
Color *I love all colors, no favorites.*
Fashion designer *Derek Lam, Thomas Maier, Doo.Ri, Peter Som*
Flower *Peonies*
Food *Urth Caffé granola*
Garden *The rock garden at Ryoanji Temple in Kyoto, Japan*
Guilty pleasure *Massages*
Hotel *Viceroy Anguilla Resort, British West Indies*
Ice cream *Baskin Robbins Peanut Butter 'n Chocolate*
Jewelry *My Solange Azagury-Partridge ring*
Lamp *A pair of vintage bronze peacock lamps*
Memory *Getting married and giving birth to two sons*
Movie *E.T.*
Museum *The Museo de los Niños Abasto in Buenos Aires, Argentina*
Perfume/cologne *Clair de Musc by Serge Lutens*
Room in the house *Bedroom*
Singer *Astrud Gilberto*
Sport *Sex*
Toiletry *Aesop Rejuvenate Aromatique Body Balm*
Wine *2003 Penfolds Shiraz*

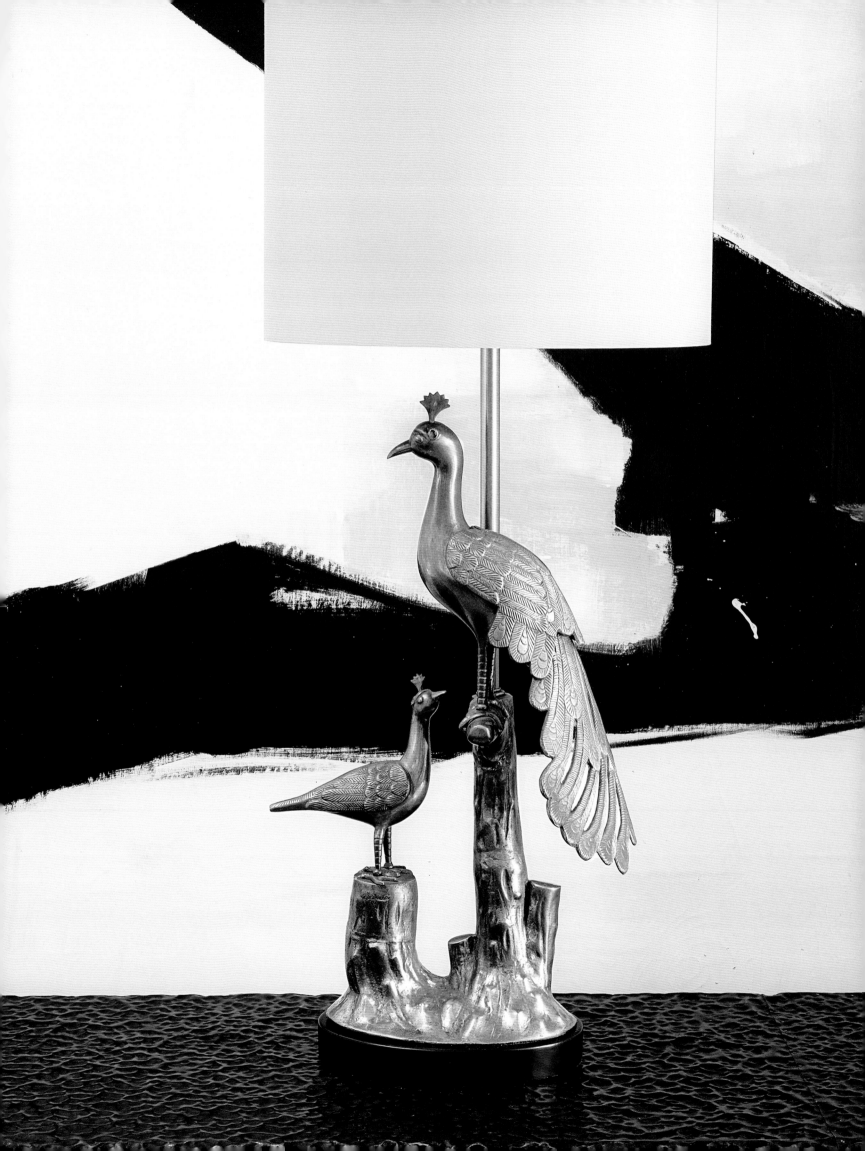

Bright Colors

Textiles, Fabrics

Kyoto

My Children

MICHAEL WEISS

Artists need to be spontaneous—to remain open to the free flow of ideas. In art, in creativity, there are no right or wrong answers. I'm a second-generation artist, and I was destined to follow this path. These early impressions, growing up in a house full of art and creativity, are still my driving force. My mother and father raised their children to be individualists, and gave us the freedom and discipline to do and achieve what we wanted. My mother, Lillian August, is a free spirit—a designer, an artist, and very accomplished painter. My father's a cardiologist and an amateur archaeologist who just published *The Mystery of the Tuscan Hills*, about his scholarly passion for the ancient Etruscans. I'm the youngest of three, and I think we were fortunate to grow up in a home filled with a wonderful optimism.

When I was eleven, my mother got serious about her design career and became incredibly successful in just a few years—seeing her drive and dedication remains an important early lesson. I worked with her for a number of years, as did my brothers, who have grown the Lillian August retail stores into an impressive enterprise. That experience laid the groundwork for my career producing original designs.

I started out at the Julliard School, studying theater and the performing arts. I may have quickly abandoned the idea of being an actor, but at Julliard I learned the most important lessons, lessons that have been invaluable to me as a designer: the sense of mastery of an art form, and the extraordinary amount of discipline, practice, memorization, and coaching that go into the development of a successful artist.

Design is a great chance to contribute and to give. I never want being a designer to be an elitist thing. I have always wanted to bring a point of view that is uniquely individual. I feel very fortunate to have an audience for my work, and to have my designs produced. I had always wanted to create a modern furniture collection, and fortunately my timing was good. When I launched my "Modernism" collection, the pendulum had swung and the marketplace was primed for a fresh interpretation of classic modern style.

I'm interested in a classic sensibility and am a student of art history and the decorative arts. I think creativity makes it imperative to have that appreciation, and it is always somewhere in the back of an inspired mind. It's important to go to as many museum shows and performances as possible—to travel and see as much as you can. Many artists inspire me. I love Claes Oldenburg for his sense of humor, and for pushing the boundaries. Eric Fischl and John Currin are doing something incredibly fresh and individual with classic oil-on-canvas techniques. Design should have a link with authenticity—it demands that you treat the act of designing fabrics and furniture like a fine art, with that level of inspiration.

Creativity is facing a blank piece of paper, with a pencil in hand, and having the need to say something new and fresh.

One of the great things about design is that you can do it forever. Look at the brilliant, prolific work of Andrée Putman and Eva Zeisel. And Frank Lloyd Wright created his master works very late in his life. A designer's work is never done. As Judy Leibowitz, a former Julliard teacher, once told me, "If you think you've learned the lesson, you've missed the point. You're always in pursuit of mastery. The goal is in the pursuit, and you will spend a lifetime on the journey."

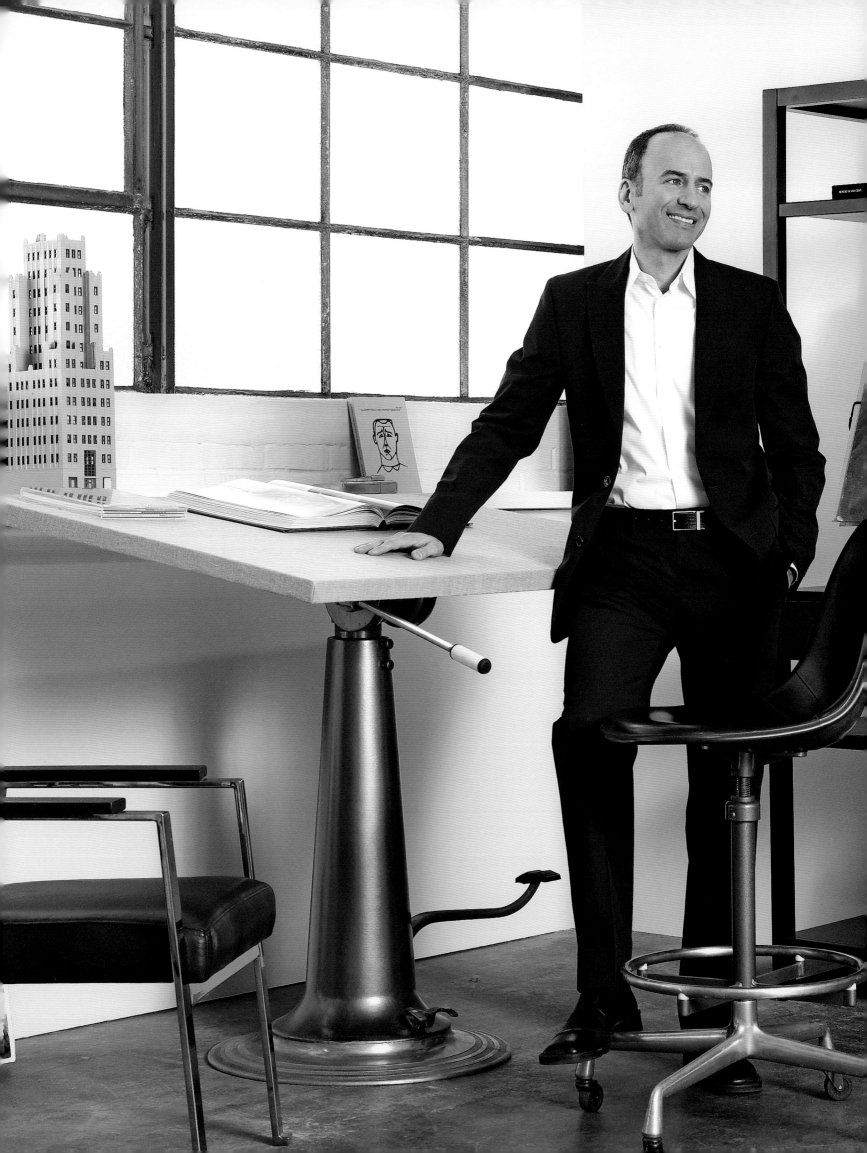

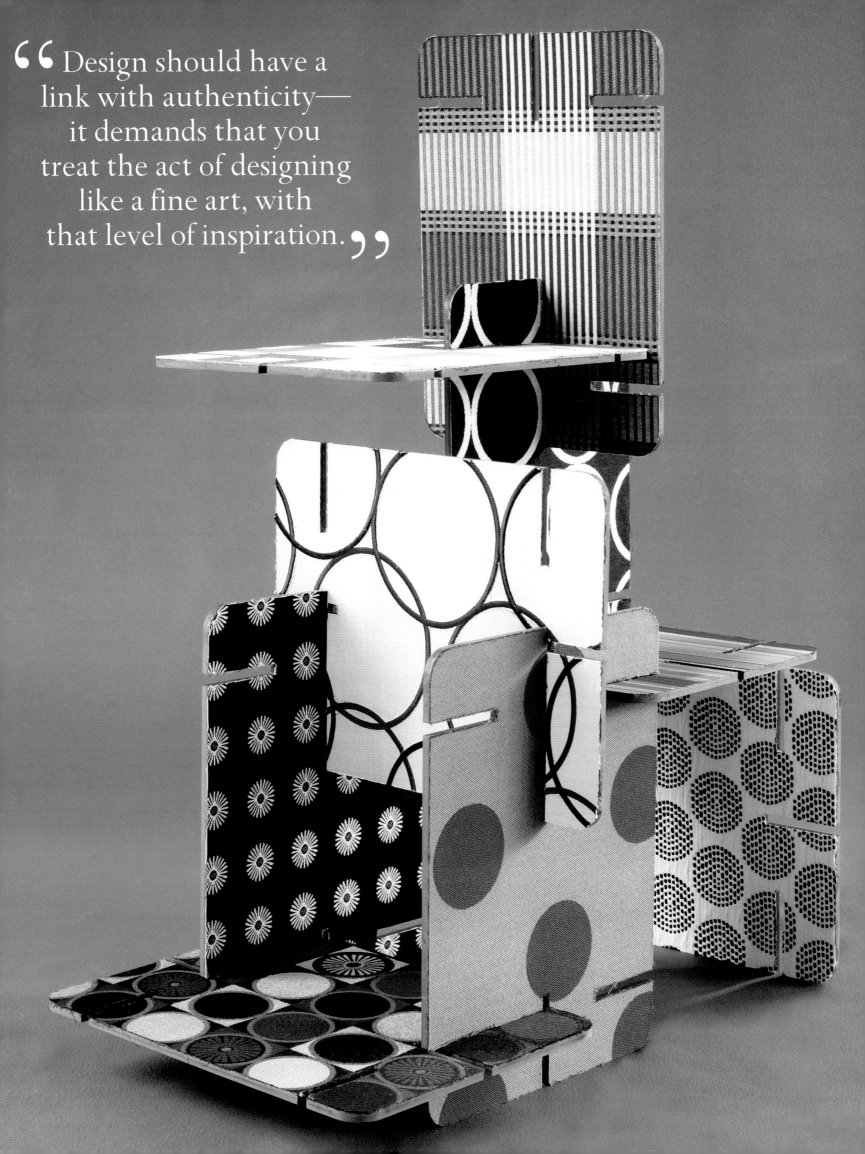

> "Design should have a link with authenticity— it demands that you treat the act of designing like a fine art, with that level of inspiration."

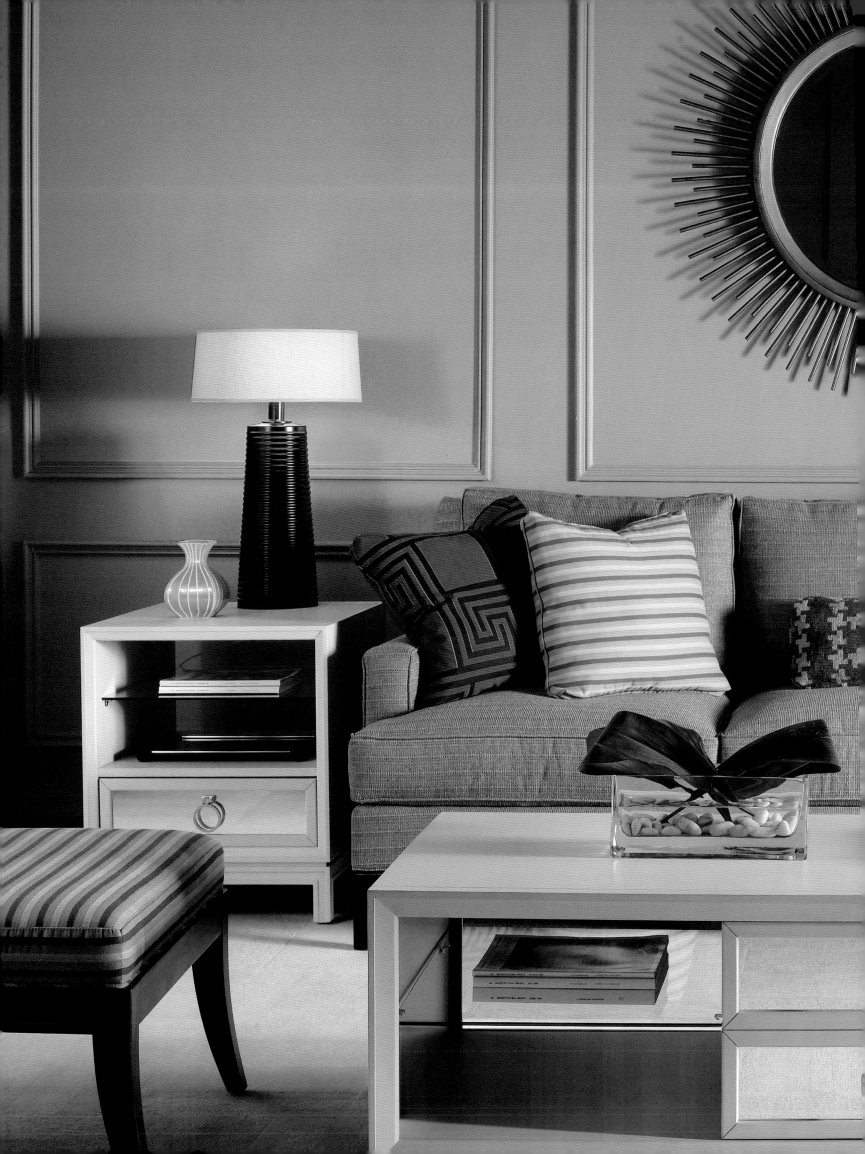

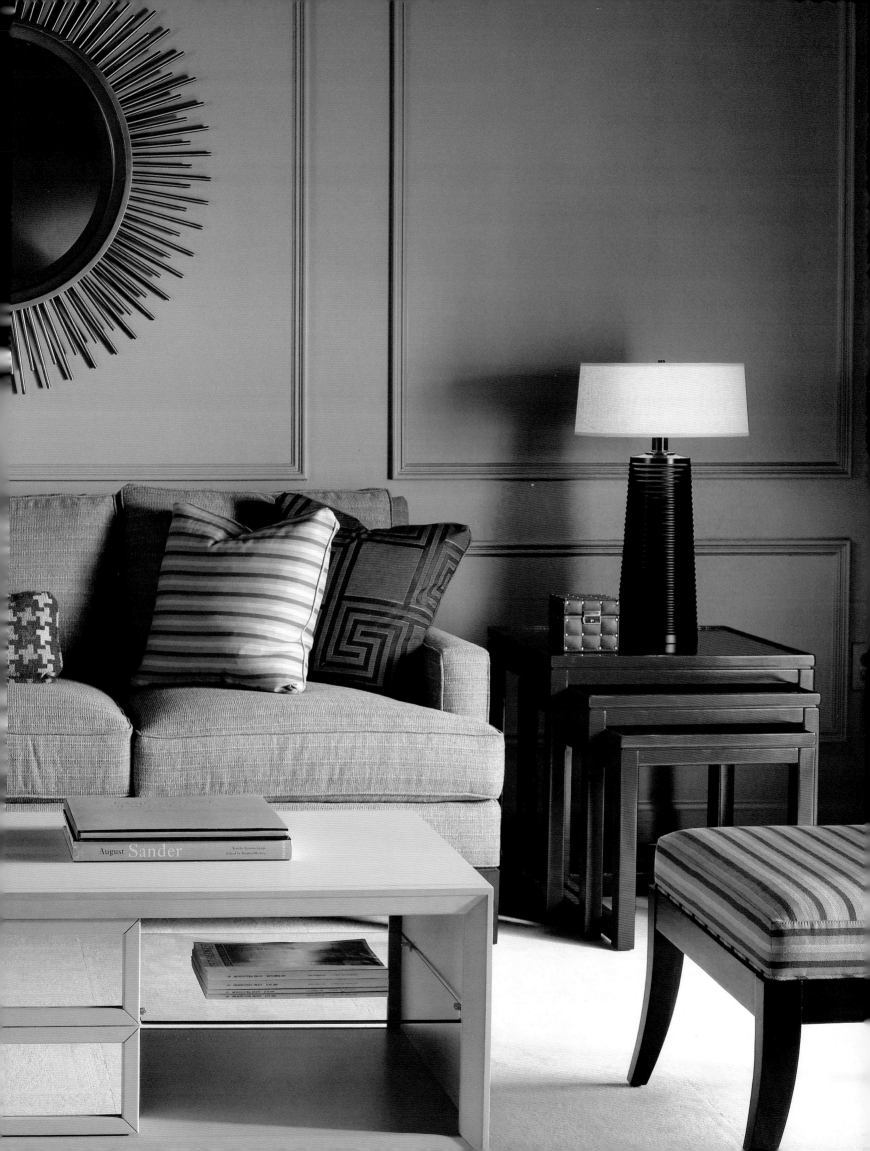

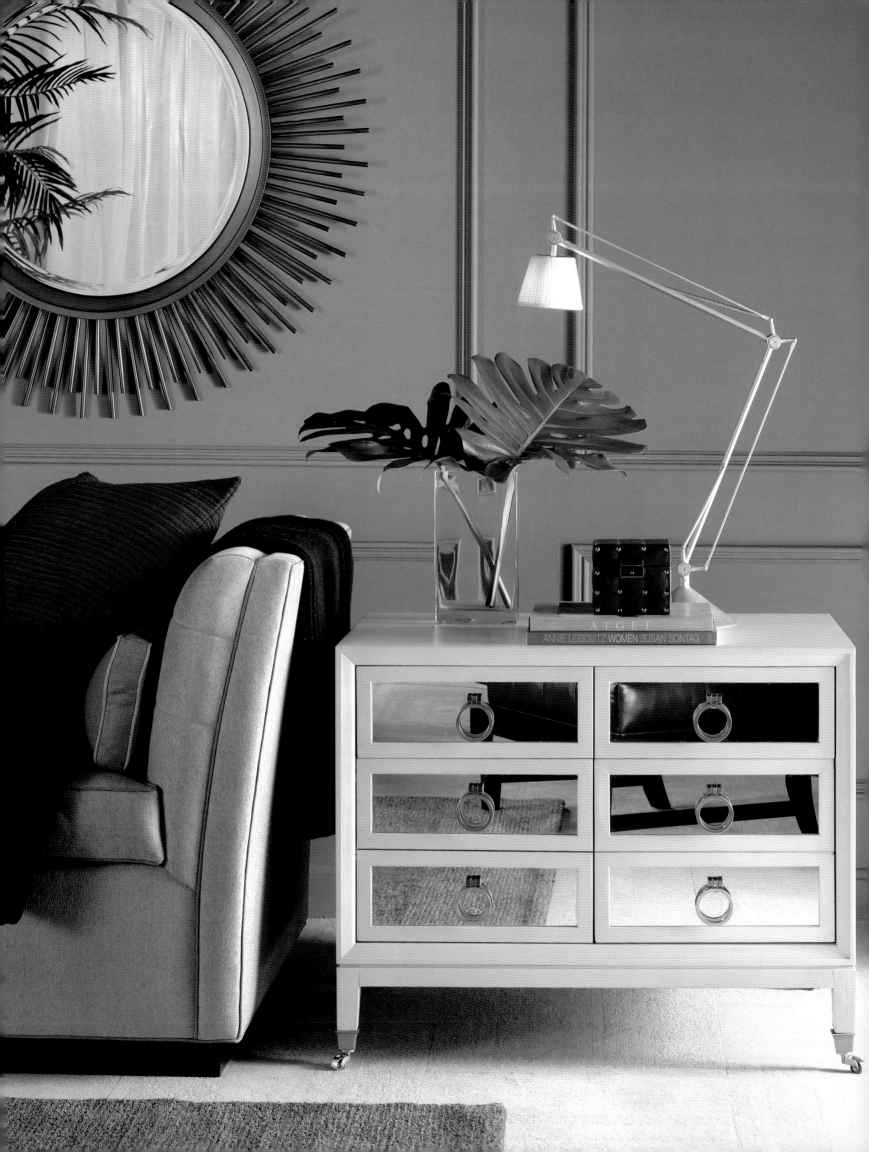

ATGET

ANNIE LEIBOVITZ WOMEN SUSAN SONTAG

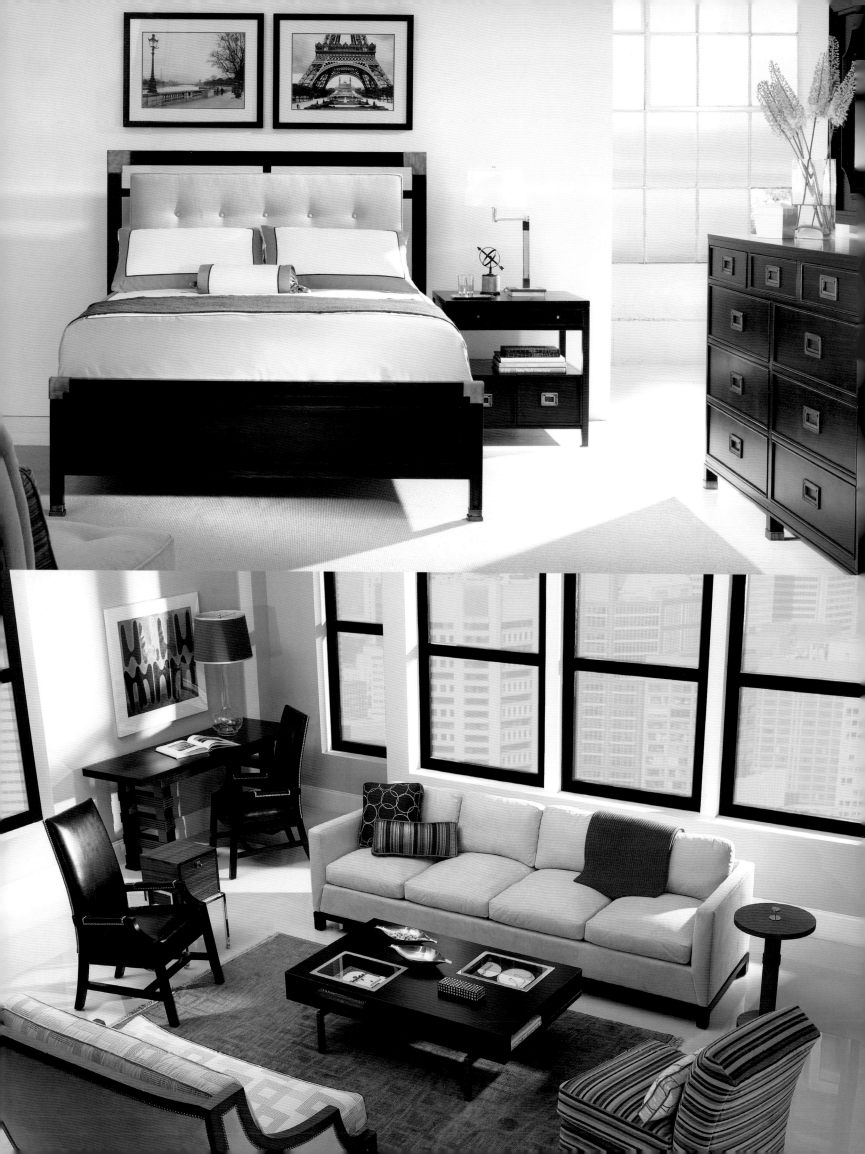

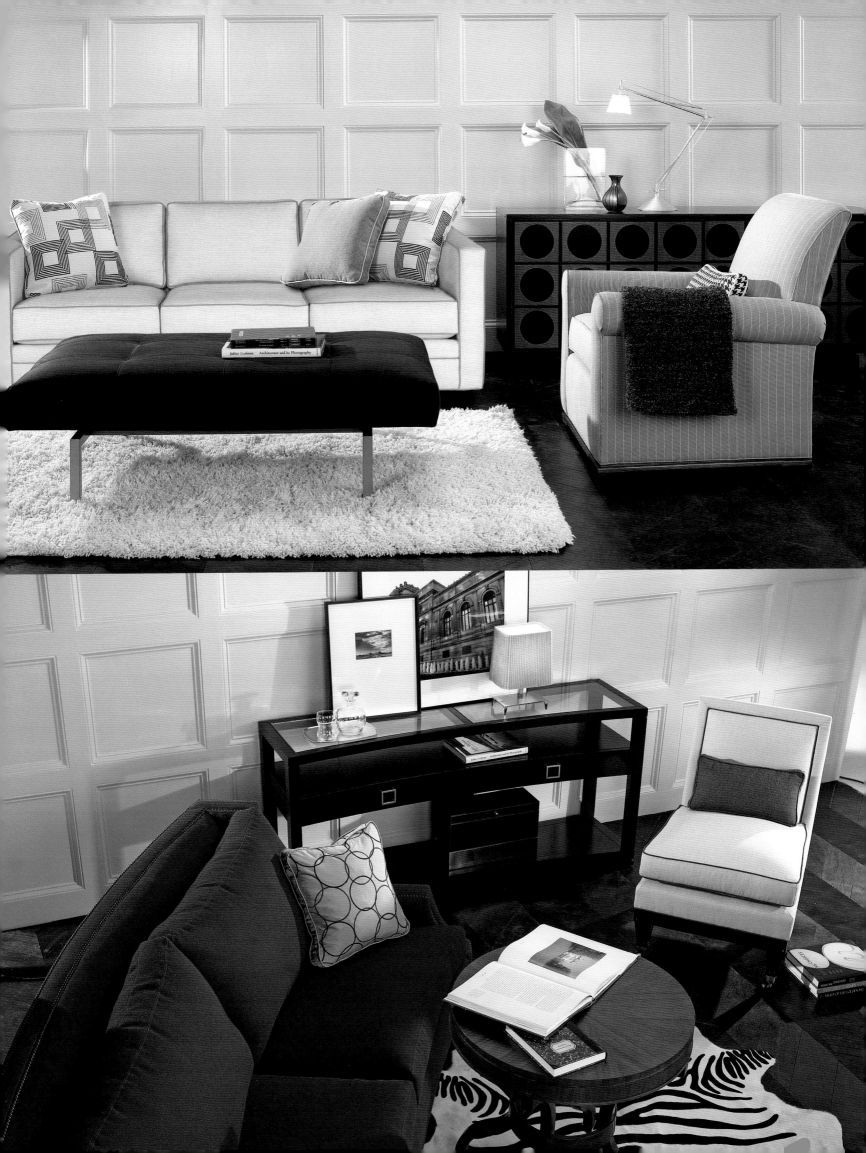

MY INSPIRATIONS AND PASSIONS

What's your favorite . . .

Accessory *Fashion—shoes. Decorative—lighting*
Actor *Judi Dench*
Airport *The Saarinen TWA terminal at JFK*
Artist *Claes Oldenburg, Eric Fischl, John Currin . . .*
Bar *The rooftop bar at the Hotel Gansevoort, New York*
Broadway play *Sweet Bird of Youth, starring Lauren Bacall*
Car *Citroën DS from the 1970s, which still looks futuristic and modern*
Chair *The Saarinen tulip chair. When I was growing up, we had four of these with bright yellow seat cushions in our kitchen.*
Chef *Thomas Keller*
Color *Blue(s)—it can be cool, mysterious, and relaxing at the same time.*
Drink *Mandarin martini*
Fashion designer *Karl Lagerfeld—he is a creative genius who turns fashion into fine art.*
Flower *Orchids*
Hotel *Hotel InterContinental Hong Kong (formerly The Regent Hong Kong)*
Lamp *Joe Colombo arc light—it's a big modernist sculpture.*
Memory *Moving to New York in 1982 for college*
Movie *Who's Afraid of Virginia Woolf?*
Perfume/cologne *Natural scents like verbena and jasmine*
Restaurant *Le Colonial in New York, for the beautiful room and great memories*
Spa *The ancient spa "thermae" in Montecatini*
Sport *Spectator sport—the horse races at Churchill Downs. It's like stepping back in time to the nineteenth century.*
Wine *Full-bodied Italian reds*

ELLSWORTH KELLY: SELF-PORTRAIT DRAWINGS 1944-1992

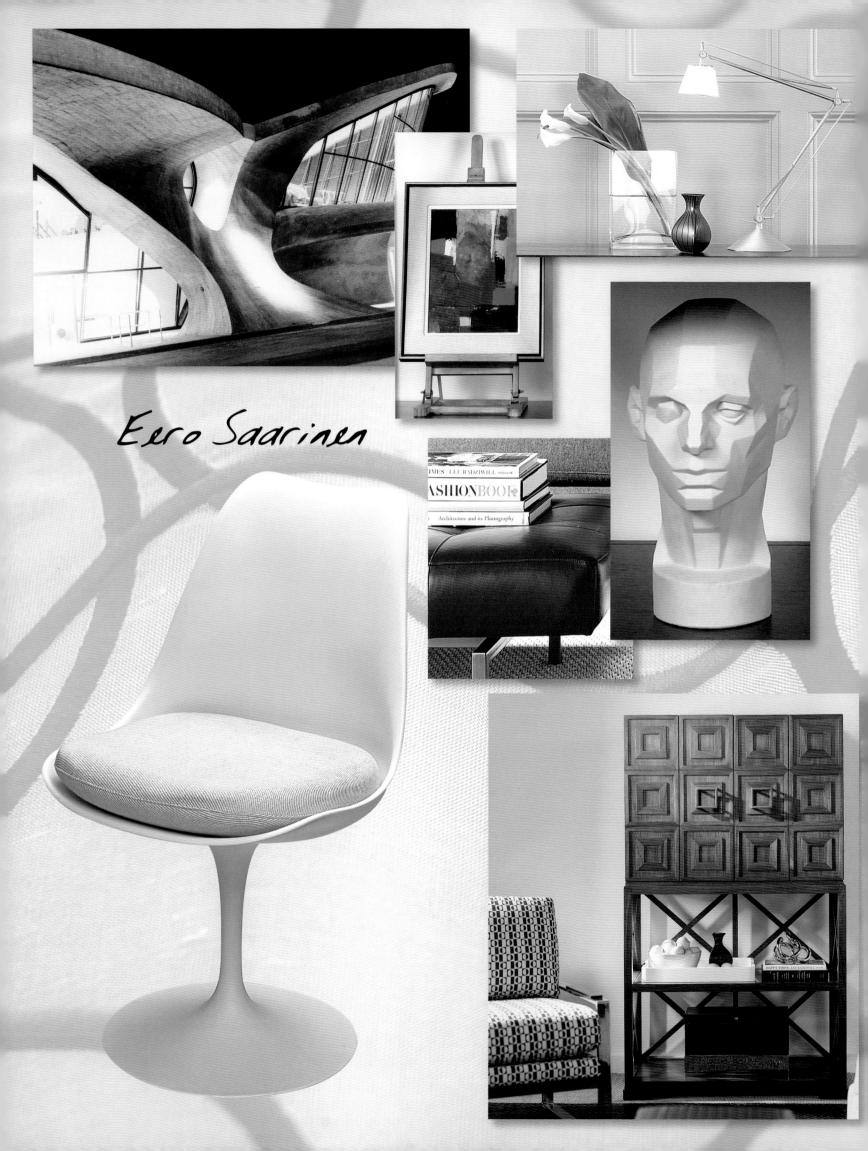

Eero Saarinen

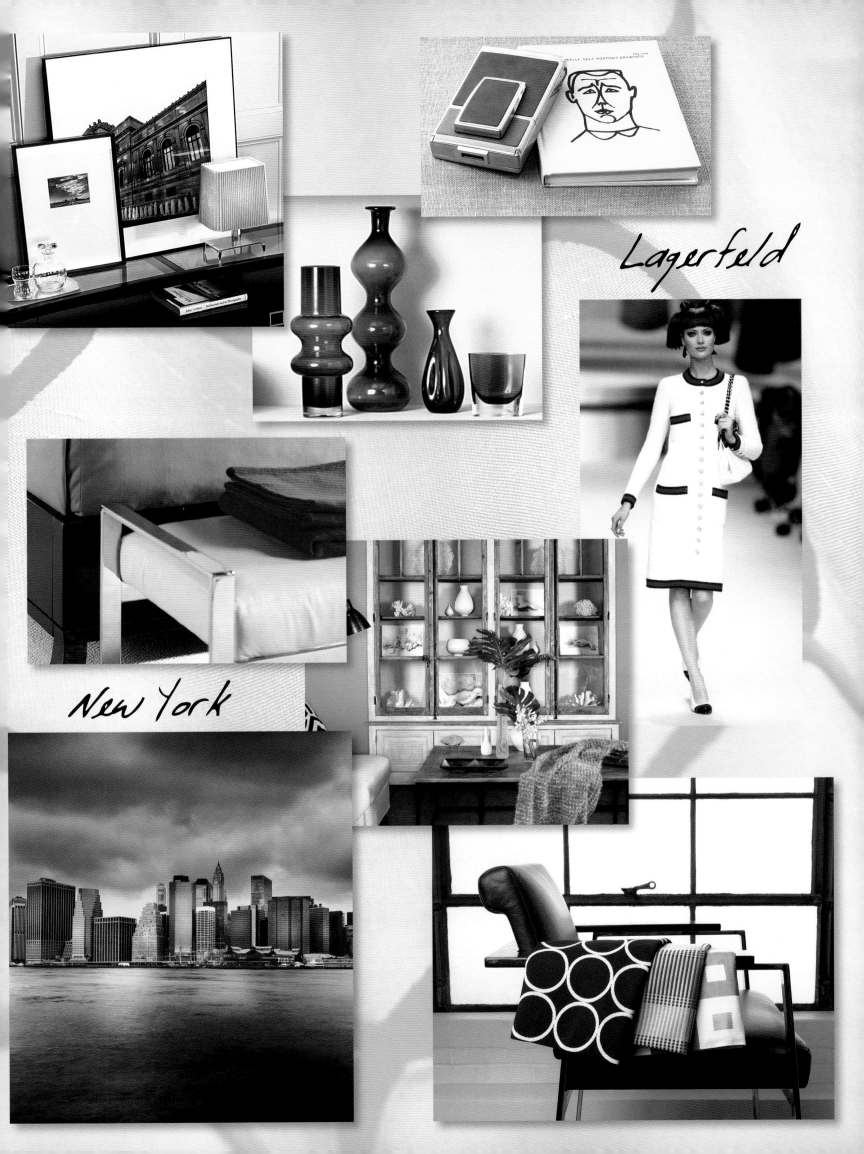

Lagerfeld

New York

VICENTE WOLF

Just being in New York is inspiration. What's happening on the street stimulates and motivates you. There's tremendous energy and the sense of what's current, of how people are thinking and feeling today. For me, though, the muse is travel—when I find myself far away from my everyday life. I like the Orient, its sense of order and balance, its aesthetic approach, its calmness and spirituality. I love going to Syria and Iran, to Israel and Jordan, places where there's another point of view—and unique color and sunlight and leaves; a dry riverbed filled with succulents in shadowy shades of gray-greens, a different quality of dark and light, a strange combination of colors.

Travel alters you. I use objects differently when I've found them at the source, instead of in a shop in Manhattan. I've gone into people's houses around the world and bought things from their original, actual environment. When you do that, you understand the object and realize its integrity. It's no longer just something decorative. For instance, when I was in Ethiopia I saw that many men carry canes cut from trees. The canes have natural shapes and are used almost as personal accessories. I bought a whole bunch, and when I got back home I mounted them on stands. When they're placed in an interior, they look like trees growing out of the floor. But I don't know that I would have related to them as trees if I hadn't seen how they were made. When you deal with different cultures and different points of view, it opens up your perspective. You become more accepting of the idea of blending, and more comfortable doing just that—putting together objects with distinct personalities, objects from various periods and ethnic origins.

Designing like this is the farthest away from taking a thematic approach. You're not trying to capture a particular period or style; you're just trying to express your point of view. That's the kind of work and play I love, and that's what I think contemporary design is: finding the yin and the yang, mixing the formal and the informal, using an eighteenth-century Italian piece and deciding what's going to go nearby, whether it's something mid-century, completely current, or from another time and a wildly different culture. Doing so gives rooms a longer life.

When I see the right blend, I know it—but it has to reflect the client. That's why I love photography. It comes from your interest and sense of what you feel is right. Photography influences my range of vision. When I'm photographing, I'm seeing elevations that are compositions. Photography makes me look at things in 180 degrees, rather than looking all the way around the object or the space. I'll focus in on different elevations and create different settings. Looking through the lens is like looking through a small window—you have to choose what to focus the camera on. It's the training of looking at things, and seeing things in isolation, and finding a controlled range of vision. When I pull back, all the views work together, but each is its own composition. A large part of the reason I show my photography is to share my point of view and to help others find their own "voice" for looking—to share with other people what has been shared with me. I don't have an academic background. I'm dyslexic, and my education was not formal. So when I'm designing I don't have the limitation of school. I'm visual and I'm intuitive. I've learned from the "school of life," which taught me to focus on what interests me. Now, I think, my skill is broader: I see things, and they all become filed away in my mental filing cabinet. When there's work to be done, the dissecting and analyzing and editing and critiquing happen subconsciously. All the information is in my head, and I sit down and do it—until I'm done.

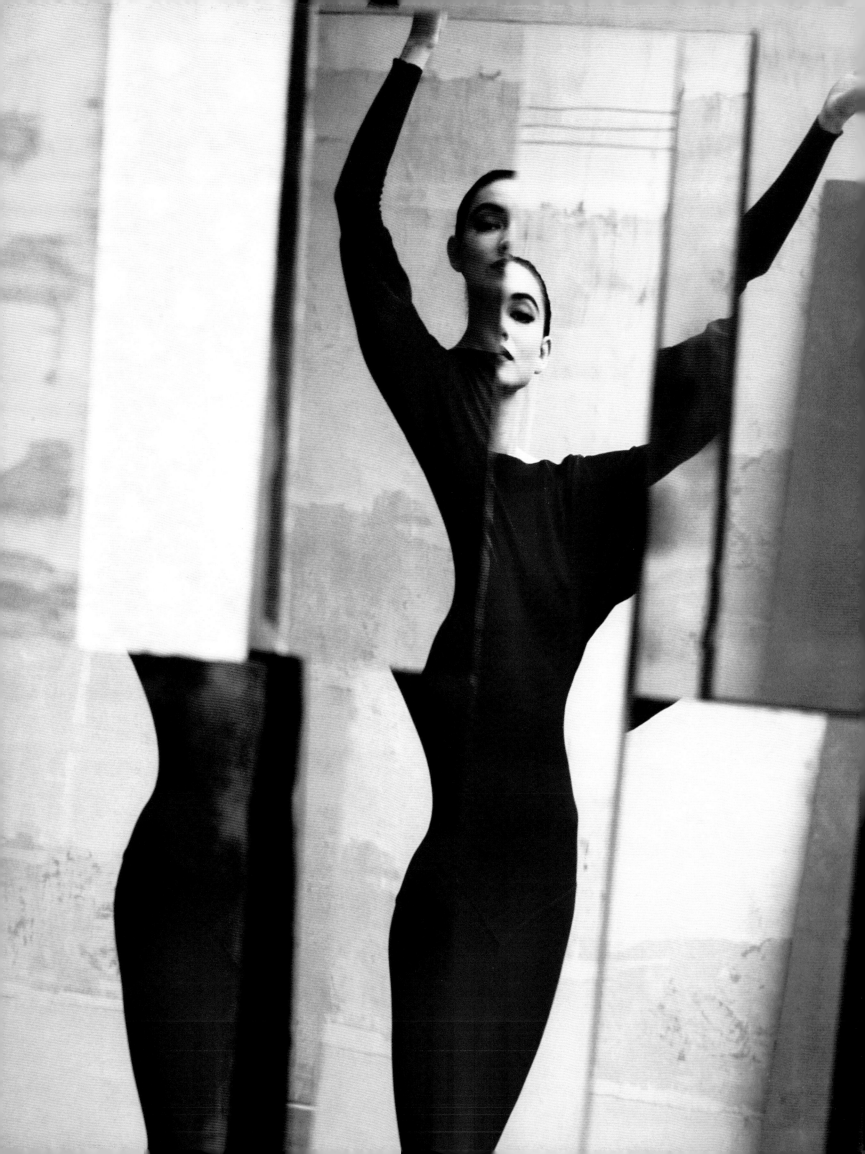

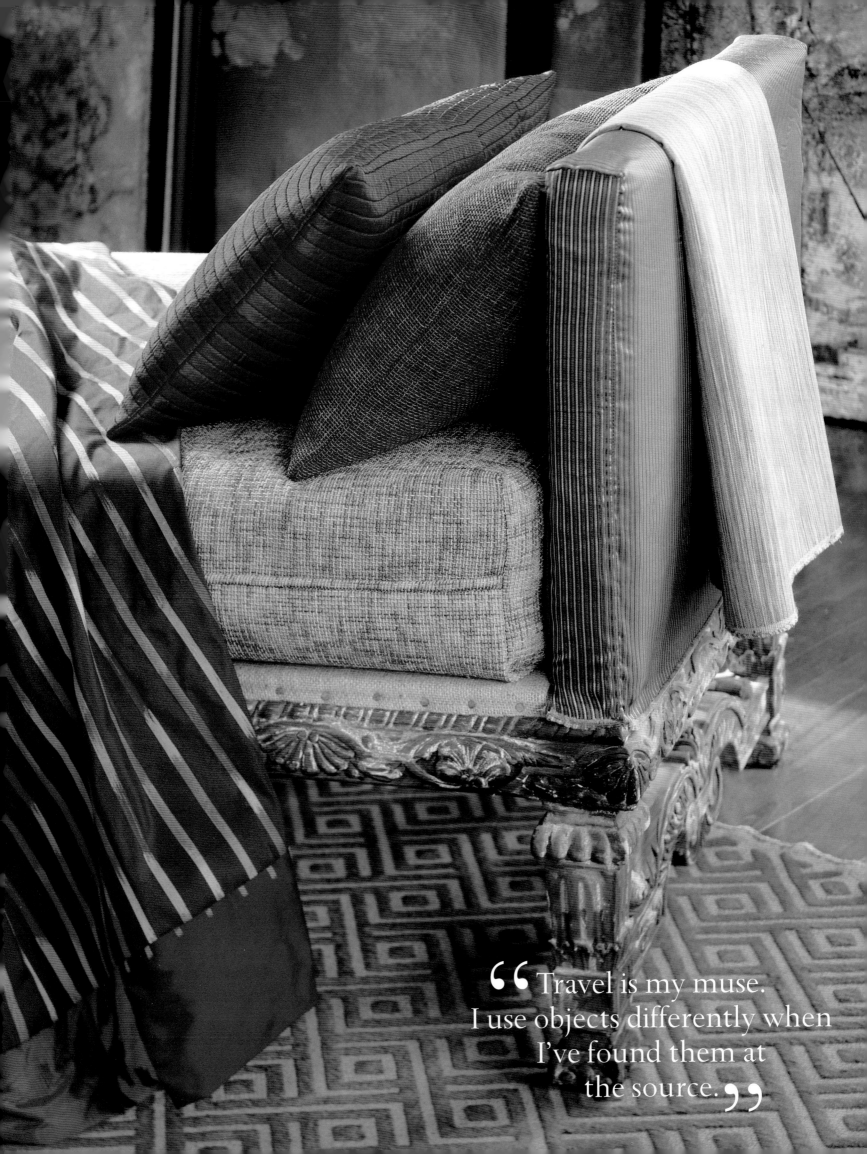

> "Travel is my muse.
> I use objects differently when
> I've found them at
> the source."

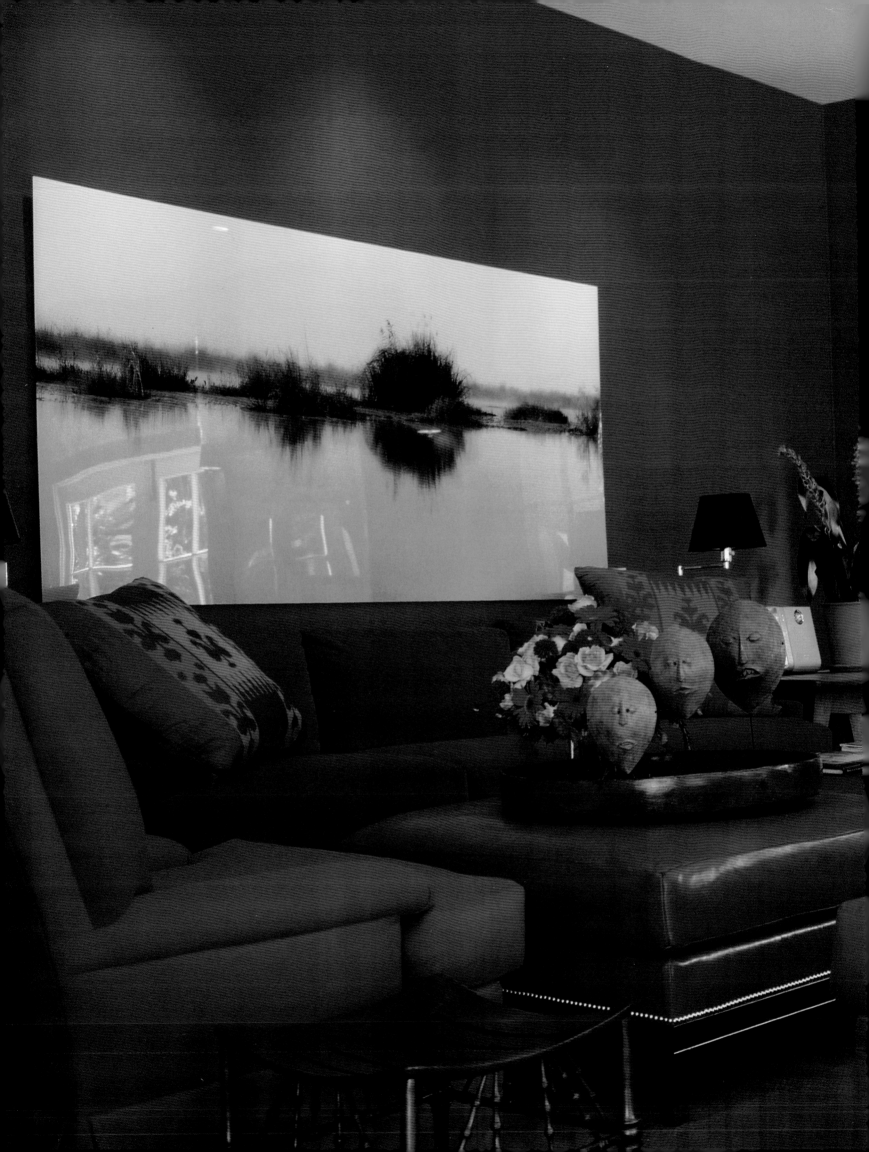

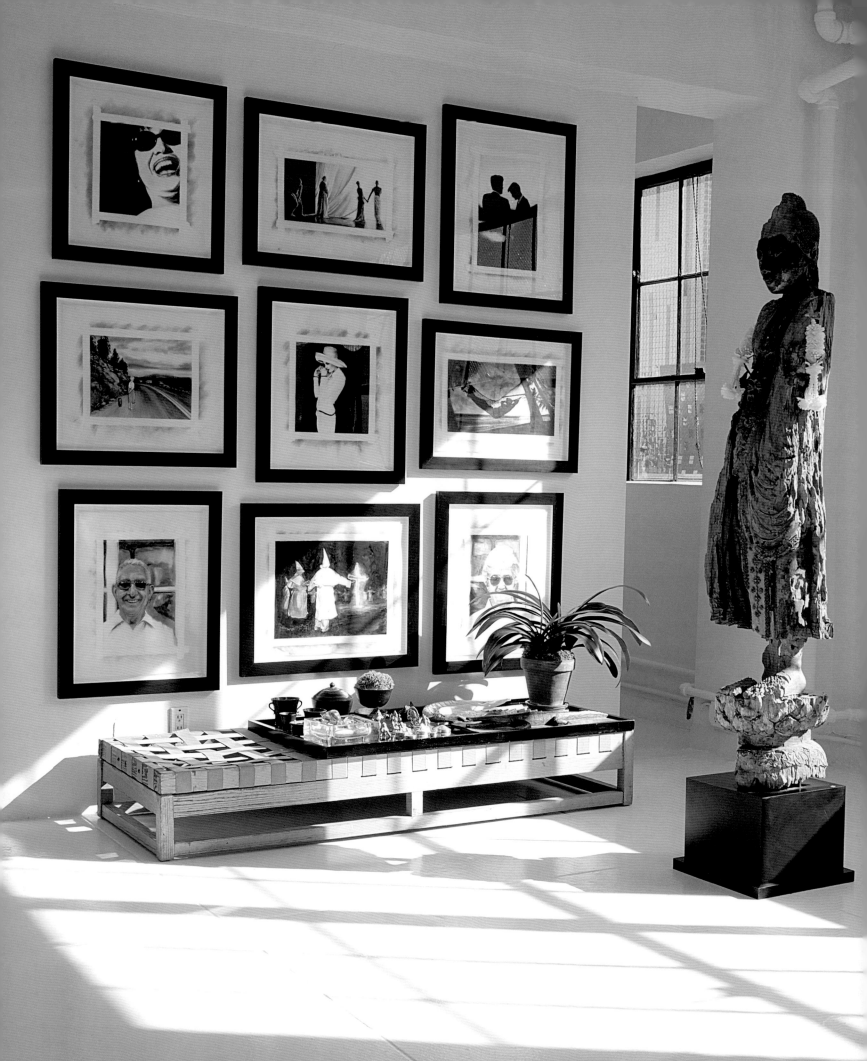

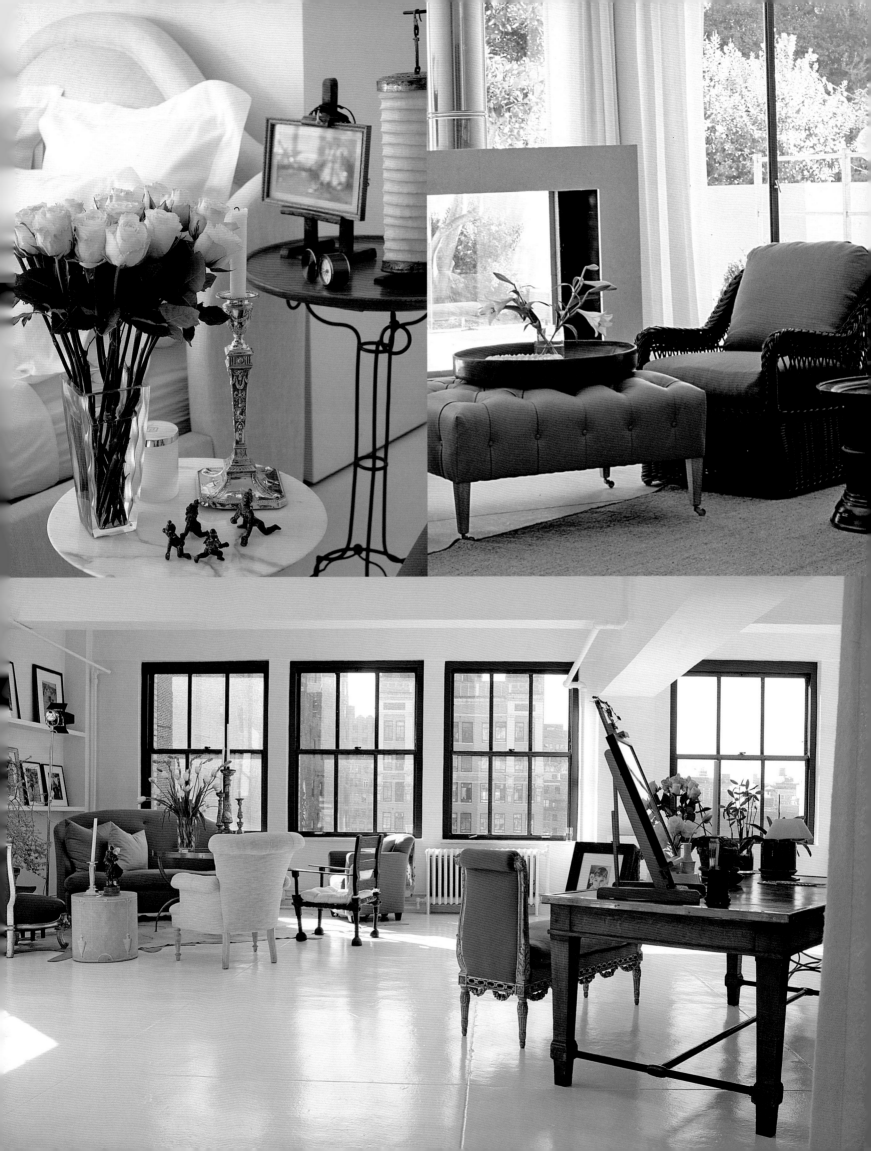

MY INSPIRATIONS AND PASSIONS

What's your favorite . . .

Accessory *Key chain*
Actor *Meryl Streep*
Airport *The one in Hong Kong*
Artist *Martin Munkácsi, photographer*
Bar *The bar at the Ritz in Paris*
Bed sheets *Anichini*
Book *The Artist's Way, by Julia Cameron*
Broadway show *House of Flowers*
Car *1962 Lincoln convertible*
Color *White*
Country *Bhutan*
Drink *Bourbon and water*
Fashion designer *Thom Browne*
Flower *Gardenia*
Food *Home cooked*
Guilty pleasure *There is no guilt in pleasure.*
Hobby *Collecting photography*
Hotel *The Oriental hotel in Bangkok*
Ice Cream *Green Tea ice cream*
Lamp *Parentesi floor lamp*
Movie *Funny Face*
Museum *The Metropolitan Museum of Art, New York*
Perfume/cologne *Annick Goutal Gardenia Passion*
Pet *My cat*
Singer *Judy Garland*
Spa *The Golden Door in Escondido, California*
Sport *Speed walking*
Time of day *5:30 a.m.*

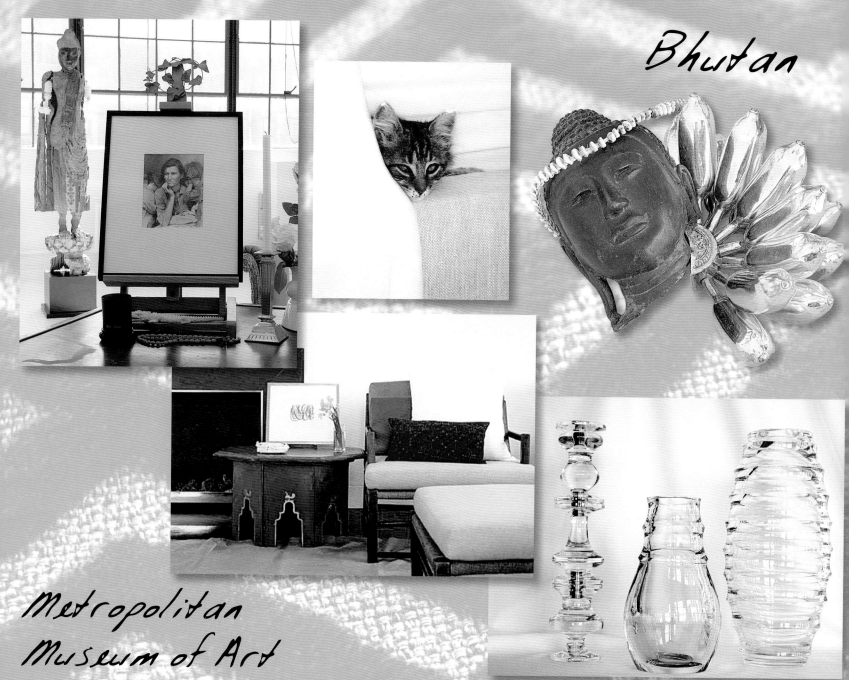

Bhutan

Metropolitan
Museum of Art

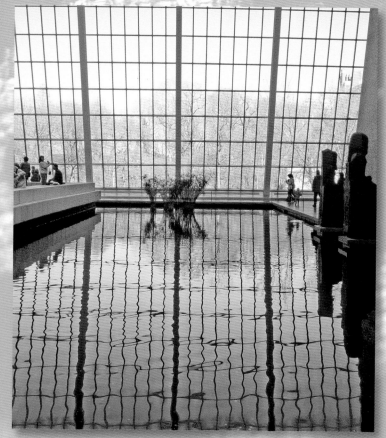

Aeron
Chair

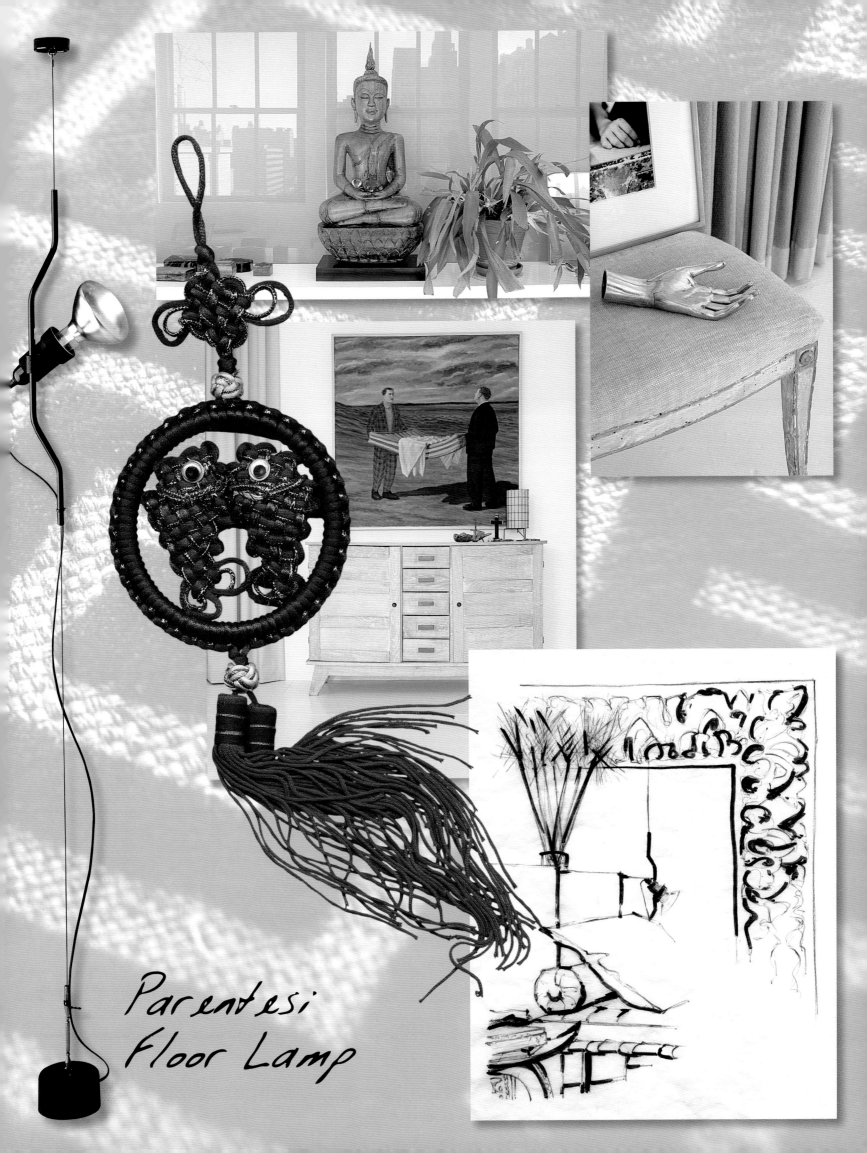

Parentesi
Floor Lamp

CREDITS